Merry Christmas 2007
Donelly & Ligell.
Lots of Love
Yvonne

Home Musings
for you!

Regina's
Secret
SPACES
Love and Lore of Local Geography

Regina's *Secret* SPACES

Love and Lore of Local Geography

edited by

Lorne Beug, Anne Campbell and Jeannie Mah

featuring photography by

Don Hall

2006

Canadian Plains Research Center
University of Regina
Regina, Saskatchewan S4S 0A2
Canada
Tel: (306) 585-4758
Fax: (306) 585-4699
E-mail: canadian.plains@uregina.ca
http://www.cprc.uregina.ca

Library and Archives Canada Cataloguing in Publication

 Regina's secret spaces : love and lore of local geography / edited by Lorne Beug, Anne Campbell and Jeannie Mah ; featuring photography by Don Hall.

(TBS, ISSN 1482-9886 ; 19)
ISBN-13: 978-0-88977-200-7
ISBN-10: 0-88977-200-2

 1. Regina (Sask.) I. Beug, Lorne, 1948- II. Campbell, Anne, date III. Mah, Jeannie IV. University of Regina. Canadian Plains Research Center V. Series.

FC3546.3.R44 2006 971.24'45 C2006-904401-5

Design by Donna Achtzehner, Canadian Plains Research Center.
Front cover photo and editor photos by Don Hall; photo of Don Hall by Julie Heinrich.
Cover design by Donna Achtzehner.
Maps created by Diane Perrick, Canadian Plains Research Center.
Thanks to the City of Regina for providing road data for maps.

The editors and publisher wish to acknowledge the financial support of the following:
- Book Publishing Industry Development Program (BPIDP)
- Cultural Industries Development Fund
- Saskatchewan Arts Board
- Saskatchewan Heritage Foundation

Table of Contents

from the Editors...

Jeannie Mah

Regina's Secret Spaces grew out of a panel discussion of *That's My Wonderful Town*, an exhibition at the MacKenzie Art Gallery in 2003 which celebrated 100 years of Regina, 50 years of the MAG, and 40 years of the Saskatchewan Arts Board. With the popular 1960s CKCK jingle in his head, curator Timothy Long asked local artists to wonder about the "wonderful" in Regina.

The ideas expressed that day about Regina were diverse, divergent, conflicting, and at times, conflicted, but always personal. As we were probing the problematic isolation of living in a small Canadian city "in the middle of nowhere," Neal McLeod pointedly reminded us that, for First Nations, this land is not "nowhere"; this active space is "home." The discussion of "sense of place" which ensued led us to propose that an anthology of cultural geography might unravel the multifaceted mystery of connection to place.

Regina's Secret Spaces: Love and Lore of Local Geography is a collection of essays by architects, writers, artists, musicians, patrons of the arts, and cultural theorists, where each essay speaks of a specific geographical location within the City of Regina. The submissions amazed and delighted us. An artistic community should be observant and critical; our job is reflection, but we are also appreciative. Personal and quirky essays reflect the wonders of our city. Some essays examine the odd and surprising ways which history and iconography have shaped the city. Many essays share a secret name, place, building, detail, or con-

Watercolour of City of Regina crest, collection of the City of Regina Archives. Photo by Don Hall.

cept. At times, the location is very familiar, but the secret may be the writer's infatuation with, fixation on, or memory of a certain site or fragment of history. By dwelling on small sites and gestures around us, we announce our appreciation of our city, as we make public the things that we think make this city great, the things we cherish. Small moments of appreciation of the local are the roots that anchor us to our geography and deepen our love of place. Without warning, we establish roots, and we begin to care.

A city is an active microcosm with which we must interact daily; it must nourish and sustain us. Cultural nourishment, aesthetic pleasure, a sense of wonder of nature, intellectual stimulation, and physical activity are necessary for us to develop to our full potential, not only as individuals, but also as a city. Timothy Long proposes that "Regina is the smallest complete North American city, because it has one of everything." I see this economy of scale as beneficial. It allows for fewer distractions, communication is simplified, and we have the space and time to think and to create.

I hope that these essays will contain clues about how and why we choose to work and live here, and why we decide to stay, despite the harsh winters, and the seemingly continuing siege on culture. Unfortunately, the proposed closure of the Dunlop Art Gallery and three libraries was announced when *That's My Wonderful Town* was on, and just when Regina had been declared a Cultural Capital. A strong and long civic protest, along with a petition bearing 26,000 signatures, finally turned this decision around, but has left the city feeling culturally insecure. My desire for the existence of this book creeps out of worry that my city's neglect for its own culture and history seems so deliberate. The sudden substitution of the Twin Towers logo to replace the City Crest — Crown over buffalo over wheat — is a denial of even our name —

Regina – and our nickname – The Queen City. By negating our historical past in favour of a manufactured corporate present, we are in danger of undermining our collective future. The threat to close down Wascana Pool in 1995 alerted me to the fact that some people in this city do not appreciate the same Regina that I do, the Regina that is already here, an historical Regina which we have been building for just over one hundred years, a city which must be sustained with foresight and planning. Yet, despite the cultural siege, love Regina we do, in our small and quirky ways.

I take inspiration from London writer Iain Sinclair, who has been intimately exploring his East End London, an un-tourist London, a lived London. I hope that, in unpredictable ways, this collection of essays will bring forth aspects of Regina which will lead to urban awareness, visual delight, walking adventures of discovery, and ... love!

I would like to thank Lorne Beug for initiating this project, and Anne Campbell for her enthusiasm, guidance, and support for two neophytes to the publishing world.

– *Jeannie Mah*

Wascana Pool.
Photo by Don Hall.

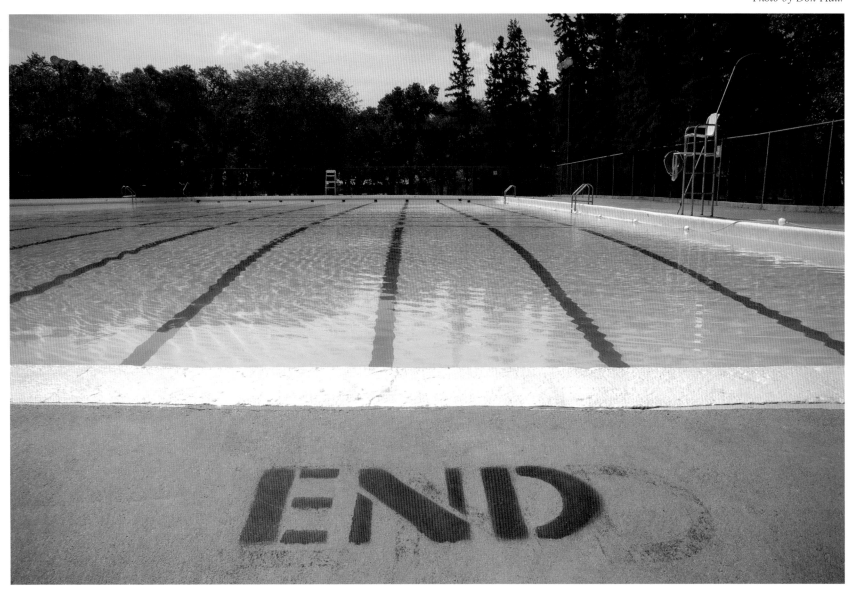

from the Editors...

Lorne Beug

My interest in Regina started in earnest in the late 1980s when I began to photograph my immediate urban environment, searching for material to use in a series of large photocollages which combined details of existing buildings to create imaginary ones, collectively making a history Regina never had. This led me to wonder: what type of city was this? Subsequent research offered a number of models.

Jane Jacobs, in her book *Cities and the Wealth of Nations*, uses the terms "Bypassed Places" and "Backward Cities." We have to ask ourselves, honestly: is Regina one of these? Mercifully, she points out, the world also needs these types of cities.

Sometimes I get the feeling that Regina is a Ghost Town. Certainly, like many other prairie cities, it has not become the metropolis that was predicted during its brief, explosive boom at the beginning of the twentieth century, even if it has become technologically and culturally more complex than anyone then could have imagined. It is striking how many of the sites chosen by contributors to this anthology are no longer present. And there are many others not mentioned in this book at all; for example the "scenes" of Regina's perennial, if marginal, Bohemia: The Place coffee house of the 60s, the 4th Dimension, the pub in the basement of the Hotel Saskatchewan and Athens By Night. Often, when the downtown has been evacuated after 5 P.M., especially in winter, Regina seems like a Surrealistic City, like a lunar, De Chirico painting.

What is also apparent, and finely articulated by a number of essays, is that despite its small size, Regina is no Toy Town. It has real problems; often it's cited as the car-theft or homicide capital (per capita) of Canada. For many elsewhere, it is of interest primarily as a laboratory experiment where an expanding aboriginal population coexists uneasily with a largely static one of European heritage. The city is also developing a potentially deadly fault line, the rapidly developing eastern and northwestern edges draining life from the centre.

Right: this satirical cartoon appeared in "Grip," a Toronto weekly, during the controversy over the relocation of the capital city of North-West Territories from Battleford to Regina in 1883. Saskatchewan Archives Board R-A2494.

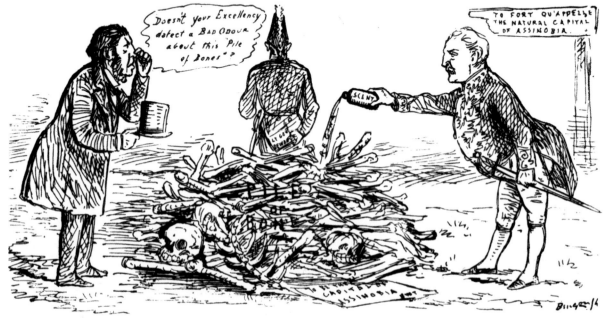

THE GOVERNOR-GENERAL TRANSFORMING PILE OF BONES INTO REGINA,
CAPITAL OF ASSINOBIA.

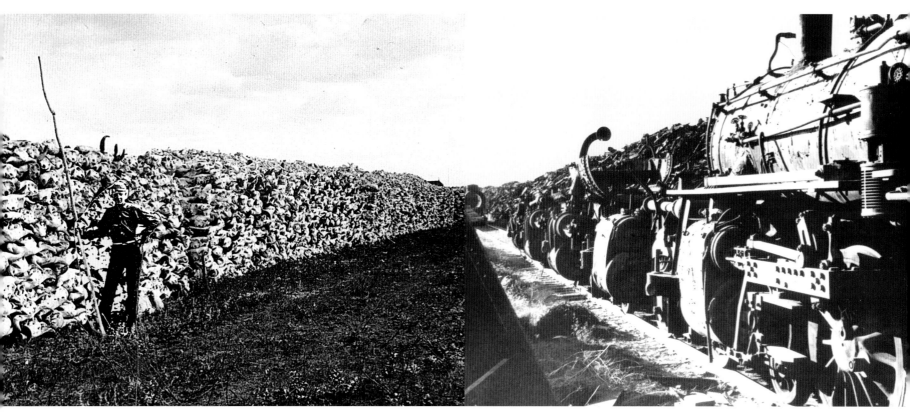

But, as also reflected in many of the essays, Regina can be viewed as an Ideal City as well; a place which offers specimens of a whole range of architectural styles, urban institutions and experiences within manageable, easily navigable limits. Perhaps, following the architect Christian Norberg-Schulz who classifies the prairie landscape, along with deserts, as the Cosmic type — essentially sky and land alone — Regina might even become a Cosmic City.

One of my favourite writers on urban landscapes is Mike Davis, who Lucy Lippard in *The Lure of the Local* described as writing a "cultural-geographical thriller." Our city is just as fascinating, if much smaller, than the Los Angeles Davis talks about in *City of Quartz*. Just think of Regina's original name alone: Pile of Bones — evocative of the deserts of surrealism, the black humor of Kafka, the visions of Aboriginal peoples who have dwelled here for 10,000 years or more.

Even a small city like Regina is a remarkably complex entity, only capable of being comprehended by a "compound eye." I have been fortunate in working with two constantly creative co-editors and the many contributors to this project who have expanded my insight into this city's intricacies and details immeasurably.

This book is admittedly subjective and far from comprehensive. The contributors are artists in various fields, academics and enthusiastic students of culture. We believed that while taxi drivers, plumbers, politicians and real estate agents have valuable things to say about the city, artists, being arguably at the "heart" of culture, are essential in writing a cultural geography of Regina.

So, life-long residents, appreciators, sufferers, explorers of the city, visitors for the short or long term, we hope this anthology will be for you, as it has been for us, a guidebook for increasing your awareness, appreciation and concern for the city revealed between its covers.

– *Lorne Beug*

Lorne Beug, "Piles of Bone/Iron Horses," 2004, photocollage (2 photographs from Saskatchewan Archives Board R-B677-2 and R-B8712-1, size variable).

Davis, Mike. 1990. *City of Quartz: Excavating the Future in Los Angeles.* London; New York: Verso.

Jacobs, Jane. c. 1984. *Cities and the Wealth of Nations: Principles of Economic Life.* New York: Random House.

from the Editors...

Anne Campbell

For many writers language is home; my own closest understanding of the world comes from language as it reaches deep to express, or comes close to expressing, our common and uncommon human experience. Another way of understanding the world is through the "built environment," the structures our culture has created in the past and those, as a society, we are building in the present.

As a writer, long involved with what we used to call the "heritage"* movement — now called "built environment" to show specific interest in buildings, parks, bridges

This page and facing page: on the wild paths in Wascana Park. Photos by Don Hall.

and such, as part of our cultural heritage — I see this "built environment" as language *writ large*, a way of seeing the past, "written" in material reality, a way of seeing that which we have created: our beginnings, successes and losses, financial good times, depression and much more, each structure allowing as many diverse memories as there are individuals, or specific community groups. Both language and the built environment are human endeavours, ways we act upon the world or mediate our way through, or to, civil(ization) society.

However, along with our place in society, many of us harbour a sort of "Garden of Eden" desire for a place outside "society," a place where our presence does not act upon the world, but is merely another part of nature in the world, along with water, grasses and animals. For many, the "wild" paths of Wascana (which I have written about) offer this temporary return to the "perfection" of a pre-verbal, pre-built, environment.

The "Secret Regina" project is one very special to me, encompassing as it does the reality of the many specific relationships Reginans have with the "built environment," and the "wilds" remaining. The sites, rendered in the immediacy of heartfelt language and photographic images, explore and evoke the *raison d'etre* of the connections individuals have with these specific locations, providing all of us with a greater and deeper sense of Regina.

Seeing the variety of locations chosen, and the variety of reasons for choosing a common location, has been wonderful; seeing new sites, and old sites rendered with feeling, has had the effect of joining all of us more closely together through mutual experience and understanding.

Our contributors are primarily artists, working in Regina in a variety of mediums, those we asked to tell us about favourite locations, as well as others who let us know they'd like to contribute a favorite place. Another book, another time, might have included other artists and other

*Heritage: what has been, or can be, inherited.

Regina citizens. Nevertheless we hope everyone reading this book will be motivated to share with others their own special Regina sites, as well as those included in *Regina's Secret Spaces*. We hope this book might serve as a reminder that Regina's heritage begins for each of us in our own special places, appreciated and shared.

Working with Lorne Beug, who brought the book idea forward, the enthusiasm brought by Jeannie Mah, and the dedication of photographer Don Hall has been a pleasure. During the project each of us was busy with other projects, yet when we met, the work involved in *Regina's Secret Spaces* did not drain energy; indeed, it energized us. We hope you will find as you explore Regina in secret that same energy and pleasure we shared.

– Anne Campbell

Acknowledgements

The editors wish to acknowledge the support and assistance of University of Regina photographer Don Hall, who roamed the city from dawn to dusk, seeking out the often illusive subject matter, waiting for the perfect light, and finding the right composition for each photo; Canadian Plains Research Center (CPRC) Publications Co-ordinator, Brian Mlazgar, for enthusiastically accepting the project proposal; CPRC designer, Donna Achtzehner, for her amazing dedication and wonderful design; the Saskatchewan Archives Board and our student assistant for this project, Jonathan Achtzehner, for help in locating historical images; the Regina Public Library, especially Sharon Maier of the Prairie History Room and Donna Holmes of the Reference Desk for their help in locating source material; the City of Regina Archives for locating and providing additional images; funding assistance from Saskatchewan Arts Board and Saskatchewan Heritage Foundation; the contributors for their generous cooperation, and the other photographers whose images appear in the book.

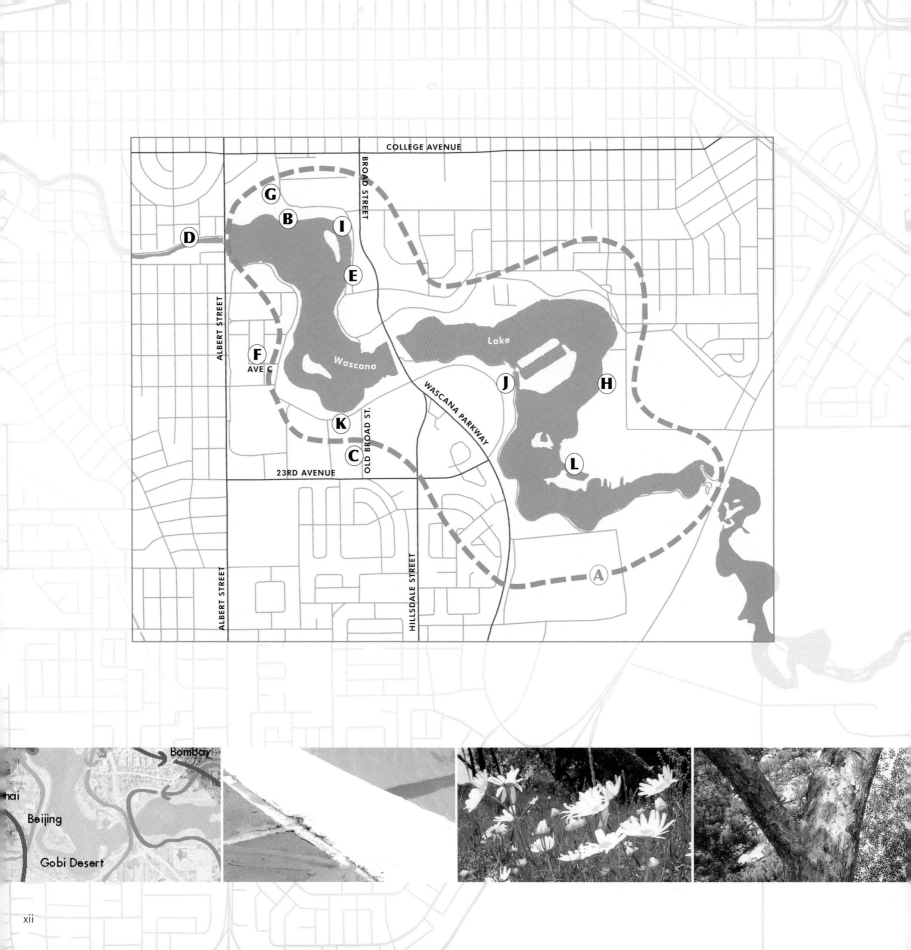

COLLEGE AVENUE

BROAD STREET

ALBERT STREET

G

B

I

D

E

F

AVE C

Wascana

Lake

J

H

K

OLD BROAD ST.

C

WASCANA PARKWAY

23RD AVENUE

ALBERT STREET

HILLSDALE STREET

A

L

Shanghai
Bombay
Beijing
Gobi Desert

Wascana Park

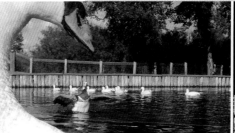

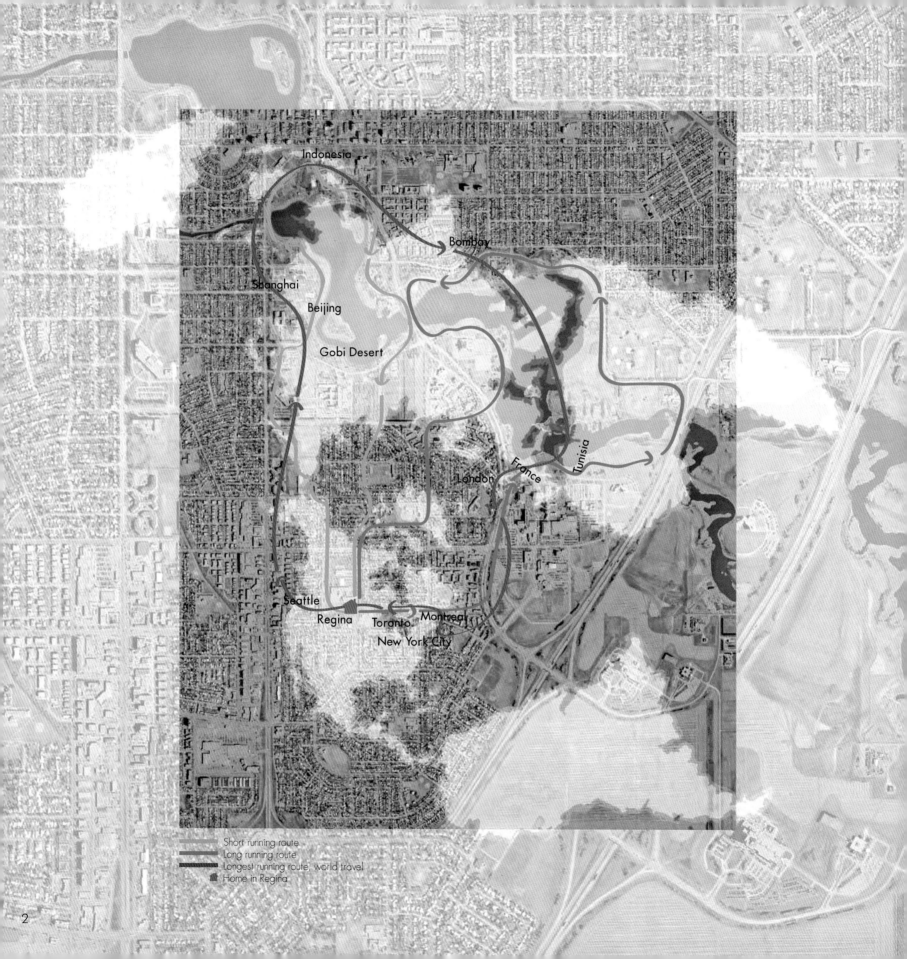

Indonesia

Bombay

Shanghai

Beijing

Gobi Desert

London

France

Tunisia

Seattle

Regina

Toranto

Montreal

New York City

Short running route
Long running route
Longest running route, world travel
Home in Regina

Running, a-way towards home

by Kim Morgan

I grew up running around the lake in Wascana Park, through all the different seasons. It was my escape route from the frustrations of an anxious youth. As I ran, I imagined myself in other places.

So when I could, I left, as fast as my feet would carry me – to Montreal, New York, Europe, China, and everywhere in between, heading towards a future that insisted on leaving Regina behind. I was driven by a restless curiosity. As I roamed around, moving through other places, gathering material, collecting information, I carried my running shoes with me, my portable solitude, my way of marking territory and embodying place.

I remember: the frenetic streets of New York City, with cement parks and skyscraper skies; the thick smog of Beijing that sticks to the skin and congests the lungs; the salted streets and crazy drivers of Montreal; the directionless bicycles of Shanghai; the luscious sunsets of Bombay; the rock beaches of Nice so grueling on the knees; and the stark beauty of the sand dunes in the Gobi Desert.

And I learned about: noise, humidity, heat, grime, garbage, and people, bemused, friendly, and sometimes belligerent. I was drawn by the novelty of these experiences; the "otherness" stilled my restlessness.

But over time, I began to miss my runs in Wascana Park. This was not nostalgia, but a longing for familiarity, belonging, my own history. On occasion, circumstances brought me back – sometimes reluctantly – to Regina; inevitably, my first thoughts were directed toward arranging my run in the Park. I quickly settled into the old routine.

Before long, I was thinking about this Park while running somewhere else. I found myself explaining, to those who would listen, about the superiority of Wascana Park with its endless supply of soft paths, an abundance of fresh air and lush green grass, the vast amount of space, the Lakeshore Tennis Club and Wascana Pool, the people who greet you along the path, even the hissing geese who force you off your path and back to consciousness.

And I emphatically insisted upon the pleasures of the Park's seasonal changes: spring, with melting snow and a sense of renewal; dry hot summers with cool evenings; and fall with its vibrant leaves that blanket the ground.

Most of all, though, even now, I prefer Wascana Park at night, and better yet, in the dead of winter, when the clear, cold air makes material of my invisible breath and leads me through the dark. The cold makes my movement slower, more tentative. Carefully, I cross frozen ice and snow, covered head to toe, anonymous.

Today, I view this familiar landscape from a more settled position. I am still restless, but I tire more easily; I still run, but I also find pleasure in walking. I still leave, running in other places, but not running away. And I carry the distant routes and foreign landscapes within. Occasionally, something will trigger a yearning, which I suspect to be nostalgia. But nostalgia is romantic, and I'm pragmatic. What I desire most is familiarity, dependability and community. Somewhere, somehow, this park became my metaphor, my route, my urban renewal, and my personal sustainability.

Can one move forward while running in circles? I am the sum of my experience, and from a higher perspective, running is a way towards home.

Opposite page: Satellite map of Regina superimposed with a world map and Kim Morgan's running route around the world and around Wascana Park. IKONOS Satellite image courtesy of the City of Regina.
Design concept by Kim Morgan.
Digital map created by Brian Danchuk Design.

Kim Morgan is an interdisciplinary visual artist, born and raised in Regina. Morgan received a B.A. from McGill University, Montreal, a B.F.A. from The School of Visual Arts, NYC and an M.F.A. from the University of Regina. Her works have been exhibited across North America. Some of her public works include installations in The Weyburn Project, and Antsee, located in Victoria Park.

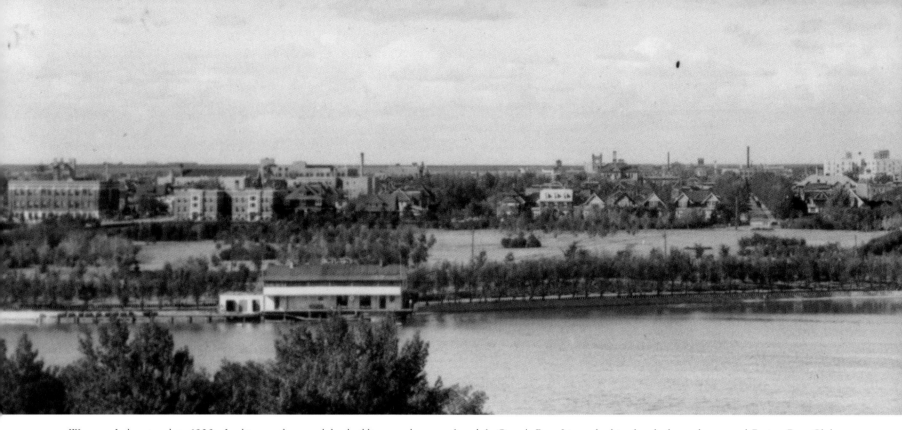

Wascana Lake, circa late 1920s. Looking north across lake, buildings on shore are, from left: Owen's Boat Livery, bathing beach change house, and Regina Boat Club. Saskatchewan Archives Board R-B9555-1 and R-B9555-2.

Memories of Regina Boat Club

by Jacqui Shumiatcher

The year — 1940. The war had started in September 1939 and most men who were interested in rowing, canoeing, sailing had gone off to war. Some men who were beyond military age or had a disability remained.

This Boat Club was a men's club with women able to hold only the office of secretary. Being young, I was not interested in holding any office. I just wanted to learn how to paddle the correct way (on our knees in those days).

For me it was quite a learning curve and fun. We had great mentors in Joan Furby, Al Kerr and others. We were able to go against all the rules we were given at

school: do not rock the boat, do not stand up. At the Club, we were told to do just that! However, it was so ingrained in us not to, it was very difficult trying to upset the canoe, letting it fill with water, climbing back in and paddling away!

I found standing on the gunnels at the very back (or very front) and trying to paddle without going around in too many circles and landing in the water exceedingly difficult. There were many tests and then examination day came after many hours, days and weeks of trying out. What a thrill to hear it said: "You've passed." Yippee! What a

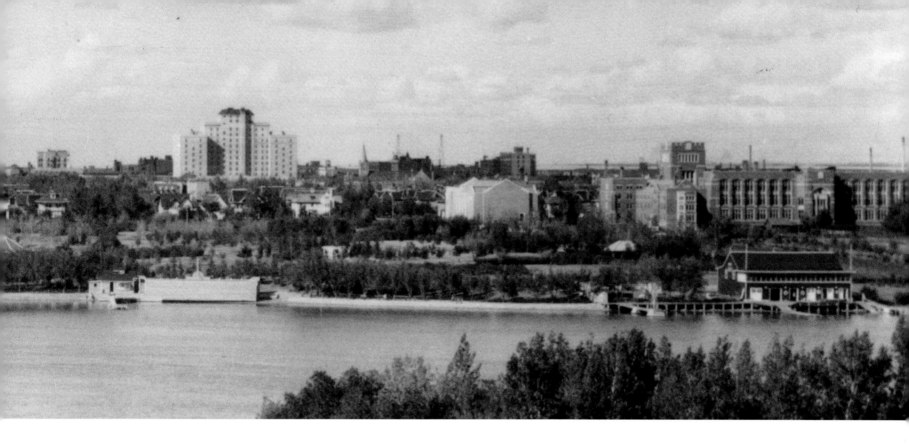

surprise to find that at the end of my first season I received a Cup for having progressed the most. On reflection, I am not too sure what that really meant!

We also tried our hands at putting up sails on the canoes and off we went towards the Wascana Country Club. We had enough wind going, but coming back, we finally had to give up, get out and push the canoes back to our club. The weeds were too much for us without the wind's help.

We did our "civic" duty as well; we bluestoned* the lake many times each year. It was not a "drag" to do that, but rather fun.

The old boat club moved from near Albert Street to what is now called Willow Island. What a luxury that was. We had a little bridge over which we walked to the Club. And, though I was not among them, many couples later walked across that bridge to the Saturday night Boat Club dances. Many other social events were held, as well as many, many regattas.

Though it is now sixty years later, with my detailed recollection perhaps not being that accurate, the exciting and happy times I enjoyed being a member are certainly still with me. I still have my paddle from those days, and I have utilized my lessons from the Boat Club to do some canoeing and kayaking in various parts of the world. However, nothing really compares to those old days!

From canoeing I then went on to motorcycling and hill climbing – oh, those glorious, free-feeling, happy times. Even though we grew up in the "Dirty Thirties" and were considered "poor," we never felt that way at all. There was a certain camaraderie that existed then. Each generation has its ups and downs, but I hope that, like me, everyone remembers their youth on the plus side.

I was pleased to see the Rowing Club come to life again, and to see boats and regattas on the waters of Wascana once more.

*bluestone: a copper sulphate crystal used to kill algae.

Philanthropist and patron of the arts, Jacqueline Shumiatcher was born in France in 1923 and emigrated to Canada in 1927. She has played a leading role in the community with her late husband, lawyer Dr. Morris Shumiatcher. Jacqui Shumiatcher has generously donated, both monetarily and personally, to a large number of cultural facilities and other organizations in Saskatchewan and across Canada.

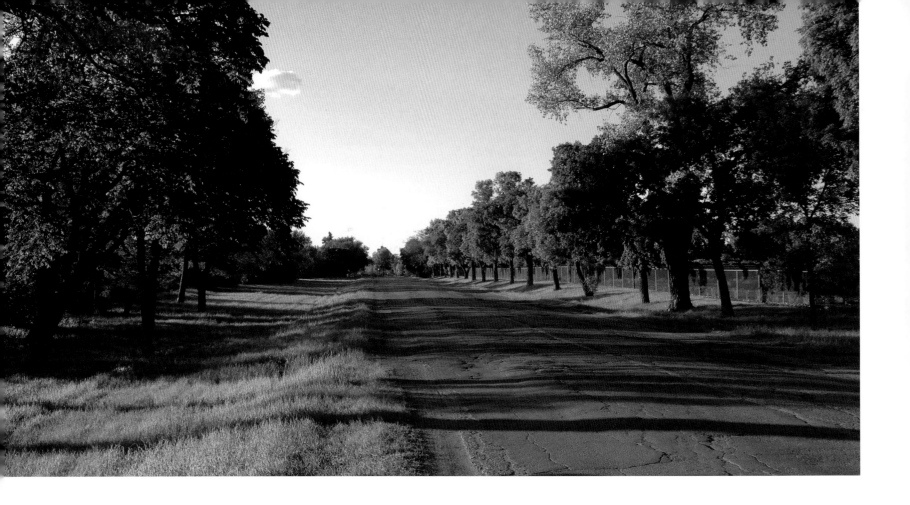

Autour de Wascana Lake: Three places that remind me of France

by Jeannie Mah

Jeannie Mah loves to swim and cycle in Regina. She enjoys the intimate size and the slow pace of this city, but ... she is often caught dreaming of France.

1. The last remnants of the Old Broad Street Bridge have been turned into an artificial waterfall; it has become a folly to amuse us, a miniature Niagara to thrill us. As we walk under its "gushing" waters, we activate a denial of history, an erasure of memory, and we become complicit in the act of historical camouflage.

However, a small section of old Broad Street still exists. Due south of the former bridge (between Lakeshore Drive and 23rd Avenue, with the Tree Farm to the east), this "lost road" is almost forgotten, yet so evocative, perhaps because of our neglect. Childhood memories of crossing the old trestle bridge, in our 1950s Austin, are the foundation upon which my adult experiences are balanced. Now, as I bicycle my way down the last remnant of the old Broad

Street, I must swerve wildly to avoid the huge pot holes and gaping fissures. The physicality of its descent into decay and neglect is bone-rattling, but this does not dull my joy. The beauty of this vista overrides my discomfort; indeed, it reinforces my love for my home town. The perspectival view of a tree-lined avenue, its vanishing point stretching out into Wascana Lake, leads my mind to stretch towards France. I make a trans-Atlantic mental leap as I cycle along, and am reminded of the rural highways of my beloved France, lined with the ubiquitous avenues of plane trees, said to have been planted by Napoleon to shield his marching army from the harsh sun of Provence. The lingering pleasures of French holidays fuse with memories of a Regina childhood, so that the city to which I returned in my

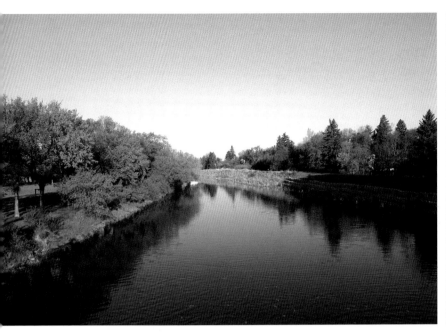
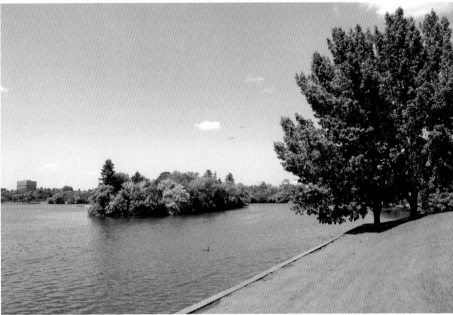

adult years becomes richer, and my attachment to the local becomes more deeply rooted, as it is knitted together with the foreign.

2. Looking west from the Albert Street Bridge, a certain bend in Wascana Creek reminds me of the idyllic, slow, meandering rivers of France. At dusk, cycling west on the north bank, where the long grass tickles toes in summer, a sense of well-being blossoms as I come upon vista after vista of heart-aching beauty, flooded in the purity of a prairie sky. While I am so aware that this can only be a prairie moment, I am stirred to recall evening walks along the banks of the river in Sens, and Auxerre, in Burgundy; or of the first strawberries of the season, warm on the tongue, eaten on the banks of the Dordogne in early summer. All memories glow in the eternal summer of the imagination.

3. On the bank on the east side of Wascana Lake, just off Broad Street, west of the Queen Building, is a spot where I love to go to just sit, even if only for five minutes. At any time of day, in all seasons, the changing impressionistic play of light is delightful! The openness of the landscape basking in a quintessential prairie light lends itself to daydreams, and the Francophile in me is transported to a site on the outskirts of Paris, which I know primarily through a painting. Seurat's *La Grande Jatte* depicts nineteenth-century Parisians on an island on the Seine on a Sunday afternoon, and alludes to the beginning of the concept of leisure for more than the aristocracy. Our man-made lake is inspired by this democratization of leisure pursuits.

It is not that I want Regina to BE France, nor am I so naive as to believe that if I squint hard enough, it will become France. Rather, it is that my deep love for both Regina and France intermingles in moments of happiness. Somehow, the intertwining of memories of both places makes my present locale all the more meaningful, for having known other geographies. I am the locus for geography. Local space intermingles with idealized memories of foreign holidays, as past and present, home and away, the familiar and the foreign grow together, to take root here, to expand the imagination.

The joy of living in a city where our urban park allows us such accessible moments of contemplation and intellectual rejuvenation may indeed be one of the secret reasons why we choose to stay, despite the difficult winters and the seemingly needless urban expansion, and why we are so fiercely loyal to this small city. These moments of quietude are enriching; these are moments filled with love — love of place and love of geography.

Opposite page: Old Broad Street, looking north. This page, left: Wascana Creek, from the Albert Memorial Bridge; right: Wascana Lake, looking northwest towards Willow Island. Photos by Don Hall.

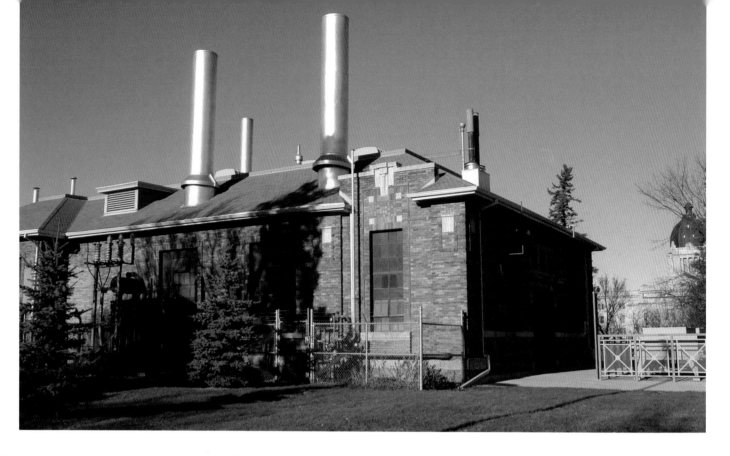

Power Behind the Legislative Building

by Cynie Lewin

Always, when nearing Wascana Park, a strong pull draws me into its world set apart from the urban bustle where special discoveries await. One day, curiosity found me turning off a road barely named, Avenue C between Avenues D and E, at a brick building of perfect proportions and interesting architectural details. I rang the bell and a lucky tour followed.

This overlooked gem is the Legislative Powerhouse. Built in 1921 and fittingly situated behind the Legislative Building which it serves, it is the power behind the power. It keeps the show going as the heating, cooling and water softening plant for the Legislative Building and other Park buildings.

Initially, four steam boilers drove four steam engines which operated generators, producing electricity for the Legislative Building and the Powerhouse. The exhaust steam from the engines was used for heating, humidification, cooking and other processes. This happened in the winter months only, as in summer there was no place to utilize the exhaust steam, making it unprofitable. In the early 1950s the system was updated. Two larger boilers operating on natural gas replaced the original four boilers, and a steam turbine replaced the four steam engines; the boilers are still in use. As before, the exhaust steam from the turbine was used for heating. The turbine also rotated the generators, producing electricity for all the area buildings at the time.

Conveniently, the heat generated in the turbine was cooled by water from nearby Wascana Lake, with the hot water returned at the pump house. This spot was a favourite for waterfowl during the cold months until about 1974 when the generator system burnt out. Subsequently, Sask Power became the full-time provider of electricity. In 1964 the air conditioning system was installed using the same pumping system to cool the heat of compression; thereafter, the warm summertime waters have attracted

geese and ducks at Spruce Island Overlook, who in turn attract people who watch them swim playfully with their young at the man-made waterfall, passing right through it.

Inside the Legislative Powerhouse, historic charm greets you. First noticed is the brass dedication plaque opposite the door. Rows of richly glazed grey and green bricks form a high dado on the face brick walls. The original shiny brass railing encloses the stairs and open loading area. (Apparently, until the 1960s, the floor below was painted with the Saskatchewan Coat of Arms!) The green-painted industrial steel sash windows with wire-mesh safety glass are entirely intact. Various original cubicles are offices and rest areas for the nine employees, many of them thirty-year veterans; they have salvaged brass gauges, a time-punch clock, an oak cabinet, and more.

Two floors are packed with generators, engines, industrial pipes, pumps, boilers, workshops, storerooms, and computer rooms; you feel the power being created. Still in place on the lower floor are the four massive cement support columns, over which once stood the original four heavy steam engines on the main floor above. Exceedingly intriguing are the underground pipe and accessory tunnels that connect the buildings to the Powerhouse: look for the air shafts on the lawn.

This lawn wasn't always vacant. I recall in the 1950s the four personnel cottages with their pathways and gardens, the Local Improvement Districts (L.I.D.) building (previously the first powerhouse, whose stack was struck by lightning in 1916), and the original greenhouse. Alas, only the delicate curve of the parking bay remains.

The Powerhouse is built from Claybank Tee-Pee Moka brick placed in a geometric relief pattern. The decorative eaves are white-painted wood. Windows and doorways are framed with fossiliferous Manitoba Tyndall stone: notice the fossil shell by the front entrance near the covered thermometer. Over the side door is a carved stone shield of Saskatchewan's Armorial Bearings: three wheat sheaves with a Royal Lion above. Both doors are flanked by pairs of metal wall lamps — flamed torches adorned with tiny metal

lion-head tiles, perhaps sentries off the shield, silently peering out, on guard.

Maurice William Sharon, second Provincial Architect of Saskatchewan from 1916 until 1929, designed the Legislative Powerhouse, ten courthouses (Yorkton, Kerrobert, Prince Albert, Melfort, Wynyard, Gravelbourg, Estevan, Shaunavon, Weyburn, and Assiniboia), the Saskatchewan Provincial Police Building in Regina (demolished for construction of the Cornwall Centre) and many others. He completed the first map of Saskatchewan in 1907. Architectural drawings of the Powerhouse plus many photos can be found at the Saskatchewan Archives Board.

Cynie Lewin (née Ratner) was born in Regina. She lives in Israel but recently spends many months each year in Regina. She sincerely thanks past and present employees of the Legislative Powerhouse and employees of the Saskatchewan Archives Board for their indispensable help.

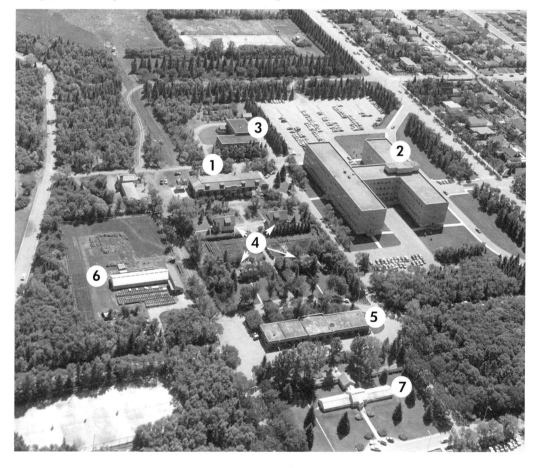

Facing page: Powerhouse. Photo by Don Hall. Below: 1957 aerial view of buildings just south of the Legislative Building. Saskatchewan Archives Board R-B4677-4. Buildings which still exist: 1. Powerhouse; 2. Walter Scott Building. Buildings no longer in existence: 3. Central Vehicle Agency depot; 4. Personnel cottages; 5. Local Improvement Districts (L.I.D.) building; 6. and 7. Greenhouses.

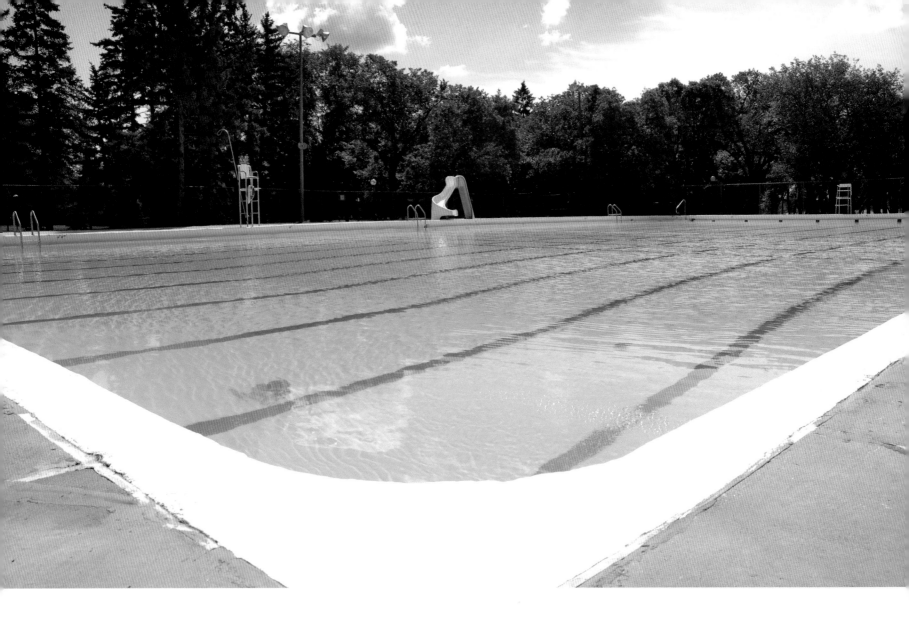

Hommage à Wascana Pool

by Jeannie Mah

During the Industrial Revolution, rapid urban development saw the creation of the urban park, a new concept of a publicly owned space, where citizens may walk, enjoy nature and fresh air, and swim. Parks were created in a spirit of Victorian zeal for social reform; they were a part of the plan to educate and to improve the masses. Exercise, cleanliness and fresh air were understood to satisfy both a physical and social need, working to promote civilization and commerce. The social space of the public park activates the mind and body, enabling citizens to be healthy, industrious and happy. The Victorians saw it as a duty of both government and industry to assist in providing for the health of the people; this was the social caring face of early capitalism, which also concerned itself with urban planning and social housing.

Frederick J. Olmstead, the creator of New York's Central Park, believed that parks should be the focal point around which a new town could be structured. In 1912, when Thomas Mawson was hired to draw up plans for the City of Regina, to create an ideal city which would be pros-

perous, liveable, and beautiful, he made Wascana Park the focal point of our city.

Water in gardens has long been associated with peace of mind, and, despite much difficulty, water was channelled to such famous sites as the Hanging Gardens of Babylon and the Alhambra of Granada. Even the great Versailles was once sad and barren, with no view, no water, no woods. We must admire the vision of the early leaders of Regina to create an oasis in the semi-desert that is southern Saskatchewan.

Water recreation has always had a place in Wascana Park. Before 1900, the lake had been dammed to be a centre for recreational activities. In 1947, when swimming was banned in the lake, Wascana Pool was built.

Wascana Pool is beautiful! To walk in the park, to stroll by the lake, to swim as one sees the ever-changing sky and the greenery of the trees, to hear birdsong and the splashing of fellow swimmers, to breathe clean air, to feel the sun: this is summertime bliss. Wascana Pool makes me fall in love with Regina!

Imagine my surprise when, in an attempt to cut costs in 1995, the City Council of Regina threatened to close down Wascana Pool. My shock and outrage at the idea of the destruction of this jewel of a swimming pool led me to realize that we must be ever-vigilant to protect the aspects of our city which nurture and sustain its citizens.

Wascana Park was created as a public space for the enjoyment and betterment of its citizens. To maintain a strong community, cultural sustainability must work hand in glove with economic sustainability. The service of providing public outdoor swimming is a most economical way to keep citizens of all ages healthy and happy.

We must guard the utopic dreams on which this city was founded, dreams which incorporated urban planning, healthy living and aesthetically green spaces, for the public good.

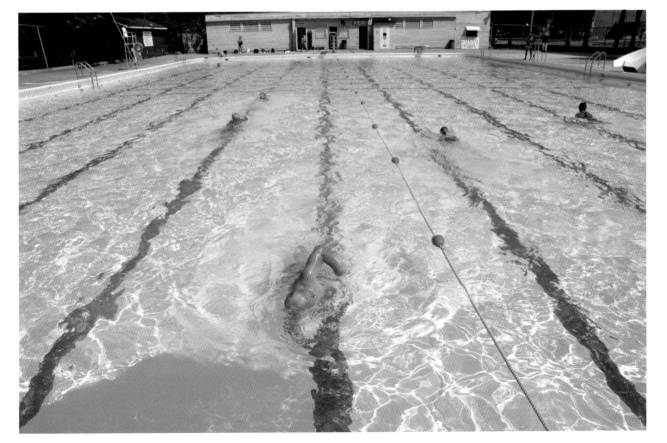

Opposite page and this page: Wascana Pool, summer 2005. Photos by Don Hall.

Jeannie Mah was born in downtown Regina. As a child, she spent long summers swimming in Wascana Pool, and has moved back to Regina to swim in Wascana Pool. She believes that swimming outdoors helps her to become a better artist.

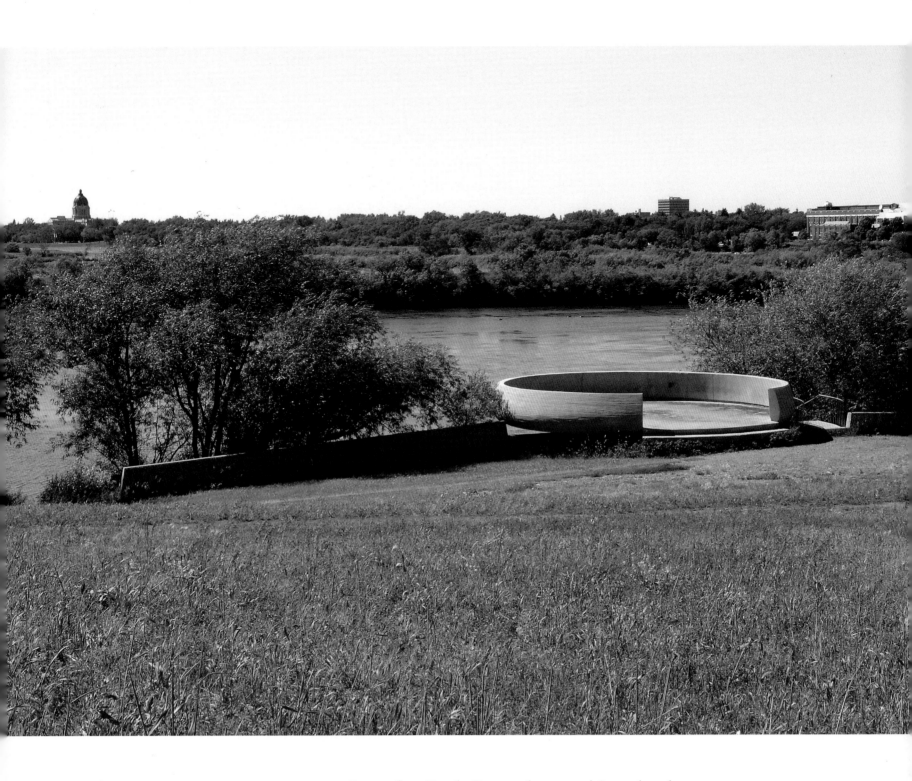

Whispering in your own ear: Douglas Park Pumphouse/Overlook

by Helen Marzolf

"Stand here. No. Right here ... in the centre."

"Okay. OKAY."

"Now. Say something."

"What?"

"Did you hear that?"

"What?"

"Jeez. Okay. Say something longer — a whole sentence maybe."

"What?"

"Oh for chrissakes. Let me stand there."

"No. Hey, wait a minute. Did you hear that? Helloooooo ... hey, you're right, I do hear it."

I speculate that countless permutations of this Godot-esque dialogue have been performed on both the Willow Island and Douglas Park Overlooks. Perhaps more often on the latter, my favourite of the two.

Douglas Park Pumphouse/Overlook is situated on a comfortably worn dirt path at the edge of the waterfowl sanctuary, just below the west face of Wascana Hill near Douglas Park. The last time I was there, it was still the kind of out-of-the-way place that lent itself to audio experimentation. And other less artful experimentation.

The Pumphouse/Overlook looks like a big concrete saucer and offers a generous vantage to Wascana Lake. It's a great bird-watching spot! On the other hand, the assortment of debris and garbage sloshing up against the base has its own special charm. I have speculated about the midden accumulating below the water, and the archeological record of adventure and misadventure, romance and heartbreak, pleasure and angst that collects within a stone's throw of the Overlook. You could assemble a decent retrospective of pop and beer bottle design by dredging this scenic spot. A sludge of saturated chip packages, apple cores, condoms and Styrofoam is undoubtedly competing with the underwater biome, too. You'd probably find a few keys, and wallets, and letters, and maybe even a few engagement rings.

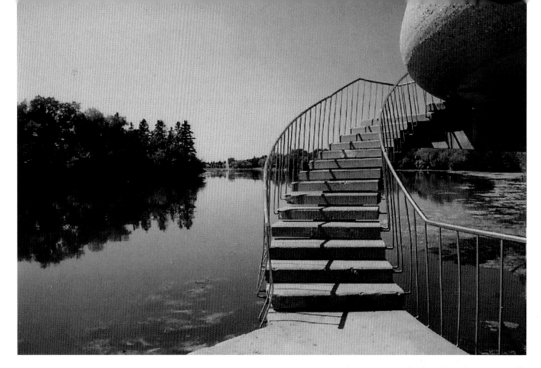

Opposite page: Douglas Park Overlook. Photo by Don Hall.
This page: Willow Island Overlook. Photo by Jim Zaleschuk.

Wascana Park's architectural accoutrements are durable monuments to the economic and political optimism of the post-war years. The architectural firm Kerr, Collingworth, Riches Associates designed the two Overlooks, the Willow Island Picnic Shelter, and the park's public washrooms. This was an excellent investment: the park structures still look great, decades later. Cast in a nearly indestructible concrete and accented with sinuous stainless steel, the structures all bear the classical features of refined functional design: no Martha Stewart faux heritage motifs here. The Overlooks are dual-purpose buildings. They pump the lake water into the Park's irrigation system, and each Overlook is topped with a saucer-shaped viewing pavilion. A peculiar attribute of the viewing saucer is this: if you stand in the middle of it, the sound of your voice bounces back with astonishing intimacy. A friend with a beautiful voice pointed this out to me in the mid-1990s. I wonder if Andrée Toman, the KCR technician who designed the Douglas Park Pumphouse/Overlook, had acoustic calculations in mind as he drafted these secret concert basins?

As she cycles to work through the overpainted "ye olde English" tourist architecture in downtown Victoria, Helen Marzolf sometimes yearns for the concrete simplicity of Wascana Park's architecture.

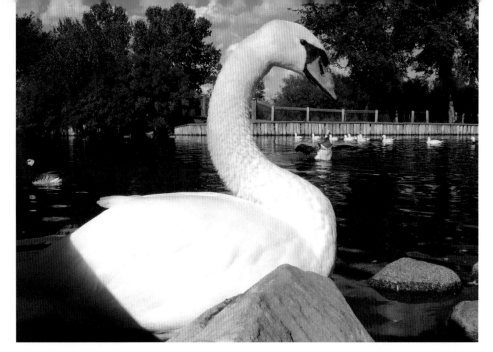

Wascana Bird Sanctuary. Photo by Don Hall.

Sanctuary

by Byrna Barclay

Byrna Barclay is the author of three novels in the Livelong Trilogy, three collections of short stories, a hybrid, and the poetic drama, *Room With Five Walls: The Trials of Victor Hoffman.* Her most recent book is *Girl at the Window.* Among her many awards, she fancies most the Saskatchewan Order of Merit and, most recently, the John V. Hicks Award for her new novel, *Waiting for God to Remember Their Names.* "Sanctuary" is an excerpt from that novel adapted for this publication.

In the bird sanctuary, I visit the swans, trying to fully understand why this place has become a haven for me.

So often I've retreated here through the years, but I can never articulate why it has become my home-within-my-home.

The sanctuary is sheltered by hand-planted elm, cottonwood, and spruce. The page-wire fence, with its wrought-iron turnstile, keeps out unwanted nocturnal visitors, not the birds who could escape it easily.

A yellow school bus deposits a horde of young invaders, and the birds retreat to the middle of their pools where the children cannot reach them. Clutching plastic bread bags, the screaming kids descend on the birds, the boys hucking bits of broken bread. "I hit one!" hollers a redhead. The girls crouch on the wooden deck, wanting the birds to eat out of their hands, their calling and cooing ignored by the feathered, well-fed population of the park.

I retreat, crossing the footbridge connecting ponds, and am nearly trampled by five hissing boys chasing a wobbling swan with one broken wing. It hobbles to the edge of the bridge, then leaps into the water, and swims frantically to join the others, while one regal swan patrols the perimeter. Disdainfully by-passing blobs of bread tossed at her, the injured swan feeds on water-insects skimming the murky surface.

I sit on a wooden bench to outwait the invaders.

Poplars shiver at the sight of a shattered peace, as a northern wind rises — so unusually cool for June. The signets hold their line in the middle of the pond, flanked by two sentinel adults. On the opposite embankment, white ducks feed on new tendrils of grass struggling to thrive on prairie gumbo packed down hard by rain and pummelling feet. This earth needs topsoil, peat moss, a sun shower. I don't understand why the birds don't fly away.

In that clear blue sky, a few scattered clouds look like spirits of birds looking down at the plight of their descendants, with sad eyes and drooping, elongated necks.

Have I turned into a cock-eyed birder?

The swan cranes her neck, as if hoping the school bus will depart soon. She preens, picking at bird lice, then rises in the water, like a ballerina on points, shaking water from her feathers. The willows lean towards the water as if protecting the lame swan hiding now in shadow.

I look up, and in that vast prairie sky see a church, its spire shrouded in snow, and stretching forever beyond it, an empty sleigh from my childhood, pulled by white horses. In the foreground, a figure, impossible to tell if it's the spirit of a man or woman, but within a single breath, it kneels.

It's time to leave, to get back to work on a novel-in-progress, a search for the spirit I've found here; it was waiting for me to give it voice all along.

In the parking lot, I unlock my car, climb into the driver's seat, lean back for one last look at the sanctuary. Above the shelterbelt, wind-torn clouds re-invent a great white bird, driven out of the blue, its long beak and crested crown like a swan's. Spirit feathers fall to earth. Wing bones vibrate like strings of a cello, their music in the wind. A hole in its breast diminishes with each wind-breath, until it closes; healed.

The great wind-borne wings swoop down, touching tip-to-tip, as if they would capture me, lift me, and keep me safe. Home.

Wascana Park on Lakeshore Drive, near old Broad Street. Photo by Don Hall.

Nicole Côté is associate professor in the Department of French, University of Regina. She teaches mainly Québec and French Canadian literature. She has translated several English Canadian authors (short stories and poetry) and published critical essays in journals and books on English Canadian, Franco-Canadian and Québec authors.

Evocative Wascana

by Nicole Côté

Regina is probably the only Canadian city where every tree has been planted. Wascana Park, where Reginans go for a glimpse of nature is thus, paradoxically, entirely artificial. A work of art, that is.

Notice the caraganas and their myriad trunks, through which the sunset on the lake looks like a Rouault[1] painting, or stained glass, with colours contoured by black. The scene may even resemble a paper collage, with dark trees silhouetted against the shimmering lake.

Near dusk, jogging by the caraganas lining the lake feels like seeing the world through a stroboscope — the landscape, through the foliage gaps, deconstructed into vivid, moving fragments.

Observing the Scotch pines, how their peeling orangey bark becomes translucent in the golden light of late afternoons, might elicit visions of the windswept, sun-drenched eastern coast of the States, where colonies of pines living in sand dunes are a prologue to the ocean. But it could just as well recall a Fauve[2] painting of a landscape in the south of France.

Whizzing by on a bicycle, I smell the wild scent of some humble willows, with their slim dark red trunks, and let a flurry of childhood memories submerge me. Then an early Kandinsky[3] painting, evoking the chromatic splendour of a bygone Russia, overlaps these images. Later I remember a burgundy basket at Bazaart, delicately woven with these same purple willow branches, and am reminded of the First Nations women and their wonderful art of weaving with boughs and barks, needles and roots.

Is the evocative power of Wascana Park stemming from its constructed 'nature,' I muse. Summoning actual geographies as well as representations of them through art is also an oxygen-producing function of a park, I decide.

1 Georges Rouault (1871-1958), French Fauvist/Expressionist painter.

2 Fauvism was a style of painting that flourished in France from 1898 to 1908, using pure, brilliant colour, applied straight from the paint tubes.

3 Wassily Kandinsky (1866-1944), Russian-born artist, one of the first creators of pure abstraction in modern painting.

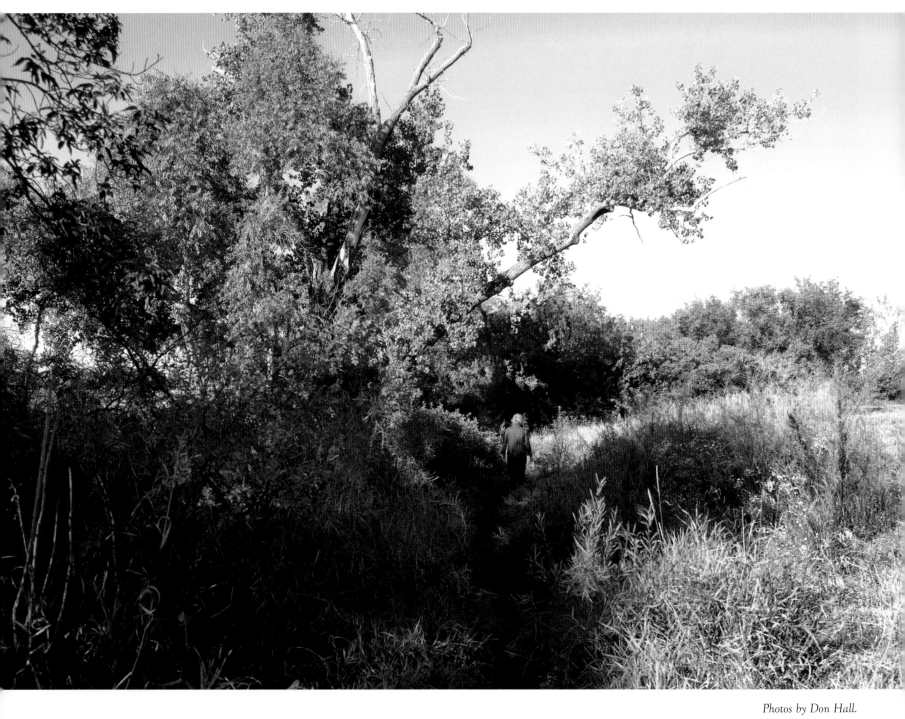

Photos by Don Hall.

The Wild Paths of Wascana

by Anne Campbell

When my children were young, there were still many unpaved paths in Wascana Park. We called these paths "wild," and on Sunday afternoons after we'd parked our car on the Legislative Building side of the lake we'd make our way over the paths, paved or graveled, to the lake, delighting each week in finding our "secret" wild paths; they meandered in and out of trees and bushes near the lake edge, touched the water, then climbed up and back for a bit of a run. My kids could hide, imagine themselves explorers in strange lands, or just sit quietly hand in hand with one another, their mother, and with nature. Sundays were wonderful.

Time passed, my kids grew up and Wascana quietly marched to more "civilized" ways; most paths were slowly coated with some hard surface, and they were filling up now, not only with walkers but with runners as well. Slowly the "wild" paths of Wascana were disappearing.

But even today, near the lake edge on the Douglas Park side of the Park, there remain magnificent and twisting "wild" paths. Quite long, one begins south of the Douglas Park sports track; it meanders down to the lake edge, gently skirting along to a little out-cropping, a wooden platform. Nearby marked posts show yet another pathway loop in the midst of a nature preserve.

The grass by these paths is untouched except by animals who visit in the dark, their forms revealed in morning by compressions in the long soft grass. There are wild flowers too, or weeds, if you prefer, and birds. And as you stand in the quiet, soft-scented grass, it is difficult to imagine anything better. Life's troubles move aside.

It's easy to stand here and imagine this place during early settlement, imagine how, in the midst of homesteading, hard work and isolation, these flowers, grasses and sky, with traces of nocturnal animals, could have been a place of respite for those inclined to roam near the little creek.

The path continues, reluctantly, or is it me that is reluctant to go forward? From this natural grass area, the path continues around (or over) the Douglas Park hill, past the Science Centre and out again to more commonly walked areas of Wascana. And always there is the urge to turn back.

What a magic place this, with kids or without. A retreat back to childhood and earlier, to the land unsettled, to the *wild* ("an animal or plant, in its original natural state"*). And isn't this what we yearn for, our original state? A blessing to have in Regina this place in Wascana, still wild, where we may touch that, even for just a moment.

* The Canadian Oxford Dictionary

When writer Anne Campbell isn't walking in the wild and working to protect it, she advocates for the arts. For many years she worked as a Regina Public Library administrator and previously in museum communications at the MacKenzie Art Gallery, Regina, and the Glenbow Museum, Calgary.

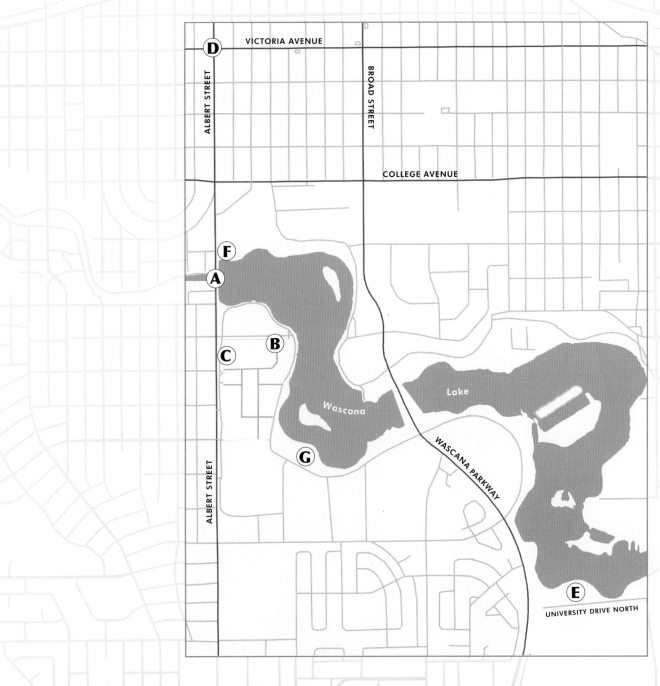

VICTORIA AVENUE

ALBERT STREET

BROAD STREET

D

COLLEGE AVENUE

F

A

B

C

Wascana

Lake

G

ALBERT STREET

WASCANA PARKWAY

E

UNIVERSITY DRIVE NORTH

Monuments

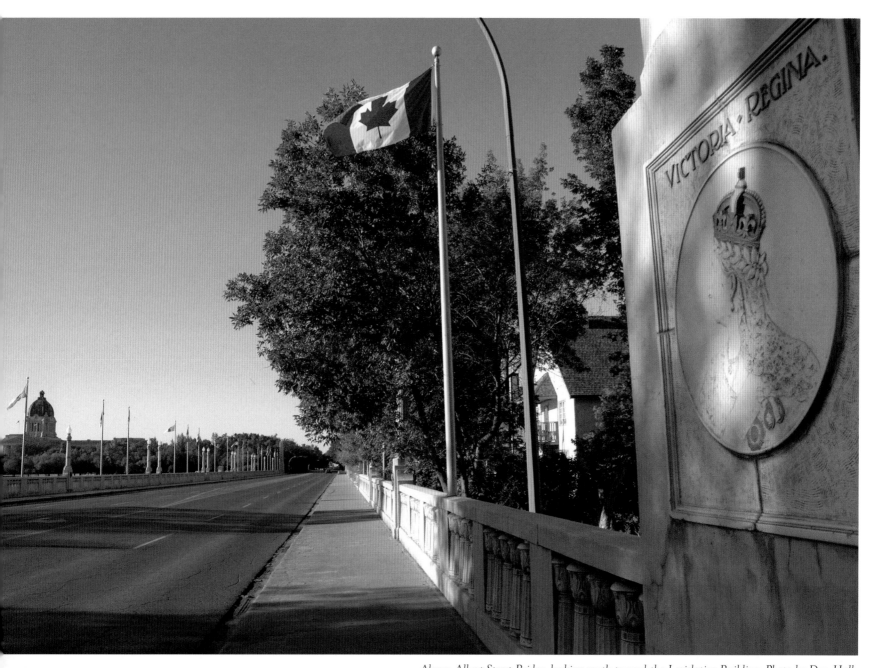

Above: Albert Street Bridge, looking south toward the Legislative Building. Photo by Don Hall.

Albert Memorial Bridge

by Timothy Long

Why would a small prairie city bedeck its only major bridge with Egyptian papyri and lotus flowers? Did it not occur to anyone that emblems of the Nile's fertile banks might look foolish beside a waterway that is, after all, a dammed creek?

The discovery of King Tut's tomb in 1922 set off a mania which was still beguiling artists and architects in 1930, the year of the bridge's construction. But why summon the ghosts of Egypt to the banks of the Wascana? Neither the bridge's planner, Col. F. J. O'Leary, nor the designer of the pillars and ornaments, Joseph Lee-Grayson, has left us with much of a clue.

What we do know is that the bridge was built as a Depression make-work project, a joint venture of three levels of government, and that it was intended to honour the sacrifices of the Great War. According to *The Leader-Post*, Saskatchewan's premier, J. T. M. Anderson, pointed out at the dedication "that the bridge was symbolical of the province's honest attempt to assist those warriors who had returned and the kin of those who had not, along the rough path of life." Anderson, who could not have imagined how rough the path was about to become, makes no mention of Egypt.

Regina is the kind of city that allows you to invent your own explanations, and in crossing and recrossing the bridge I've had time to speculate about the decorations and their meaning. Those papyrus bundles have become for me polychrome wheat sheaves and the lotus flower lamp bases a kind of exotic substitute for the western red lily. Reading the symbols in another direction, plains bison heads stare out like dryland water buffalo, and Queen Victoria surveys the scene like a matronly Nefertiti. In this light, the Saskatchewan Legislature across the lake has taken on a new shine as a prairie Thebes and the once-soupy Wascana as a stand-in for the mighty Nile.

It begins to make sense. Just as Egypt had been the breadbasket for the Roman Empire, so Saskatchewan was for the British Empire. What better message to send at a moment of economic crisis and social unrest than a reminder of imperial power and colonial duties?

Yet, I can't help thinking about the thousands of relief workers who toiled to make this bridge and to deepen the lake. Those who built the bridge say they were well paid, but that was before the On-to-Ottawa Trek. Is there a bit of prophecy in this? Israel in Egypt, its oppressed masses waiting for a messiah — Moses or Douglas — to lead them to the promised land?

The bridge, like the city it graces, is the improbable flower of the colonial imagination, an exotic transplant which has taken root to support its citizens.

Timothy Long grew up looking out his back door at Kitchener School, and he retains today traces of a north-end accent. His studies in Art History took him from the University of Regina to the State University of New York at Stony Brook where he learned an alternate pronunciation of "coffee." He is currently Head Curator of the MacKenzie Art Gallery, where he has produced Regina-inspired exhibitions such as *That's My Wonderful Town* and *Regina Clay: Worlds in the Making.*

Below: Albert Street Bridge pillar detail.
Photo by Don Hall.

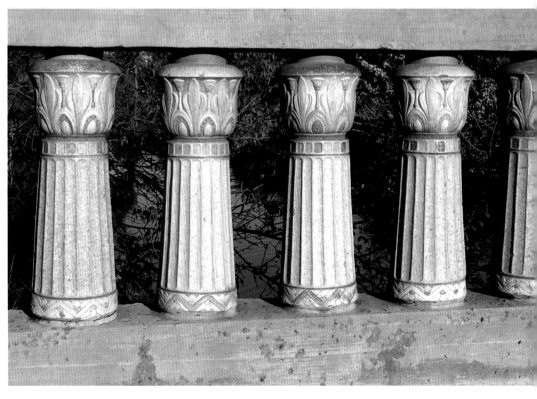

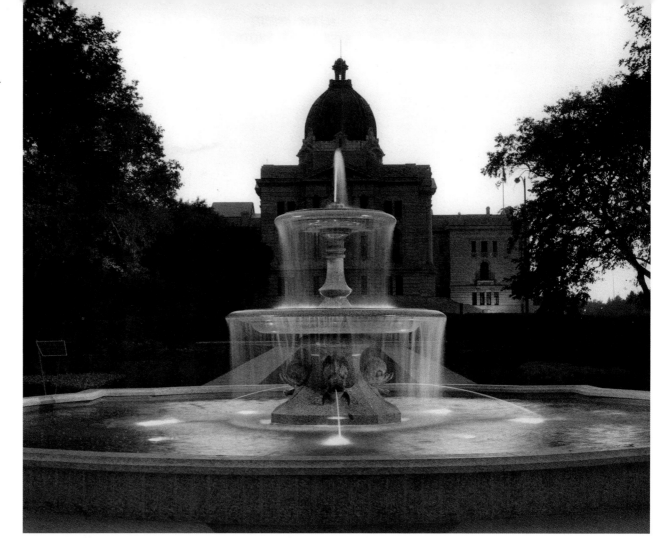

Photo by Joe Moran.

The installation and dedication of the Trafalgar Square fountain on the eastern approaches to the Legislative Buildings, Regina, Saskatchewan

by P. J. Moran

In the early development of Wascana Centre, there was interest in introducing some elements in the landscape which would reflect the British and French cultures upon which the country of Canada was founded. Sculptural objects from Britain were obtained and proved to be somewhat more accessible than those of French origin.

The fountain erected in Wascana Centre is one of an identical pair, designed by Sir Charles Barry, R.A. It played in London's Trafalgar Square from 1845 to 1939. It was sculpted from the red granite of Aberdeen, Scotland.

Barry is, perhaps, better known as the architect for the Houses of Parliament in London. The pair of fountains were removed from Trafalgar Square to make way for larger fountains which were operational on Trafalgar Day, October 21, 1948. The original fountains were found by Mr. H. Clifford Smith in the possession of a dealer in statuary and garden ornaments at Isleworth in Middlesex. Mr. Smith drew them to the attention of the National Art Collections Fund of Britain, which acquired the fountains for presentation to a Dominion Capital. Canada accepted

the two fountains through the National Gallery of Canada. Only one of these fountains was erected in Ottawa by the National Capital Commission in a park not far from the Chateau Laurier Hotel. The mate to the fountain in Ottawa was donated to the Wascana Centre Authority by the National Gallery of Canada; however, the upper five foot diameter bowl was broken in half.

Count Alexander Von Svaboda, in partnership with Remo de Carli, artists and mosaicists of Conn-Arts Studio, Toronto, Ontario, assured the Authority that he could, with the Connoly Marble Mosaic & Tile Co. Ltd., fabricate a duplicate of the upper bowl which would be indistinguishable from the original granite bowl. The finished product was identical in form and appearance with its highly polished terrazzo finish and the colour and texture of the original red granite.

The height of the large bowl on the bed of the transport truck exceeded the height of the underpasses of the Trans-Canada Highway at that time, so there was no way that the fountain parts, already on the semi-trailer truck, could be shipped to Regina. Officials of Canadian Pacific Cartage solved the dilemma by driving the truck with the fountain onto a flat-bed rail car to be hauled by train, as the C.P.R. could manage sufficient height clearance on its lines to transport the fountain safely to Regina.

The Wascana Centre Authority's landscape advisor, Mr. Thomas (Tommy) D. Church of San Francisco, recommended several changes to the fountain pool and site design. John Watson, a landscape architect from Dallas, Texas, specializing in landscape illumination, was retained to do the illumination of the fountain and illumination of the trees in the fountain area. Underwood, McLellan and Associates were retained to undertake the consulting engineering work for the structural design and hydraulics of the fountain and to supervise the construction work.

On Friday, August 2, 1963, His Excellency, Viscount, Lord Amory, P.C., of Tiverton, and British High Commissioner to Canada for the United Kingdom, officially turned on the operation of the fountain with the illumination of it and the surrounding area at 9:15 P.M. He dedicated the fountain to the founding of the North West Mounted Police Training Headquarters in Regina in 1882.

Patrick Joseph Moran, C.M., B.Sc.(Agric.), B.F.A., Hon. F.R.A.I.C. Joe Moran was born in Calgary, Alberta, and is a naval veteran of World War II. He was the Provincial Horticulturist and Landscape Architect for Saskatchewan from 1951 to 1962. From the inception of Wascana Centre Authority in 1962, he served in a number of capacities and was Executive Director from 1966 until his retirement in 1987. He served as a volunteer consultant for the Canadian Executive Service Organization in Peru, Bolivia and the Philippines.

Photo by Don Hall.

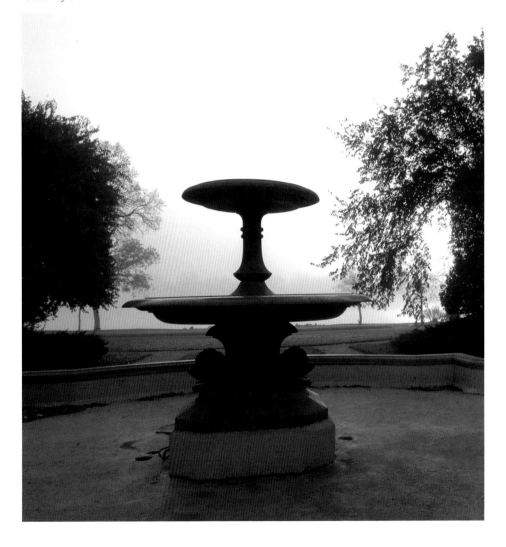

Photo by Don Hall.

At the Woodrow Lloyd Memorial

by Paul Wilson

There are very few places in Regina where politicians are remembered. There is the audacious statue of John A. Macdonald in Victoria Park and the understated tribute of Joe Fafard's wall-mounted bust of Tommy Douglas at the entrance of the MacKenzie Art Gallery in the T.C. Douglas Building. Of course the Saskatchewan Legislature houses portraits of all our premiers. On the lush grounds that surround the Legislature is a permanent memorial to Woodrow Lloyd. I have often visited this tree-shaded alcove where one can always find a space for contemplation bordering busy Albert Street. There is no image of Lloyd here; only a stone monument with a brass plaque inscribed with his accomplishments and the Robert Frost poem that he felt exemplified his life: "The Road Not Taken."

24

Sunlight skims ghosts of snow. I shiver and think of Woodrow
Lloyd as a child skating on a frozen lake, always leaping ahead—
eleven years old, when he entered high school.

I clear snow from the face of the cairn. Ice fills the serif font
of Frost's brass stanzas. Woodrow Lloyd walked here, pausing
in the hollow hum of Albert Street traffic.

Under the elms and spruce did he think of Frost,
his paths, his roads, his mutable woods, and his winter hours?
Did Woodrow recall Swan Lake School, 1932?

How to nurture minds, when stomachs are empty—
when hope is a poem, a prayer repeatable in darkness?
Woodrow is electric as he reads; the students hear the sigh

in his voice, a deepening sorrow in the words.
Woodrow senses them listening as never before. The wind
gnaws at the sills, door jambs, dirt clacks against window panes.

In this classroom no one will fail to choose, no one will fall.
Woodrow holds up a photograph of Frost slouched, rumpled
in a coat and tie. It is a face a farm boy might recognize as fatherly,

weary eyes, barely open. Each student holds the image,
and is drawn by Frost's gaze to the long bones of his hand,
to the sharp nib poised above the blank page.

Here at the Memorial, where the path divides,
I imagine Woodrow standing utterly still. Not speech,
but language in his head — *Though as for that the passing there...*

As he walks the wooded path, then the four slow blocks to his home,
he wonders if it is something that came to him in sleep,
this unswerving self, somehow unalterably lost to its opposite.

Even to rhythm and the caressing of an idea there is no solution.
I stand *bent in the undergrowth*, and dream Woodrow here,
half-sheltered from the wind, meditating on the persistence of metaphor.

Paul Wilson is a writer and arts administrator. He published his first book of poems, *The Fire Garden,* in 1987 with Coteau Books. The author of three poetry books, including *The Long Landscape,* which won the City of Regina Book Award, he is also a partner in the Regina-based literary publisher, Hagios Press. His fourth collection, *Turning Mountain,* will appear from Wolsak & Wynne Publishers of Toronto in 2007. Wilson has served as the Executive Director of the Saskatchewan Writers Guild and is currently employed with Nature Saskatchewan.

A legacy of appropriation and imperialism. Above: Regina's major street and avenue are named for Queen Victoria and Prince Albert; top right: "Pemmican Pete" is one of the symbols of Regina's Buffalo Days Exhibition. Inset right: buffalo head on the Albert Street Bridge. Photos by Guy Lafayette. Images of buffalo and Crown are incorporated into both the crest of the Royal Canadian Mounted Police (inset, opposite page) and the City of Regina crest as displayed on the Albert Street bridge (this page, bottom). RCMP crest photo by Guy Lafayette. City of Regina crest photo by Jim Zaleschuk.

Buffalo and Imperial Legacy

by Guy Lafayette

Guy Lafayette is an artist/researcher from Regina, Saskatchewan, who graduated from the Ontario College of Art and Design in 1987 from what was then the Photo-Electric Arts department. Guy has worked in both traditional and digital media and has exhibited and published work in Regina, Toronto, and London, England. Recent research projects have focused on finding viable solutions for urban sustainability in both London and Caracas, Venezuela. Guy's work often explores the integration of architecture, culture, nature and spirit.

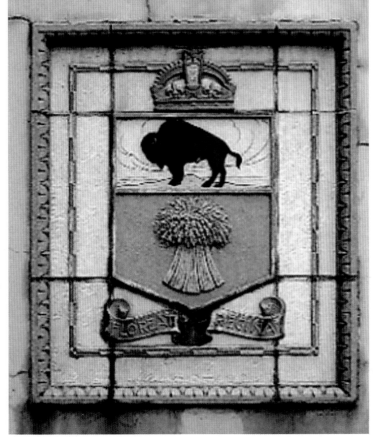

Our schools teach us that the original "pile o' bones" was the outcome of years of buffalo hunting by local Native people. Although this area was an important hunting ground for local people, the pile of bones was more likely due to an engineered eradication of buffalo that occurred during the 1870s from the Battlefords to the Black Hills of South Dakota. This sanctioned and systematic culling resulted in clearing space for settlers as well as tearing out the spiritual heart of the people who held the "ley" of the land.[1] The buffalo was once integral to the survival of the original cultures of the plains and is still considered sacred.

Some say the pile of bones, which were harvested in Regina and used for making fertilizer and china, included the bones of Native people as well.[2] The English ruling classes may have sipped tea out of human bone china. Is this representative of a legacy of a military-industrial civilization that thrives on the ritualistic assimilation of conquered races and cultures?

This land was taken over in the same manner that the rulers and priests of Christendom subdued 'pagan' worship in Europe. The appropriation of symbols as well as the construction of cathedrals and seats of power on sacred megalithic sites empowered conquerors to subdue that particular land and the indigenous people that inhabited it.

Throughout the city of Regina there are subtle symbols and features that reveal a legacy of appropriation and imperialism. Even the crossing of Albert and Victoria streets is an act of geomancy and a declaration of dominion over an area once integral to various tribes. The intersection symbolizes the consummation of yet another offspring of the British Queen and her consort.

Another example of symbolic urban planning is the Albert Memorial Bridge. The image of the buffalo appears on the base of each Egyptian-influenced column along the entire span. At the top of the columns are lights, which might imply that the Buffalo represents a source of energy that now illuminates the bridge to the seat of power.

We must ask ourselves if Colonial powers and attitudes still have an influence on the psychogeographic development of the Queen City. A symbol of two towers is featured on the shield of the Grand Seal of the Grand Lodge of Saskatchewan for the Ancient Free & Accepted Masons. Two skyscrapers now feature prominently in Regina's cityscape and between these two towers lies yet another representation of the symbol most sacred to the Prairie Native races: the ancient and once free Buffalo.

Below: Buffalo at Ipsco, north of Regina. Photo by Guy Lafayette.

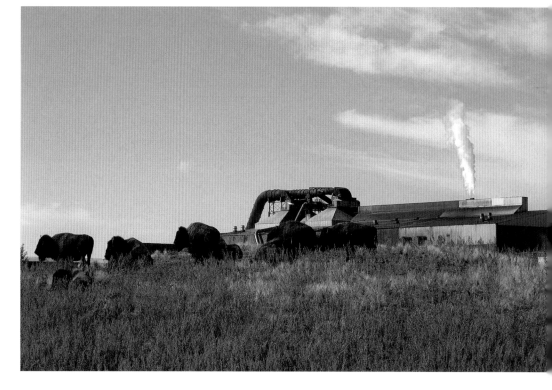

1 "ley": one of a network of hypothetical lines or ancient tracks connecting prehistoric sites.
2 *See* Greg Beatty, "Skeletons in Regina's Closet?" on pages 66 and 67.

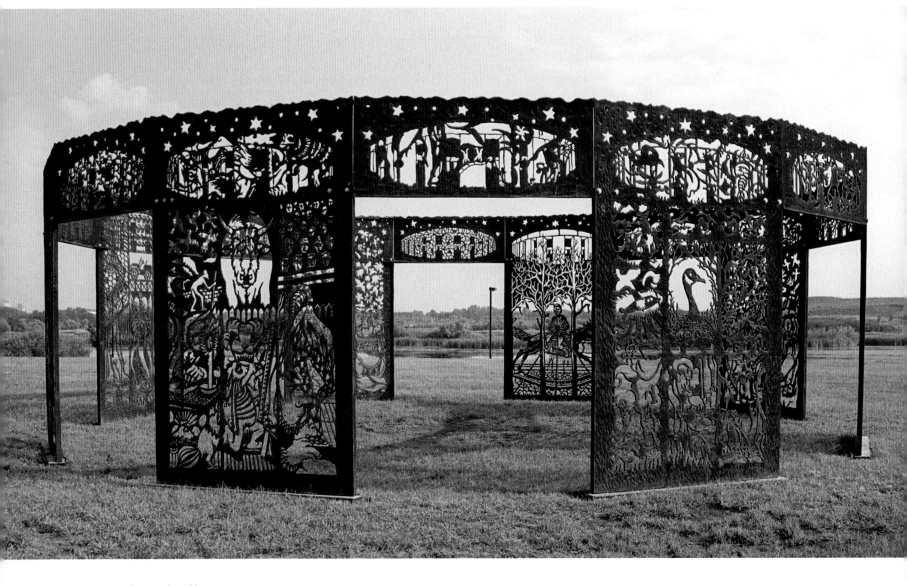

Le jardin de l'esprit

by Joe Fafard

For me, a clearing just north of the University of Regina, just beside Wascana Lake, has become my sacred spot, my personal Stonehenge. It contains my hopes, my disappointments, my sweat, my brain machinations, my efforts and pleasures, my tenacity, my perseverance and victory. I conceived it, carried it and brought it up. There it is — "Le jardin de l'esprit."

How it came about is part of its story. I had been asked to submit an idea to a memorial committee that was charged with erecting a monument to Canada's contribution to the Great Wars. It was to be located in Green Park, London, England. The committee had selected about eight artists to take part. I worked diligently for months and felt I had something sound to offer. But it was not to be. Someone else was chosen. I was dejected for days. Then I decided not to give up. I would do it anyway. I trolled the idea elsewhere. I included it in some of my exhibitions in commercial galleries — Mira Godard in Toronto, Susan

Whitney in Regina – but to no avail. Finally, I thought a collector of mine might be interested in sponsoring it. My representative in Vancouver, Doug Udell, set up a meeting between Gordon Diamond and myself, along with his accountant, in a fine restaurant. Doug had shown the maquette to Gordon previously. Not much persuasion was necessary. We had a deal, and not much later, over just a handshake, Gordon gave me enough money to get the work rolling. I hired a lad named Lionel Ireland, who worked doggedly for six months tracing the projected images onto styrofoam sheets 4' x 8' x 3/4", then cutting them out. He also shaped the edges to my specifications. That done, I used a torch to further texture the styrofoam cut-outs, and make them ready for the foundry.

The foundry, Julienne Atelier Inc., located in Pense, worked off and on for two years, casting the pieces in sand using the lost-styrofoam method. In all, about 16,000 pounds of bronze was used at about $2.50 per pound. The man-hours were too many to count! The assistants who carried out the work were Michel Hamon, Lionel Ireland, Brian, Martin and Phil Tremblay, and Terry Deneve. Eventually everything was ready. The Wacana Authority had agreed to accept the structure on loan for three years. A support structure of piles was sunk into the ground and the sculpture was erected. It was a great feeling to see realized something that had been so long struggling to become real. Gordon Diamond and Doug Udell came out to see it and we had a party! In June 2005, Gordon and I, as co-owners, successfully donated "Le jardin de l'esprit" to the University of Regina.

But that is just the story of its birth. What does it mean? Why did it need to exist? Was it just vanity on my part? I can't rule that out, but it did seem that I should do it. I had given a lot of thought to all the spirits of the very young people whose lives were truncated by those awful wars. I thought about all those things that 110,000 dead Canadians were never to experience or accomplish. I thought about all that talent wasted. I imagined all their descendents who will never exist. It seemed necessary to attempt a tribute to those lives that were sacrificed.

For me, "Le jardin de l'esprit" is not just a monument to contributions of the war dead; it is also about the efforts and sacrifices of those who survived. All of society was focused on victory. War is a breakdown, it is chaos, but it requires great organisation to overcome such cataclysm. Such efforts are a constant, even in peacetime, to better our lives and give meaning to our daily strife.

"Le jardin de l'esprit" is about such "victories," because there really are no victors in war; just victims. Keeping wars from occuring is the only victory! Let it be a monument to peace then, as it provides an enclosure with many windows on the world to reflect on potential and loss.

Opposite page: "Le jardin de l'esprit," north of the University of Regina. Below: Detail of "Le jardin de l'esprit." Photos by Don Hall.

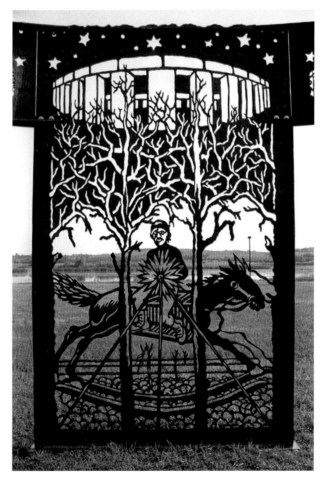

Joe Fafard, internationally recognized artist, lives on an acreage near Lumsden. An Officer of the Order of Canada, he has also received the Saskatchewan Order of Merit and the Lieutenant Governor's Centennial Medal. In the 1970s, much of his sculpture used clay as a medium, but in 1985 he shifted to bronze as his principal medium, and he successfully established his foundry in Pense. Joe's bronze cows have become one of his trademarks.

Photo by Don Hall.

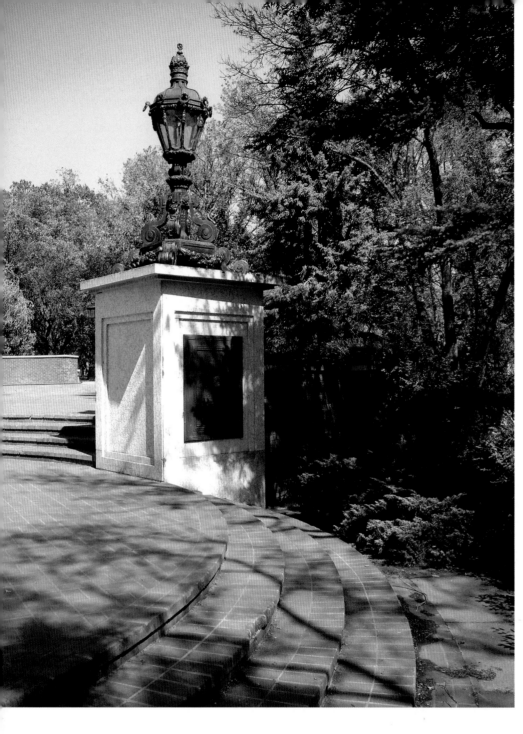

Speaker's Corner

by Anne Campbell

Anne Campbell was born in a Red Cross Outpost Hospital at Paddockwood, Saskatchewan, where her English grandfather was not reluctant to speak his mind. She was raised in Saskatoon and Hanley, and has lived for many years in Regina, albeit with sojourn years in Calgary and back in Saskatoon.

At the northeast end of the Albert Street Bridge, just inside Wascana Park, Speaker's Corner is waiting.

While others may have done so, I've never seen anyone "speaking" there, though I have seen wedding photographers, and skateboarders, and walkers straying from Wascana's paths. But speakers? No.

As I pass the Corner, I wonder what this silence says about us — other than the obvious: we don't use a space designed for public speaking to do so. The site design is interesting: any actual crowd gathering would need to spread to either side of the corner as the space filled, since moving back would put "listeners" on Albert Street. Was the design meant to limit group size? If so, it seems this was unnecessary, as we limit ourselves, no speakers or listeners gathering.

I wonder if we might be embarrassed at the sight of our fellow citizens giving forth "unofficially"? Do we prefer our information "authorized," perhaps "sanitized"? Have we left behind the impulse of our English grandparents who liked nothing better than a good speaker to question or heckle? And what of the history of other immigrant groups and their places of public discourse?

Whatever past history and lost opportunities, I hope there might come a time soon, perhaps mediated by organization — if we need that security — when Speaker's Corner might actually become a space where citizens gather to voice causes and concerns, while others listen. Now is the time, more than ever, for fresh views, opening our minds, stimulating our thought.

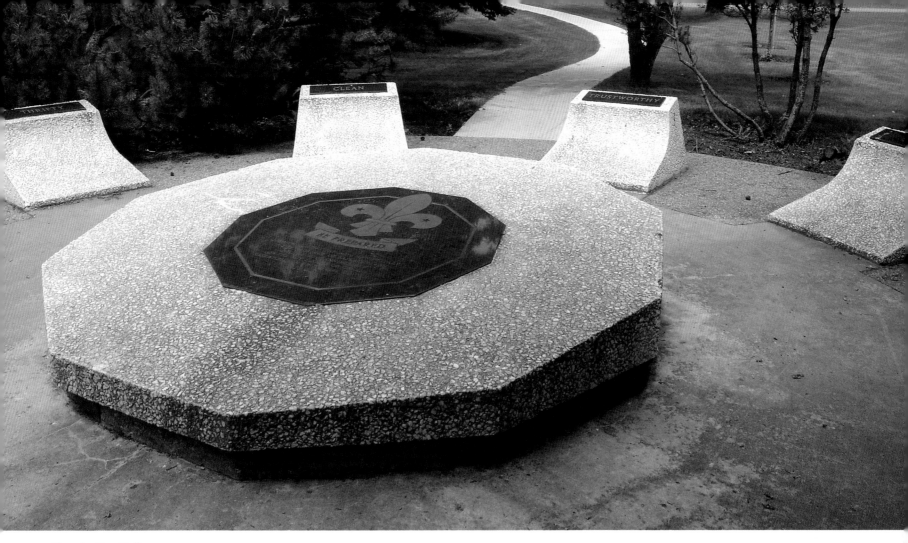

Photo by Don Hall.

The Boy Scout Monument

by Connie Gault

In Wascana Park, not too far from the lake and not too far from the Legislative Building and across the road from the Wascana Rehabilitation Centre and the lonely information kiosk, four paths meet at a hidden spot of hallowed ground. Here a mortuary hedge of bent, dwarfed pines encircles ten markers that are splayed out like the spokes of a wheel around a commemorative concrete button erected in 1965. The ominous motto of the Boy Scouts is engraved on the button: Be Prepared. On the 60th anniversary of the province of Saskatchewan and the 50th anniversary of their own organization, the Boy Scouts of Canada chose to warn us of the bleak future we face by ignoring their message.

Here, in Wascana Park, they buried their best. Here lie the virtues of what must have been a more innocent age. I often wonder, when I walk by the monument, what rites were held to mark the burial of these fallen heroes, what mourners followed them to their final resting place, what eulogy praised them and the good they tried to do before they fell. I always leave the site in a ruminative mood, knowing that I'm leaving behind ten scouts who might have saved the world if they hadn't died. Thrifty, Cheerful, Brotherly, Trustworthy, Loyal, Courteous, Kind, Clean, Helpful and (my favourite) Obedient lie buried here in Wascana Park. They are gone but not forgotten.

Connie Gault is a writer. She has lived in Regina for a long time. She is currently working on a novel set partly in the city in the days before any of us were born.

31

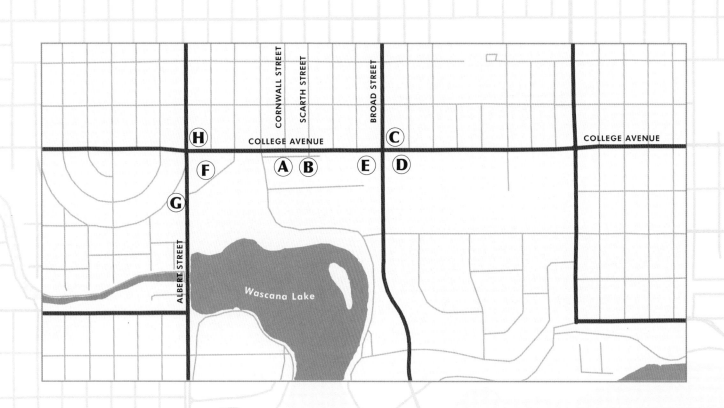

CORNWALL STREET

SCARTH STREET

BROAD STREET

COLLEGE AVENUE

COLLEGE AVENUE

H

F

G

A B E D

C

ALBERT STREET

Wascana Lake

College Avenue: Intellectual Corridor

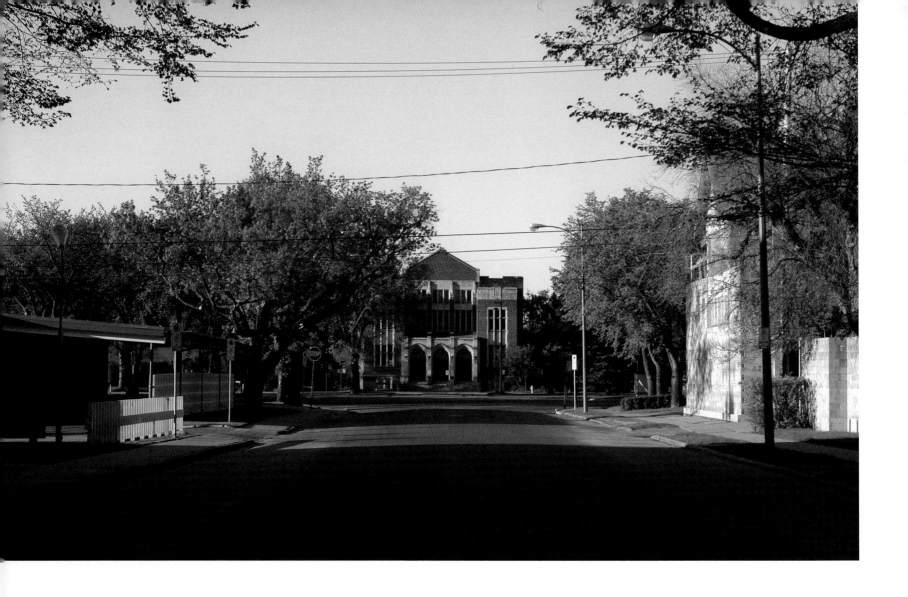

Prowling the Queen City with Martin Heidegger

by Béla Szabados

The artwork moves the earth itself into the Open of a world and keeps it there. The work lets the earth be earth... The poet also uses the word – but in such a way that the word only now becomes and remains truly a word.

Turning and twisting through serpentine crescents, with Leopold and Albert, in an ecological mood, join Wilf Perreault as Reginald, steely grasshopper embedded in impatiens white, yellow, pink, blue, with ivy as veins and intestines, coming alive each spring fat in summer slim in winter, wiry bones showing. Positivist dancer, frozen in mid leap, antennae gesturing towards "The Ledge," earth support.[1]

Béla Szabados has lived in or around the crescents of Regina for the past thirty years and brought up his late son Imre there. Among his books are the autobiographical *In Light of Chaos* and most recently *Once Upon a Time in the West: The Making of the Western Canadian Philosophical Association*. Also, he is a co-editor, with Ken Probert, of *Writing Addiction: A Poetics of Desire and Its Others*.

Cross-roaded, veering left, landmark: old brick telephone building now housing dinosaur bones for the museum of natural history — communicating past messages. Resting, glance east: *was ist das, Adolf Loos?* an inviting shape, an arch with long view, modernist box with parallelograms — splash of colour and ornament — austere master would surely decline to Invest, screaming ornament is crime.

Back alley beckons away from concrete lines to fertile margins, teeming life; cross to enter, ambulate disappointed along asphalt alley; dwelling on margins of green caragana and prairie lily orange escaped the designer's compass, sudden vans bearing down, delivering goods, security guards weight training with keychains; pass by the fenced gardens of the beneficent "Schumis"; clearing of Cornwall street.

Walking south, Cadillacs of grey loss left and right: "Speered" and "Helmsinged,"[2] we approach necropolis, witnessing our own funerals; look up, fix eyes on a welcoming trinity of arches, portals of Darke Hall, at the edge of park Wascana, pool and playground, swings and sand, once a lake of green algae harvested by boats, where I swung a small boy of lightning joy un-minding of sand in toes and eyes.

Light of Darke Hall, old Campus, across the avenue College, punctuated by ashes and elms, with annual perennials. To the left the arts building where once upon a time in the west, on a thanks giving weekend in October 1963, in the sun of a prairie autumn, before Joe Fafard cum students created the croak-less frog — looking to the centre with its lenses of ceramic plastered glass — a handful of wisdom-lovers hid from administrators, lest they be disabled from dreaming difference.

Break onto the other side, with the doors open: Haydn, Bach, Brahms, ring out with *missa in tempora belli*, brandenburg as concerto, german requiem; where Mahler grieves with Kindertotenlieder, and Bartók speaks dissonance; givers of nourishing spirit, walk through the arches to performance where instruments in communion are honed and sing; where children take their piano turns, and you courageous beloved, a neophyte at forty, also take your turn, making up for missed lessons when you were trapped in circumstance, perform now, as children delight and astonished kin applaud when with them you interpret "Mikrokosmos" and take your bows.

1 *See Wilf Perreault's "Reginald, the Great Big Grasshopper" on page 45.*

2 The Helmsing funeral home is no longer at its long-time College Avenue and Cornwall Street location, although the building remains and is under renovation.

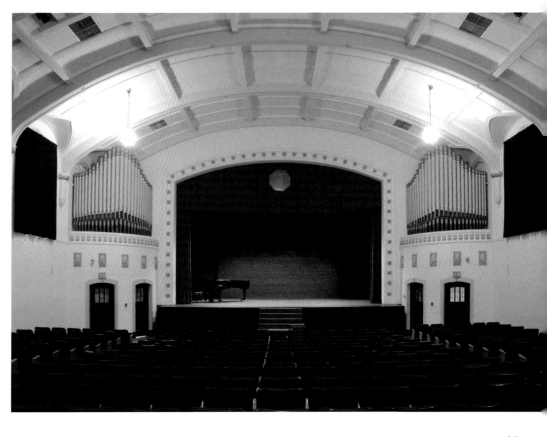

Learning from the Past

by Loanne Myrah

The College Building, located at College Avenue and Scarth Street in Regina, houses a hidden treasure – its historic Lecture Theatre remains untouched on the second floor. First used by students in 1912, the building and the Lecture Theatre have accommodated high school and college students, Royal Canadian Air Force pilot trainees, church services, plays and community meetings over the past ninety years. Surviving virtually in its original form, the Lecture Theatre provides a window into Regina's past and into the hopes and dreams of Regina's earliest citizens.

The Lecture Theatre was at the heart of Regina College, an institution established by the Methodist Church to provide high school and early college education for young people in Regina and its surrounding communities. At the time, there were few high schools in southern Saskatchewan so that only 17 percent of the students of the day continued their education beyond Grade 7. The Lecture Theatre also served as a chapel for the many residential students housed at the College. During World War II, Regina College became the site of "No. 2 Initial Training School" for the British Commonwealth Air Training Plan, with high school and college students relocated to rented rooms at other locations. After the war, the buildings were returned to their original purpose as an educational facility.

Some noted guest lecturers came to Regina College during its early years and would have spoken in the Lecture Theatre, as it was the largest facility for the College. The Reverend J.S. Woodsworth, future leader of the Co-operative Commonwealth Federation (CCF), discussed the impact of immigration, industrialisation and urbanisation upon Canadian society. Mrs. Emmeline Pankhurst, the celebrated suffragist, described the achievements of Soviet society after the overthrow of the Tsar. As well, novelists and poets of the day such as Nellie McClung, Ralph Connor, Bliss Carman, Wilson Macdonald and Sir Henry Newbolt addressed the students.

College faculty taught in surrounding classrooms and the Theatre. The Reverend Egerton Roswell Doxsee was the longest serving and most esteemed faculty member of Regina College, teaching classics from 1911 until his death in 1932.[1] A respected and beloved teacher, he developed a successful Latin club in spite of initial student reluctance to join. Students played Latin games, sang Latin songs and even listened to lectures in Latin.

Regina College was the forerunner to the University of Regina, and its attractive buildings now house the University's Centre for Continuing Education. While much of the College Building is devoted to contemporary use, the Lecture Theatre has been neither altered nor restored. This is to our advantage, as we still can view the steep tiers providing wooden seating and writing surfaces, the seats numbered to assist with attendance records and the small upper balcony allowing for ventilation of the windowless room. From there, it is easy to imagine the students who climbed those stairs to their seats during past decades.

Loanne Myrah is employed by the Centre for Continuing Education located on the College Avenue Campus of the University of Regina. Several members of her family were educated at Regina College and she appreciates the opportunity to work in this historical building where they attended their classes.

1 Pitsula, James M. 1998. *An Act of Faith: The Early Years of Regina College.* University of Regina, Canadian Plains Research Center.

The Madrid and its Venerable Neighbours

by Susan Birley

The Madrid Apartment building, at the intersection of College Avenue and Broad Street, is neighbour to a number of institutions that were significant in Regina's history. It has drawn tenants from these institutions over the years, making it one of Regina's more interesting addresses.

The Madrid was one of the prestigious apartment complexes designed by architects Storey and Van Egmond, who also designed many of the heritage homes along College Avenue, as well as two of the most prominent apartment buildings in Central Regina – the Frontenac and the Balfour.

The Madrid was built in 1927 in the Mediterranean style, with a number of appealing features, such as arched windows and doorways, decorative medallions and pedimented parapets along the roofline. Its suites were designed to accommodate significant social gatherings, with generous dining and living room space.

To the south is a distinct group of six buildings which were formerly part of the Anglican Church's Diocese of Qu'appelle properties. The Diocese formed the centre of the Church's educational and mission-building activities in southern Saskatchewan. The Anglican mission provided the new communities being built along the expanding national railway system with a strong spiritual presence, as well as reinforcing Canada's British heritage. This spirit is reflected in the Collegiate Gothic style of the buildings, which draws on the architectural traditions of Oxford and Cambridge universities.

The Diocesan buildings were constructed between 1912 and 1926 and were oriented to an original site plan based on the design of the British 'Union Jack' flag, which is why some of them were built at angles to College Avenue. The original plan was to build a Cathedral at the centre of the flag; however, due to the changing fortunes of the Qu'Appelle Diocese following the Great Depression, it was never built.

The Diocese buildings include St. Cuthbert's House, which housed members of the 'Railway Mission.' The Railway Mission established many Anglican parishes and constructed churches in the new communities along the railway. St. Chad's College was originally a hostel for the churchmen who were recruited for the missions, and it eventually become the first home for the Qu'Appelle Diocesan School for Girls. Anson House was built as the residence for the Diocesan secretary, and Bishop's Court served as the residence for the Bishop of Qu'Appelle from 1926 until the late 1970s. Harding House was built by donations from the Fellowship of the Maple Leaf in England. This charity sent British teachers to schools in western Canada to help ensure a strong British presence in the new colony. The Diocesan properties were recently sold to a developer, but will hopefully be allowed to retain their unique heritage character.

The building on the southwest corner from the Madrid was originally the home of the Regina Normal School, its name apparently originating from the French, 'Ecole normale superieure.' It was built in 1913 as a teacher training college, and served many purposes over the years, including the first site of the Museum of Natural History. The Normal School was also designed by architects Storey and Van Egmond in the same Collegiate Gothic style that

may be found in the Diocese of Qu'Appelle buildings. The Normal School eventually became part of the Regina College Avenue complex, which formed the start of the University of Regina.

Regina's College of Fine Arts was housed in the Normal School from 1969 until 1997, when the new Fine Arts building was built on the University of Regina campus. The College of Fine Arts was the incubator for many influential artists such as the Regina Five – Ted Godwin, Art Mackay, Ken Lochhead, Ronald Bloore, and Doug Morton. They were modernist painters who achieved international recognition in the 1960s, as did the ceramic artists of Regina Funk in the 1970s. Many former students of the Fine Arts School, such as David Thauberger, Marilyn Levine, and Bob Boyer, also achieved an internation reputation.

The Normal School was the subject of some controversy in the late 1990s, when it was under threat of demolition due to the high cost of renovation. It was reborn, with extensive renovations, as the Canada-Saskatchewan Sound Stage, and now plays host to many film and television productions.

The Madrid has drawn its tenants from the professionals, students and faculty of each of these institutions over the years, as well as a number of prominent Regina citizens. In the early days it would have housed the teachers from the Qu'Appelle Diocesan School for Girls or St. Chad's College. In more recent years it has enjoyed a more Bohemian clientele, including many writers, artists, actors, members of the film industry, and university professors and students. It continues to play a central role in Regina's cultural and artistic community through the lives of its residents.

Photos by Don Hall.

Trained as an archaeologist, Susan Birley is interested in exploring the strata of human histories that make up buildings and neighbourhoods. She is active in saving libraries, heritage preservation, neighbourhood planning, and greening playgrounds in an effort to make Regina more "citizen friendly."

Material on the Diocese of Qu'Appelle and Normal School courtesy of the Heritage Branch, Government of Saskatchewan.

Angels and Anglicans

by Lorraine Bethell

Jane Jacobs once said, "Cities need old buildings so badly it is probably impossible for vigorous streets and districts to grow without them" (*The Death and Life of Great American Cities*, New York: Random House, 1961). Lorraine Bethell is a citizen of Regina who has grave concerns about the loss of our historic buildings and the subsequent effect it will have on our city.

Languishing in the midst of our city is a parcel of prairie land with five brick buildings that seem oddly tossed, like fairy dust from some magical wand, onto the corner of College Avenue and Broad Street. I'm not sure why I am drawn to this location, which was officially named The Archdiocese of Qu'Appelle, but which has become known as the Anglican Properties.

Something happens to me whenever I walk this urban piece of prairie. It may be the melancholy that seems to echo from building to building or the ghostly stillness occupying this space that captures my heart. These magnificent buildings are shrouded in the shattered dreams of a people who had planned to build a religious and educational centre for Anglicans in southern Saskatchewan. It was a vision that included a cathedral, a bishop's residence, a theological centre to train clergy, a hostel for teachers. Those dreams were crushed by a "Great War" that sucked away the nation's attention and resources almost immediately. There was no recovery.

It may also be the inevitable and persistent questions that come when I wander from building to building, circling each one individually. Why are three of those buildings so oddly placed — at an angle to the street? What were the builders thinking? Some suggest that the Union Jack was the template for a grand design that was meant to emphasize the association with British culture and heritage. At the heart of this design would sit the cathedral that was never built.

Amazingly, there are three chapels on this little patch of land: one on the third floor of Bishop's Court, a beautiful chapel in St. Chad's College and a chapel attached to the northeast corner of Harding House, all in addition to the proposed cathedral.

With each visit, I pause to admire the architectural details on each building, and to verify, in some peculiar way, that they are still there — details such as the stone sculptures on the north wall of St. Chad's College representing Matthew, Mark, Luke and John and, of course, the terra cotta angel perched high on a ledge of the south wall. Who decided to put it there? And why?

Each spring my visit to the site included a visit to the abandoned garden behind Bishop's Court where a glorious patch of rhubarb reigned — part of a larger garden that was once an integral part of the bishops' culinary experiences. Imagine my disgust when I discovered one year that the owners (in an attempt to "make maintenance of the landscape" a priority) had mowed over this heritage garden, destroying all the rhubarb that I so enjoyed harvesting each spring — rhubarb that was green and sour, but sweetly reminding me that the eight bishops who once lived there probably ate pies from the fruit culled from this patch. I loved that thought.

In the end, historical properties are essentially about people. I like to think my visit rekindles the joys — and maybe the sorrows — of those who graced this region in the past. Perhaps it was the Aboriginal people who lived in harmony with this land. Perhaps it was the Anglicans, whose grand dreams were never realized, or members of the Regina Community Gardens who, until very recently, had filled this space with lovely rows of vegetables and herbs and flowers. Or, ironically, it may have been an inmate, who, as part of a jail farm, had once worked this land, not long before all these wondrous Anglican plans took shape.

This space is a bit of history suspended in the middle of the city. Untouched for now, the buildings wait patiently to see if their past will be respected, and if they will have a renaissance, a new life.

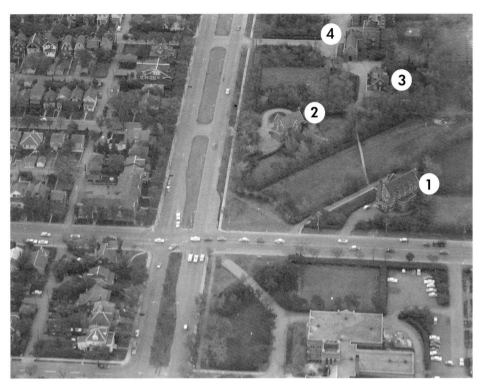

The aerial photo above shows the angled placement of roadways and buildings, indication of the original "Union Jack" design (Saskatchewan Archives Board 59-139-03). Buildings are: 1. Harding House; 2. Bishop's Court; 3. Anson House; 4. St. Chad's College. Below: Terra cotta angel on the south wall of St. Chad's College. Angel detail, inset on facing page. Photos by Don Hall.

Gnosis

'secret (hidden) knowledge'

G ... genetic, genesis — creation, origin

NO ... negative pole, the opposite of yes

Gerry Ruecker is a self-educated Regina artist working in mixed-media sculpture and photography. His work has been exhibited in galleries in Regina and western Canada, and is included in collections throughout Canada and the world.

Photos by Gerry Ruecker.

SI ... affirmative pole — yes

S ... the sound of fire

43

Wild in the City: The Prairie Garden at the Royal Saskatchewan Museum

by Ken Wilson

Top right: The Prairie Garden, Royal Saskatchewan Museum. Photo by Don Hall.

Flower detail above, from top to bottom: prairie coneflower; aster; seed cluster of long-fruited anemone; inset, right: rhomic-leaved sunflower. Photos by Ken Wilson.

Ken Wilson is a teacher and writer in Regina. His native-plant garden was included in the 2005 Secret Garden Tour.

When I moved to Regina eight years ago, I wondered what the land looked like before it became fields of wheat and flax and canola. The city itself provides few clues. While the tree-filled parks in eastern cities echo the forests that once stood there, every tree in Regina was deliberately planted. People here are justifiably proud of the hundreds of thousands of trees that grace the city. But there are few echoes of the grassland, the prairie, that was once here. It's as if that wilderness was too strange, too alien, for the people who settled here. It had to be excluded, its traces erased.

Except for a few small places, that is, where the prairie has been allowed to return. My favourite is the prairie garden on the southeast side of the Royal Saskatchewan Museum. In 1992, a group of volunteers convinced the Wascana Centre Authority to donate space for a prairie garden. They collected seed from a remnant prairie near the city, and in 1994 began planting seedlings. Volunteers from Nature Regina continue to care for the garden.

It's a beautiful place, partly because it's always changing. Beginning early in the spring, when prairie crocuses appear, new flowers bloom every week: golden bean, three-flowered avens, beardstongue, prairie coneflower, gaillardia, asters, goldenrod. Tall bluebunch wheat grass waves in the wind; the delicate flowers of blue grama grass dance below. In the winter, the flowers and grasses catch the snow and provide food for birds.

But the prairie garden is also a tiny piece of wilderness in the city. There's a sense of productive chaos here, so unlike the carefully manicured lawns elsewhere in Wascana Centre. I think it has a lot to tell us about the place we call home, if we care to listen.

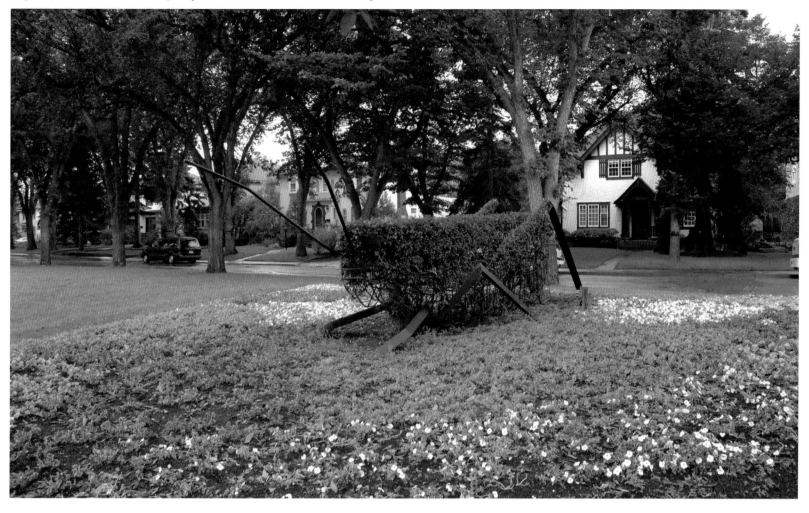

Reginald, the Great Big Grasshopper

by Wilf Perreault

Reginald, the Albert Street Grasshopper spells his name "Regina" with "ld" added: Reginald. (Regina Lawn Decoration).

I was a sculpture major at the University of Saskatchewan and, sometime after moving to Regina, was commissioned by the Dunlop Art Gallery (through the City of Regina Horticulturist, Ken Beattie) to make a flower bed design for an outdoor exhibition for Victoria Park. Reginald was made from Rebar and angle iron fabricated by City workers from my design. He was originally filled with earth and covered with sod, a "grass" hopper.

Following the exhibition, Reginald moved to the Les Sherman Park at the Balkwill Centre. He then moved to his home on the corner of Albert Street and Leopold Crescent, just south of College Avenue, where he has lived ever since.

Changes have taken place for Reginald over the years. Today he is filled with Manchurian Elm instead of sod; this way he can be kept trimmed, and he needs less water. I visit Reginald every year at Christmas time, when my family, with friends, decorate him with thousands of lights.

Born in Albertville, Saskatchewan, in 1947, Wilf Perreault grew up in Saskatoon, where he graduated from the University of Saskatchewan with B.A. (Honours) and B.Ed. degrees. Wilf is known as an artist of sculpture, canvas and paper.

Cathedral of Silence

by Heather Hodgson

East side of Albert Street, just north of College Avenue. Photos by Don Hall.

A port in a storm. A sanctuary. These are the consolations of the cave. Reminders that space can fuel the imagination and become poetry.

Albert Street is one of the major north-south arteries of our city. During the work week it bustles with people and cars. Frantic. Busy.

Yet in the midst of the noise and the traffic and directly adjacent to it, we find this secret of calm: a quiet nest for dreaming. The most ephemeral glance can erect a shelter in our busy minds for imagining.

Alleys have an ancient grace. They are the oft-forgotten vestiges of a former and slower rural life. They are the fissures and edges of our existence that refuse to pick up the pace of the urban spaces where we live.

Mere images of these spaces — by virtue of the solitude they promise — enable us to imagine the possibility of withdrawing into ourselves. They are symbols of the solitude that nourishes us.

In *The Poetics of Space*, Gaston Bachelard asks how such places can be endowed in our intimate daydreaming with virtues that have no objective foundation? But "Storms," he reminds us, "make sense of [these] shelters that provide intimacy in immensity." The almost palpable solitude in the image of this alley — framed by the Investors' Group building and facing west onto the busy traffic of Albert Street near the corner of College Avenue — effects that intimacy and quietude in our thoughts. The image becomes a portal for our imagination, a refuge from the storm where we can take shelter and dream.

The image can also evoke memories of alleys from our childhood; it reminds us that there are still places we can step back into — and thus out of time — for a while.

The pleasure of the alley is an oft-forgotten secret in our culture as city dwellers. As the edges and arteries that surround the spaces we live in, they are so unimposing and discreet, we almost forget they're there.

Heather Hodgson lives a few blocks from the noise and traffic of College and Albert. She looks into this tranquil alley each time she passes by it but has decided never to enter it for fear it will destroy the allure.

Bachelard, Gaston. 1964. *The Poetics of Space*. New York: Orion Press.

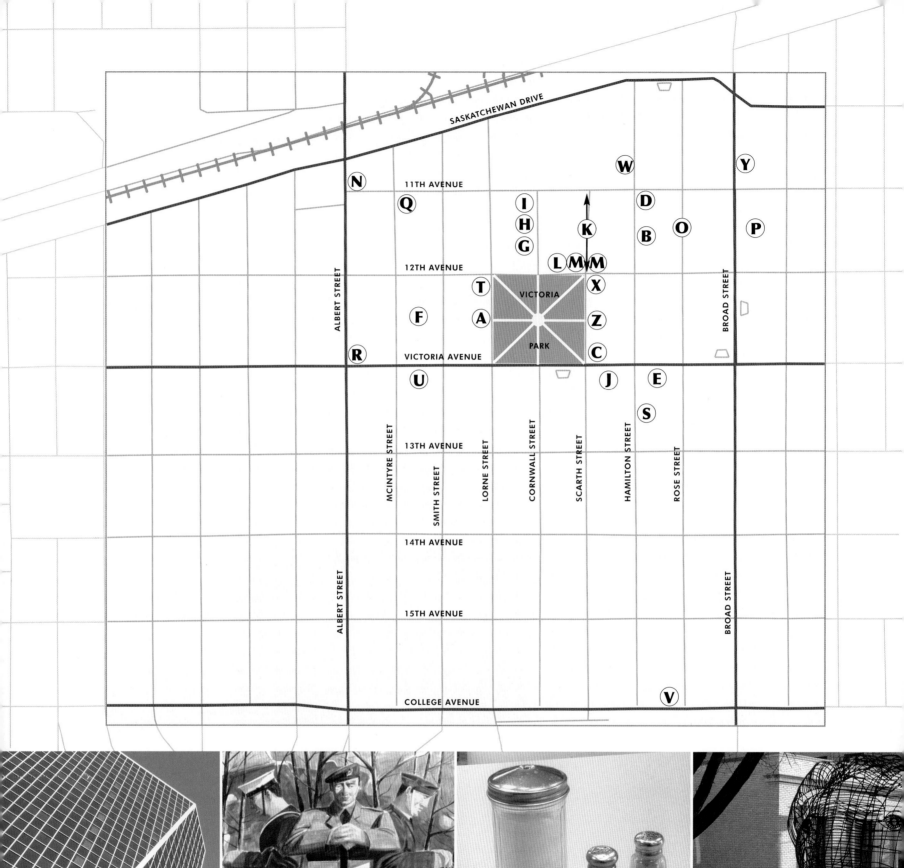

SASKATCHEWAN DRIVE

11TH AVENUE

12TH AVENUE

VICTORIA

PARK

VICTORIA AVENUE

13TH AVENUE

14TH AVENUE

15TH AVENUE

COLLEGE AVENUE

ALBERT STREET

ALBERT STREET

BROAD STREET

BROAD STREET

MCINTYRE STREET

SMITH STREET

LORNE STREET

CORNWALL STREET

SCARTH STREET

HAMILTON STREET

ROSE STREET

N Q W Y
I D P
H O
G B
K
L M M
T X
F A Z
R C
U J E
S
V

48

City Centre

In the image, engraved stone text reads:

THIS STONE WAS LAID
ON JULY 22ND A.L. 5926.
BY M.W.BRO.W.J.SMITH.G.M

"WHO DREAMS SHALL LIVE

Above: Masonic Grand Lodge, 1930 Lorne Streret.
Opposite page: Leader Building, 1853 Hamilton Street.
Photos by Don Hall.

Who Dreams Shall Live, But Who Works Makes the Dreams Live

by Elizabeth Raum

The inscription on the front of the Masonic Temple in Regina reads, "Who Dreams Shall Live." I've passed that inscription many times on my way to the Regina Public Library, and every time I see it, the thought crosses my mind that it's easy to dream, but much harder to make those dreams come true!

What makes a dream come true? I guess that depends on your dream. In 1990, I wrote an opera called *Eos: The Dream of Nicholas Flood Davin* based on the political career of Davin, who immigrated from Ireland in 1872 to Canada, where he worked as a journalist and a lawyer. In 1883 he came to Regina, founded the Regina *Leader*, the city's first newspaper, and soon after was elected the Conservative MP for West Assiniboia.

In my opera, Davin sings many times the words, "Who Dreams Shall Live," and one of his dreams was that the flat and desolate place in the middle of nowhere could one day become the thriving city that it is. This vision was a beginning, but there was something more profound in force. Hard work and tenacity were the major keys to this transformation, for after the dreaming comes the practicality, the struggle, and the teamwork necessary to build a city. These were skills possessed in abundance by the sodbusters, the immigrants, the tradespeople, the politicians, and the many others who came to Saskatchewan and made it what it is today.

Davin was also a writer and a poet, and I wonder if, when he looked at a blank page to begin to create something where there was nothing, the feeling might have been similar to that when he stared out over the treeless plain and imagined the great city that was to be. To use Davin's own words:

> *Standing here today as on a mount of vision, I look back and I see a land a decade ago, a wilderness. But today, I see thriving towns growing into cities, and in the future, I see a teeming population with great cities and markets, stately halls and temples, tall chimneys of industrial life, towered structures and domes of learning.*

All creation, whether a poem or a musical composition or a city, must begin from a place within, where vision, inspiration, and hard work are the building blocks of the achievement. "Who Dreams Shall Live" is a good place to start, but it's the work that follows which is often the reason many dreams never come to fruition. This work consists of layers and layers of organization, budgets, time tables, work orders, and recruitment, for while one person working alone can achieve much, in most cases he needs the help and cooperation of others.

It took much blood, sweat, and tears to turn the little wooden structure that used to be the Regina *Leader*, standing on the muddy streets of Regina, into the beautiful, modern building we now see at Park and Victoria. It's true that "Who Dreams Shall Live," but who dreams and then does the work shall make those dreams come true.

Elizabeth Raum is one of Canada's most well-known composers, having written operas, chamber pieces, vocal and choral works, several ballets, concerti and major orchestral works. Her opera, *Eos: The Dream of Nicholas Flood Davin*, was premiered in Regina in 1990 and produced again by the University of Regina in 2003 in celebration of the centennial of the City of Regina. She is included in the *New Grove's Dictionary of Music and Musicians*, the *New Grove's Dictionary of Opera*, and the *New Grove's Dictionary of Women Composers*.

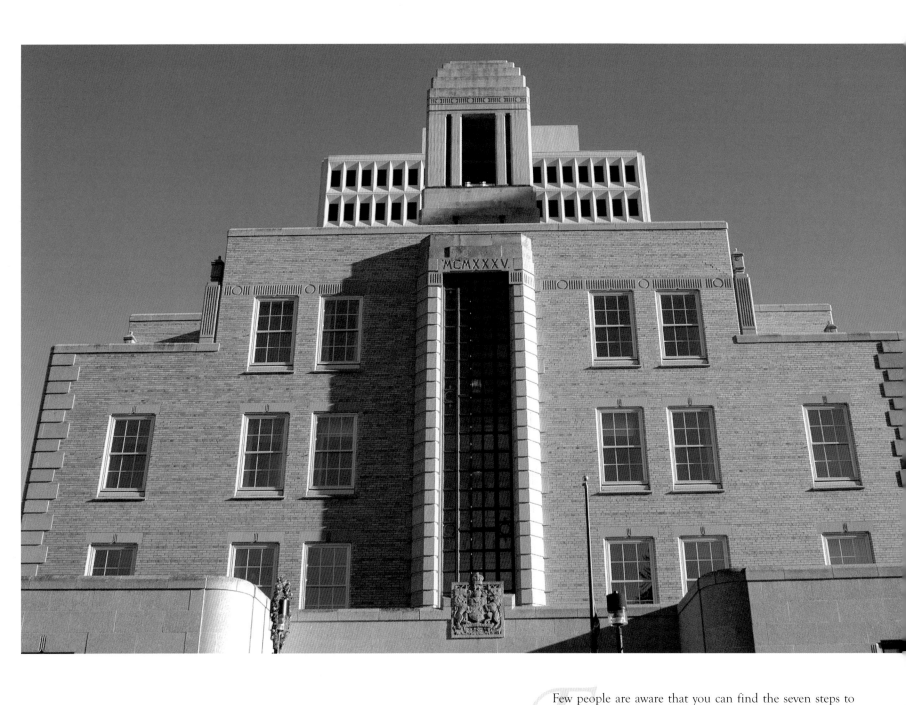

The Federal Building and the Temple

by Susan Birley

Few people are aware that you can find the seven steps to heaven in the centre of Regina. The initiated will tell you to examine the structure of the Federal Building, located on the northeast corner of Scarth Street and Victoria Avenue. The building's stepped façade, crowned by a temple, brings to mind the ziggurats of ancient Mesopotamia. These massive, stepped pyramids were constructed in the third millennium B.C.E. by the Babylonians, in an area known as the 'fertile crescent,' where agriculture first developed.

A ziggurat was usually built on seven levels, representing the seven planes of existence and the seven heavens, through which one was required to progress in order to attain enlightenment. Seven was a magical number in the ancient world and was integrated into art and architecture in many forms. If you look closely, you will find that the Federal Building also has seven levels, including the tower and the temple, possibly to reflect the ancient tradition of the ziggurat. The Sumerians called the ziggurat "Etemenanki," or the foundation of heaven and earth. The ziggurat was not a place of public worship. The temple was believed to be the home of the gods, and only the priesthood were allowed access. This, too, is echoed in the Federal Building: under current security policy, the public is not permitted entry beyond the lobby; only the priestly elite may enter.

The Mesopotamian temple atop the Federal Building may partly be understood as an element of Art Deco style, which is well represented in the Federal Building. Art Deco was the predominant style of the 1925 Paris Exposition, which focused on designs celebrating the new, modern world. It combined a stylized vision of the future, evoking the world of industry, machines, metal and Modernism, with adaptations of design elements from ancient cultures, such as those found in Egypt and Mesopotamia.

The building's stepped, streamlined profile, rounded corners, porthole windows (reminiscent of an ocean liner), and horizontal bands of decoration are all Art Deco features. The Art Deco elements of the building may be appreciated from the entrance on Scarth Street. The use of metal, such as the bronze decorative detailing around the doors and windows, provides a dark contrast to the light-coloured Tyndall stone. The large, ornate central door is guarded by two bronze lamp standards, with miniature lions at their base. The interior of the lobby also features bronze detailing on the staircase and the elevators. The central light well rises three floors above the entrance, with

fleurs-de-lis worked into the design of the window grille. The architect's signature, T.F. Portnall, may be found on the reverse of the federal coat of arms, mounted over the central doorway.

The Federal Building is located on the site of Louis Riel's trial. It is now a heritage property. It was constructed between 1935 and 1937, as a Depression-era relief project. The combined forces of the Depression and a decade-long drought during the 1930s destroyed hopes for what was to be a province with a projected population of twenty million. One wonders what the 'relief men' thought of the structure they were building, with its futuristic design, and extensive use of marble, bronze and decorative effects, such as a temple. It may have seemed a waste of government money, when their lives were blowing away in the dust.

Was the architect mindful of the contrast between the building's decorative fantasies, and the severity and deprivation of the surrounding environment? Is there some link between these two elements — ancient and modern — that the architect wanted to communicate through the building, some hidden symbolism that might be interpreted like a holy grail? Perhaps the Federal Building was designed to symbolize a province built on the promise of agriculture, but which was awaiting a golden future, based on the wonders of the machine and the industrialized world.

Opposite page: The Federal Building, northeast corner of Scarth Street and Victoria Avenue (with Avord Tower visible behind). Inset below: Oblique view. Photos by Don Hall.

Susan Birley has been seeking enlightenment on many levels including the exploration of the human past. She has worked as an archaeologist, museum consultant, oral historian, and heritage planner in British Columbia, Alberta and Saskatchewan.

Above: Hamilton Street, ca. 1946, Saskatchewan Archives Board RA-8135-2. Opposite: The Simpson's building just before it was demolished, 1981. Photo by Lucien Caron. Courtesy of the City of Regina Archives, C-2143.

End of the Line for Mrs. Mouse

by Gord Ames

The Simpson's department store at 11th and Hamilton was a part of every Christmas, its showcase windows wrapping around the corner filled with holiday displays. An annual highlight was the animated diorama of Santa's elves and woodland creatures involved in a variety of jolly seasonal activities — toymaking, caroling, and so on.

When I joined the Display Department staff there in August of 1979, one of the first tasks was to take one of the large red and black Simpson's delivery trucks and fetch those reindeer, squirrels and gnomes from their off-season repose in the Simpson's warehouse. Steve, the Department's handyman, explained as we drove that the figures were made in Germany and had spent their first season or two at the flagship store in Toronto. They then moved on to Montreal, Halifax, and London, until finally winding up in Regina.

At the warehouse, it was obvious that their journey had not been an easy one. They lay in an undignified heap, trailing heavy electrical cords, detached limbs arranged on top, under sheets of dust-covered plastic. It was now apparent why we were starting so far ahead of the season.

Back in the Department shop on the 4th floor, we surveyed the extent of the damage. A large grey mouse in poke bonnet and apron lay completely crushed at the back. A reddish squirrel in a Tyrolean hat, when plugged in, appeared to be having some sort of siezure, and most of the rest were at best shabby or inoperative.

In the following weeks, amid all the other day-to-day activities that so often seemed to involve riding the escalators with a manikin's torso and a staple gun, work proceeded on the repairs.

The figures operated by small electric motors, each of which moved metal rods against other rods or inside loops of thick wire. Many of these pieces were nearly worn away and had to be built up with solder.

I clearly recall Steve working on a near life-sized reindeer.... The head is off, and moist cloths protect the fur while he repairs its mechanism with the soldering gun. His eyes squint against the smoke curling up from inside the reindeer, and from the cigarette in the corner of his mouth....

The mechanical issues having been addressed, the fur and costumes were then repaired.

To arrange the displays, consideration had to be given to the various figures' good or bad sides, type of motion or activity. If Mr. Rabbit's only function is to repeatedly proffer a gift-wrapped box, then it is better if there is an appropriate recipient, preferably looking his way.

Two showcase windows on Hamilton Street were reserved for the diorama and their heavy drapes remained drawn during setup. At the start of the Christmas promotions, a Thursday evening I believe, the windows were opened to the street full of shoppers... *et voilà*!

Elf toymakers are hammering, sawing, and waving paintbrushes, overseen by a reindeer sipping from a wobbly teacup while a model train makes its way around heaps of gifts, past a squirrel in lederhosen, toward a large mouse wielding a broom, her bonnet and apron gleaming with fresh paint, her fur held tight with pins and hot glue, ready once again for showtime.

Just over one year later, the Regina Simpson's store sold off all stock and fixtures and the building was then demolished.

Gordon Ames has worked as a bookseller for over twenty years. He was co-owner of Toronto's This Ain't the Rosedale Library until the mid-1990s, subsequently opening Buzzword Books in the Cathedral district of Regina. He is pondering his next move.

The Assiniboia Club

by Garrett Wilson

Dating from 1882, the Assiniboia Club of Regina was the first of the private clubs established in the North-West Territories after that huge region became part of Canada in 1870, providing the landscape out of which the provinces of Saskatchewan and Alberta were carved in 1905. Pre-eminent among the elite lodges that dominated business, social and political life on the Canadian Plains during the nineteenth and most of the twentieth century, the Assiniboia Club has a rich and fascinating history.

They were called private clubs, but they were bastions of male socio-economic privilege, anachronisms today, but created in a time when women were denied full access to life. The Assiniboia Club building at 1925 Victoria Avenue, designed by Storey & Van Egmond, the city's foremost architects, was constructed in 1912 (four years before women secured the vote in Saskatchewan) and provided for them a separate and restricted entry that appears entirely offensive today.

A sidewalk led from the front entrance around to a door on the west side through which female guests of members were permitted to enter "the ladies' section," consisting of a cloakroom/washroom/lounge and a modest dining room. Lady guests were not welcome even in the main floor rotunda, and certainly not in the main dining room or the lounge, and definitely not in the second floor billiard and card rooms or the reading room, well-stocked with newspapers and periodicals. The third floor consisted of living quarters for a few members who were boarding, one bedroom maintained for non-resident or transient members while in the city.

A dismal place for a twelve-year-old boy, but there in the 1940s I once overnighted, parked in the spare room on arrangements made by my father, a non-resident member of long standing, concerned about the sin I might be exposed to in a downtown hotel. A mouse appeared, providing welcome diversion as I tried to capture it, causing something of a scuffle. An imperious knock came on the door. I stiffened, sure that I had earned a reprimand. My neighbour in the next room introduced himself, G. C. Rooke, of the Rooke Thomas accounting firm. He had been unaware that he had company and would I give him the pleasure of joining him in a nightcap. Partially in shock and too witless to decline, I followed dutifully. Mr. Rooke poured two dollops of scotch, a splash of water, and wished me good health. I had never tasted alcohol but found the taste less unpleasant than expected as I tried my best to keep up with a fully adult discussion on post-war Europe. Our drinks finished, my host thanked me and I toddled back to my bed, where I slept like a rock.

The Assiniboia Club prospered in an era when it was socially acceptable for men to leave their wives and families for an evening of male companionship at "the club."

During those years the Assiniboia Club was the center of Regina's social, business and political life and often the unofficial seat of Saskatchewan's government. MLAs were granted club privileges during the sittings of the Legislature, and lively political discussion was standard fare.

Swiftly changing social mores found the Assiniboia Club struggling to keep apace. Not until 1972 were women guests allowed into the main dining room and lounge; full membership became available only in the late 1980s.

The Assiniboia Club fell into financial distress and today occupies only a portion of the building it formerly owned. The separate ladies' entrance has been bricked over but remains easily visible, an archeological vestige of a much earlier time.

Lawyer/author Garrett Wilson is a passionate son of Saskatchewan. Born and raised in a small southern town during the dustbowl years, he practised law in Regina for more than half a century. The Assiniboia Club was the Regina home of the Wilson Family. Garrett's forthcoming book is *The Tumultuous Times*, an historical account of the Prairies' first years as part of Canada.

The City of Regina Cafeteria:

Birthplace of the Regina Liver Lovers' Luncheon Club

by Heather Hodgson

This is where it all began. In 1984, two friends — Gord Gault and Sue Oakley — would meet here on Thursdays for liver. Within two years their tradition was not only established, but others had joined them. Suddenly "Liver Lovers" constituted something unique and worthy of official status in the world and, to mark that, Gord Gault's mother designed and made badges for the inaugural members. Her "limited edition" badge was made of felt and consisted of a red plate on a pink place mat with LLC in black for "Liver Lovers' Club." The (empty) plate held a knife and fork. The badge was a very fitting symbol indeed and is now regarded as an important historical artifact of the origin of the club, not only admired by latter day Liver Lovers, but coveted.

The group decided it needed a song — not that they were at all short on revelry — but they wanted a catchy tune that members could sing at meals to celebrate their love of liver, thereby sharing their joy with unsuspecting others around them. Hence, The Liver Lovers' Anthem was born! As years went by, more verses were added. Today the song is so long (and so hilarious) that song sheets are distributed at meals so members don't forget the words!

In 1987 Liver Lovers went global. A Polish exchange student named Yanis joined the club and, to mark the expansion, the club renamed itself the "International Liver Lovers' Luncheon Club." In fact, the membership had been steadily increasing throughout the 1980s, and for a part of that decade, buses were chartered to get the lovers from the Sask Power building (where most of them worked at the time) to various restaurants around the city. These trips are now legend. Tales of buses full of happy, hungry people, raucously singing the Liver Lovers' Anthem to and from that day's eating establishment, abound!

Liver aficionados are a discerning lot; they know their liver. So in the interests of liver improvement throughout Regina, and for the general nourishment of the public good, the Liver Lovers started rating Regina restaurants in order to judge which served the best liver. A ranking sheet was soon developed and the hunt began in earnest. After each meal, the lovers attentively recorded comments and criticisms so that later their verdicts could be passed on to the chefs and restaurant proprietors for their benefit, edification and, no doubt, amusement!

Yet it was this modest City Hall cafeteria where it all began, this place which, back in 1984, bore witness to the genesis of Liver Lovers!

Since those early days, the lovers — being somewhat fickle — have strayed. They found other good places to eat liver in Regina. Thus far, the list includes Nicky's Café, the Hotel Saskatchewan, Bartleby's, Golf's Steak House, The Keg, Greko's, The Harvest, The Brass Lantern, The United Services Institute, Tomas Cook's, Topps, The Assiniboine Club, and Peter's (a.k.a. the CBC cafeteria). Other restaurants are bound to be added as the lovers continue their quest for the beloved delicacy. In order to entice new members, the group also has a website.*

Liver Lovers have had ample coverage by the media. They've been on CBC radio and television, and have been written about in the *Toronto Star* and *The Prairie Dog*.

They hold dinners as well as luncheons, depending on the occasion. The largest gathering was a luncheon when 52 people met at Nicky's Café in the late 1980s. And being lovers, of course, means there is an annual Valentine's Day Liver Lovers' meal!

To mark the 100th anniversary of the Province of Saskatchewan in 2005, the Liver Lovers met at the Lakeshore Steakhouse for an evening gala dinner! New badges were distributed in the presence of the original founding members, Sue Oakley and Gordon Gault. After a toast — to 100 Years of Heart (and liver) — the members sat down and thoroughly enjoyed their liver!

Facing page: City Hall Cafeteria. Photo by Don Hall.

* http://stedwill.sasktelwebsite.net/liver.html

Heather Hodgson acquired a taste for liver when she was a young girl in Quebec. She thanks her chef-trained father, Bill Hodgson (who cooks it to perfection), for nourishing his family's taste for this oft-maligned organ food. Heather joined Liver Lovers International in 2002 after being invited to a meal by Joan Roy, one of more than fifty Liver Lovers in Regina.

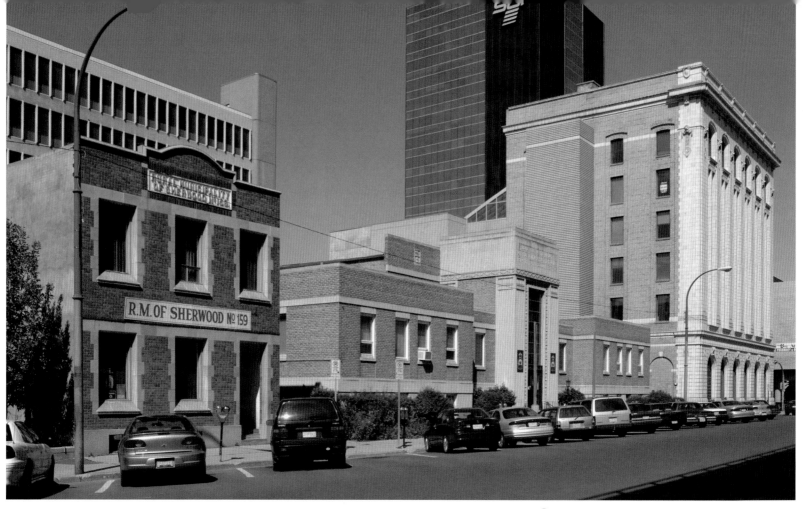

Right to left: Canada Life Assurance building; Royal Canadian Legion Hall; R.M. of Sherwood building. Photo by Don Hall.

Three buildings on the 1800 block of Cornwall Street – in the centre of Regina

by Don Hall

The work of Saskatchewan-born photographer Don Hall has been exhibited across North America and is in public and private collections. He is the manager of the Photography Department and instructor of photography at the University of Regina.

The Canada Life Assurance Building: a Provincial Heritage Property, constructed 1912–1914, second tallest building in Regina when it was completed. The terra cotta façade reflected a confident, prosperous future for the city and province.

The Royal Canadian Legion Memorial Hall: a Municipal Heritage Property, built in the early 1950s, a bold monument to veterans, with elements of Classicism in its styling. Just inside the Tyndall stone entrance, the Kenneth Lochhead murals depict scenes of past conflicts.

The R.M. of Sherwood building: a typical small-town office building from the 1920s, found on main streets throughout the Prairies.

Three very distinct structures, each with its own personality, each a classic. They remind me of the rich architectural heritage that once existed in our city.

I make a point of visiting these old buildings whenever I am downtown.

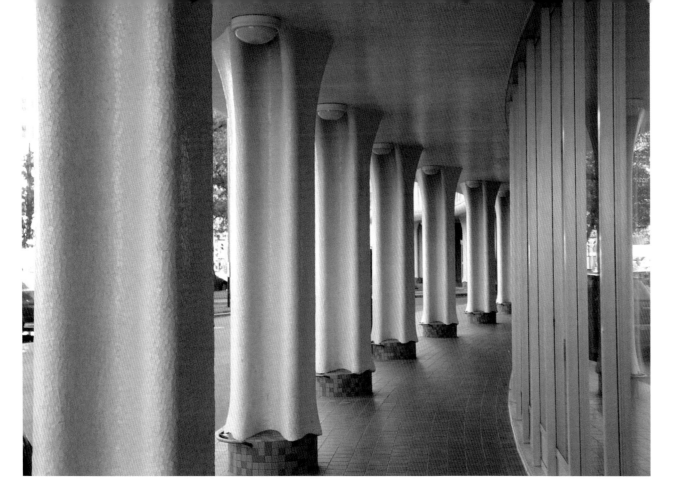

Photo by Bernard Flaman, Government of Saskatchewan.

Saskatchewan Power Corporation Headquarters

by Bernard Flaman

The experience is still vivid: it was an elementary school visit to Regina from Southey, and Miss Mang, my third grade teacher was there, which probably makes it May or June of 1968. We traveled into the city to see the RCMP Museum, the "Telorama" on the first floor of the Sask Tel building (telephones with television! I think it's now called the internet) and the observation deck on the 13th floor of the Saskatchewan Power Corporation Headquarters. It seemed so glamorous, going to the top of a tall building to look out over the biggest city that I had ever experienced in my young life.

Completed in the fall of 1963 and designed by architect Joseph Pettick, the Power building was and still is one of the most avant-garde buildings in the province. It combined design elements from Brazilian modernism with regional materials and motifs, including a wheat-colored local brick and a ceiling system called "prairie ice" meant to evoke the frost of a Saskatchewan winter. The gentle curve of the front façade, one of the most distinctive and memorable features of the building, also orients it toward Victoria Park in a beautiful and very sensitive way. Now, as buildings from the '50s and early '60s are starting to be assessed for their heritage value, I had the great pleasure to present the Saskatchewan Power Corporation headquarters at an international conference on modernist architecture held in New York in the fall of 2004.

I remember being packed into the elevator with the rest of my classmates, emerging on the top floor and seeing the icicle ceiling. Even at the age seven, I wanted to be an architect, and this experience confirmed it.

Raised on a farm near Southey, Bernie Flaman joined Culture, Youth and Recreation in 2003 as Heritage Architect for the Province of Saskatchewan. He has presented papers at international conferences on the design of the Saskatchewan Power Corporation headquarters in Regina and the development of Canadian airport terminals in the 1960s.

The Royal Canadian Legion Mural

by Erik Norbraten

I discovered the Legion mural while designing the catalogue for Kenneth Lochhead's retrospective *Garden of Light* at the MacKenzie Art Gallery in 2005. I must admit I had a preconceived notion of Lochhead's work before starting the project. Publications generally include work from his early surrealist period (1954's "The Bonspiel") or one of his famous colour field paintings from his "Regina Five" years (1963's "Dark Green Centre"), but seeing the images from his whole career was an eye opener! Most artists find a style or subject and follow it for a career, but not Lochhead. His work bounced between representation and abstraction with ease. The diversity and eclectic nature of his work was inspiring!

In the 1950s, Lochhead completed two major mural commissions: one for the airport in Gander, Newfoundland, and one for the Royal Canadian Legion branch in Regina. The Legion mural consists of 14' x 10' panels spanning eight walls. Painted in an expressive, representational style, the dense, colourful, and lively compositions chronicle the Riel Rebellion, the Boer War, the two World Wars, and the Korean Conflict. The mural is a major artistic achievement and fitting tribute. With Lochhead's importance in the local and national art community, why isn't this mural more well-known? Is it because it doesn't fit neatly into the Regina Five section of Canadian art books or because it is inaccessible to the general public? Whatever the reason, the Legion mural is a first-rate work by one of Canada's finest artists.

Ken Lochhead, Regina Legion Mural, 1955–1956, egg tempera on panel, 14 x 10 ft. Collection of the Royal Canadian Legion. Photos by Don Hall.

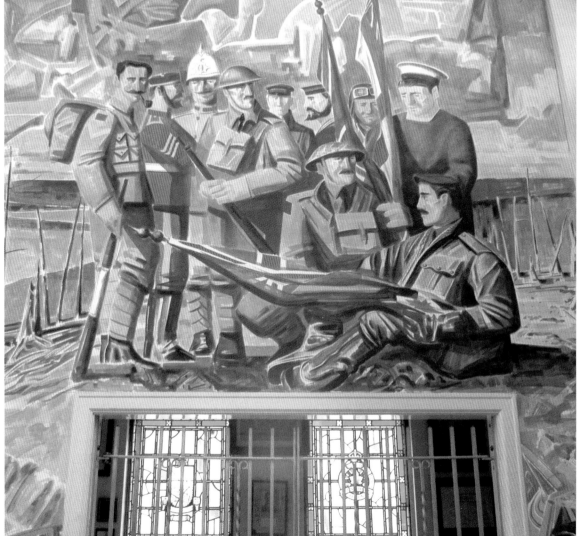

Erik Norbraten is a graphic designer and visual artist who was born and raised in Regina. A graduate of the University of Regina and the Nova Scotia College of Art and Design, he presently works as an Art Director in the Regina office of Brown Communications Group.

Ken Lochhead died on July 15, 2006.

Top: *Regina, New Mexico. Centre and bottom: Scarth Street Mall.*
Photos by Dennis J. Evans.

Q. Is there a Regina, New Mexico?
A. Yes.

Q. Have I ever experienced syncope in Regina?
A. No, well maybe.

Q. Is Nirvana obtainable in Regina?
A. Of course.

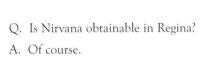

Regina-related Questions and Answers

by Dennis J. Evans

Dennis J. Evans has recently circumambulated Mt. Kailash in Western Tibet to photograph the tangibility of light and form and space (ethereal tangibles). He has done several projects with Boreal Art/Nature, La Minerve, PQ. His recently completed straw bale observatory at Flying Creek Valley near Craven is further research to observe and photograph light, its quality, movement and reflection. He is head of the sculpture program at the University of Regina.

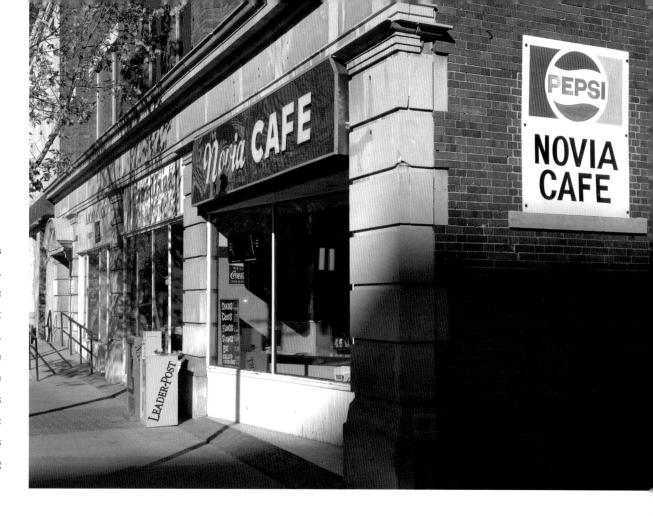

Novia Cafe, 2158 12th Avenue. Photo by Don Hall.

All over Regina, in cafés, we sit across tables from one another leaning forward, engaged, mostly; or sometimes one person sits back in a chair, firmly. This is when talk is about separating. We've been here in earlier days, planning a future, a new job, a move away from the city, even marriage. And we may return, for reunions and reconciliations. Cafés in Regina today, and others, long gone, the La Salle Hotel Café, Gene's and Waldo's, places for traversing highs and lows, places offering space for talk of change, and continuity.

Other Man (in the Novia Cafe)

by Anne Campbell

"Other Man (in the Novia Cafe)" from *No Memory of a Move* (Longspoon, 1983). Reprinted with permission.

I reach for you
 more tentative than I was
 with that first man
want to touch
 across a table in the Novia Cafe
but instead we sit
 talk
hear a man call a friend on a phone
 when he leaves
 we go on talking
while a Chinese waitress
 sweeping the floor
closes one section
 after another

Anne Campbell's published works include four collections of poetry, many poems and stories in anthologies and journals, and musical compositions with composer Tom Schudel.

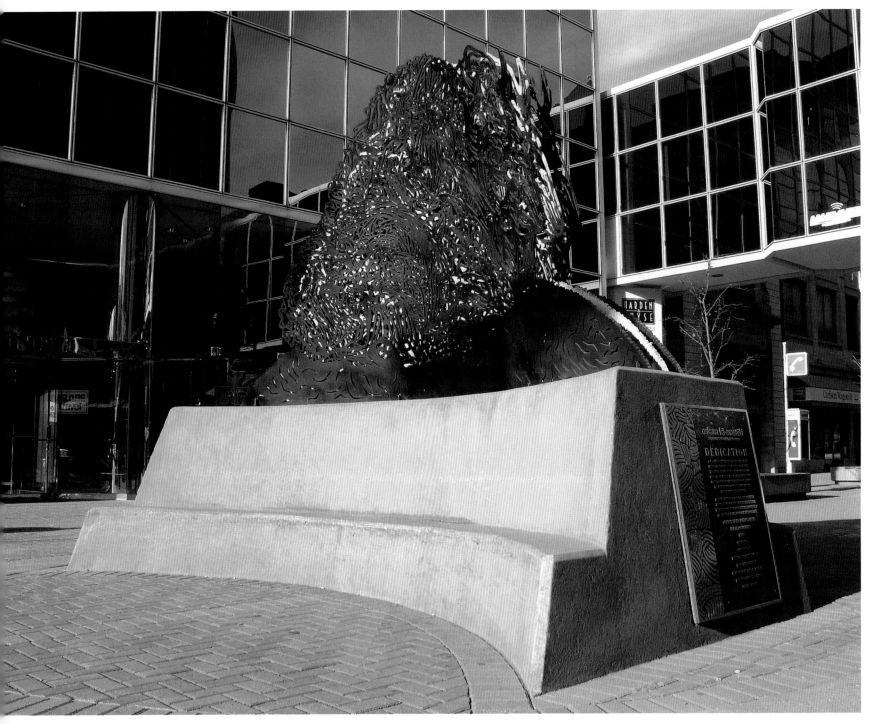

Joe Fafard, "oskana kâ-asastêki," 1998. Photo by Don Hall.

Skeletons in Regina's Closet?

by Greg Beatty

When Regina was first settled in 1882, it was known as "Wascana" (a corruption of the Cree word "oskana" which means "Pile of Bones"). The name was coined by Captain Palliser in reference to a spot near what is now Wascana Creek, where during his 1857–60 expedition exploring western Canada he found a pile of buffalo bones approximately two metres high and twelve metres in diameter. When Regina was subsequently established on the creek, the appellation was attached to the community, until supplanted by its current name. But "Pile of Bones" remains an important part of the city's heritage, finding its quaintest expression in the annual "Pile o' Bones" picnic preceding the Buffalo Days Fair.

In December 1997, noted Saskatchewan sculptor Joe Fafard was commissioned by a downtown business group and several civic agencies and private corporations to erect a sculpture on the Scarth Street Mall (now the F.W. Hill Mall). The following June, "oskana kâ-asastêki" (Cree for "the place of burnt bones") was unveiled by then prime minister Jean Chretien. The sculpture, made of stainless steel and consisting of a stylized representation of a bison rising from a pile of bones, was meant to honour Regina's past history as a First Nations' buffalo kill-site.

From the outset, the sculpture attracted criticism from some in the Aboriginal community, who argued that Fafard, as an artist of Euro-Canadian ancestry, was insufficiently versed in First Nations' history and culture to appreciate the significance of the buffalo, both economically and spiritually, to Aboriginal people. Thus, they regarded the sculpture as an inappropriate infringement on their history and culture.

Coincidentally, Saskatchewan Metis artist Edward Poitras had been conducting research into the origins of the "Pile of Bones" story. "I'd always wondered about the link between Regina and 'Pile of Bones'," Poitras said in a 1998 interview. "It didn't make sense to me why First Nations people involved in the buffalo hunt would camp in such a desolate spot." One piece of information he uncovered was a transcript in a 1916 issue of the *Regina Morning Leader* of a speech given by Father Joseph Hugonard to the local branch of the Canadian Club. In discussing "Pile of Bones," Hugonard, who had emigrated to Canada from France in 1874 and later founded the Lebret Indian Residential School, noted that the actual site was located where "the trail crossed the creek."

Upon investigating Hugonard's statement further, Poitras found a North West Mounted Police map that showed the Fort Qu'Appelle/Wood Mountain cart trail crossing Wascana Creek twelve kilometres northwest of Regina near Sherwood Forest, a site that offered a ready supply of wood and water, making it much more conducive to camping than the open plains around Regina.

That's not all Poitras discovered. In his speech, Hugonard also noted that while many of the bones in the pile Palliser found were buffalo bones, "many were human, and I have been told these were piled together by survivors, some years after a band of Indians had been decimated by an epidemic of small pox."[1] In the four centuries it took Europeans to conquer/settle the New World, such epidemics were common. Death rates in infected Aboriginal communities reached 75 percent, while survivors, who were often blinded and disfigured, were left in a state of abject despair. Poitras suspected the remains mentioned by Hugonard were from a smallpox epidemic that struck the Assiniboine in 1837–38, and that the bones were piled on the trail by survivors as a barricade to discourage its further use by Metis buffalo hunters who were encroaching on Assiniboine territory.

If true, this information casts a long-standing piece of relatively benign Regina folklore in a much more sinister light. While the virtual extinction of the buffalo through over-hunting in the mid-nineteenth century was, from an Aboriginal perspective, an historical tragedy, the thought that the presence of human remains in a large pile of buffalo bones could have been so cavalierly dismissed by both Palliser and the European settlers who began arriving in the region shortly after, is truly disturbing.

Gregory Beatty is a Regina-based freelance writer and contributing editor for *Prairie Dog* magazine who specializes in covering the arts and culture scene— although he's also written on such diverse topics as STDs, curling, creationism vs. evolution, and cycling.

1 *Regina Leader*, May 27, 1916, p. 3.

Regina's Technological Sublime

by Lorne Beug

Lorne Beug first established a reputation as part of the Regina Clay scene in the 1970s. Since then he has produced mixed media sculptures and architectural photocollages. His many commissions include a ceramic mural at the Regina Fieldhouse, floors at the University of Regina Riddell Centre and Residence Buildings, and, most recently, the bar at the Cathedral Village Freehouse.

I have observed and photographed Regina's Twin Towers since their construction in the early 1980s, in different seasons and light conditions, just as Monet studied his haystack, and have always felt ambivalent about them. They do have a certain grandeur and majesty, a mutability in light, and they have become successful in creating a landmark image for the downtown. Their lineage is that of the glass architecture first envisioned by the German Expressionist architects working around the 1920s, who were particularly inspired by faceted, crystalline forms. Probably the most visionary of them was Bruno Taut, who

proposed unbuilt schemes for cutting off the tops of mountains, smelting the rock into glass and then building artificial prismatic glass peaks in their place. Echoes of this style can be seen in the rotunda of the National Gallery in Ottawa and right here in Regina in the McCallum Hill Towers (now officially called Hill Centre Towers I & II).

On the other hand, the towers have for me an ominous air, especially close-up; from the pedestrian point of view, the massive points of leaden blue glass seem to hang like guillotine blades ready to drop. In this respect they seem, like the palace and garden complex at Versailles,

to be in the long line of architecture as instrument of power and domination.

Although local architectural firms were involved in the construction, the "marquee" architects were Skidmore Owings & Merill (SOM), probably the biggest architectural firm on the planet, headquartered in New York City with fifty offices in countries around the world. It seems that SOM was contracted to give Regina a globally generic, instant landmark.[1] The towers appear as if they were parachuted into Regina, or precipitated from the ether, rather than evolved from our landscape and culture. It's as though they were extruded by the metre, Regina ordering, say, 100 metres of tower, another metropolis maybe requesting 250.

In researching the towers, I thought it would be interesting to see what SOM's website had to say about them. Their site is vast, with its own powerful search engine. When I typed in "McCallum Hill Towers" I received no response; entering the word "Regina" into the site produced the same result: "zero items match the keyword"!

And what are we to make of the fact that there are two towers, mirror images of themselves? Without entering into some postmodern "Fun-House" of theory, it does seem to reinforce the notion of power – "they" can make as many of these buildings as they want, or rotate them, or "flip horizontally" as if by the touch of a button in a Photoshop program.

These towers seem to be prime examples of the Technological Sublime. The Technological Sublime is not exactly a style but more an elusive, pervasive cultural condition, such as surrealism and postmodernism have become. It is related to the eighteenth-century concept of the Romantic Sublime – feelings of awe and dread before the overpowering forces of nature. A succinct definition of this contemporary variant of the Sublime is provided by the writer Joseph Tabbi, who describes simultaneous impulses of attraction and repulsion in the face of "... corporate forces and technological systems beyond the capacity of a

Facing page: Hill Centre Towers I and II; above: construction in Regina's Big Box "Power Centre" southeast of Victoria Avenue and Fleet Street. Photos by Don Hall.

single human mind to comprehend."[2] Besides corporate architecture, the global transportation system and the invisible, incomprehensible workings of the digital world may evoke these contradictory feelings.

I also see glimpses and echoes of the Technological Sublime in the commercial development taking place southeast of Victoria and Fleet streets, Regina's Big Box "Power Centre." In a striking parallel to the artifice of the public Wascana Park, the land is being boldly reshaped again, this time privately, to create an artificial, meandering waterway designed to maximize views for chain stores, condos and malls with enticing names like Riverbend and Riverview.

I feel an equivocal fascination with how this development came into existence, springing up, as it has, like a giant Fairy Ring overnight on a summer lawn. There is promise, and perhaps escape, offered here, but once there, disorientation and depersonalization quickly set in.[3] Invisibly underlying it all, as behind the McCallum Hill Towers, seem to be the massive power lines of transnationalism and technology, erupting here on this patch of prairie, creating a veritable museum of generica.[4]

This is a bizarre landscape, a sharply defined edge where grain fields and tumbleweeds give way to global capital and the Technological Sublime.

1 See the interview with Paul Hill in Brett Bell's film "Home Town," exhibited in *That's My Wonderful Town*, Mackenzie Art Gallery, 2003.

2 Tabbi, Joseph. 1995. *Postmodern Sublime: Technology and American Writing from Mailer to Cyberpunk*. Cornell University Press, 176.

3 For more on strange feelings in the East End, see Jen Hamilton, "Suggestions on How to Find Yourself the Last Remaining Human On Earth" on pages 204 and 205.

4 generica: "Generic America." Landscape features (such as strip malls, pre-fab housing, and streets named "Main") that are identical no matter what part of America you visit.

Saskatchewan Power Building, Regina, 1957–1963

by Joseph Pettick

Selection of architectural consultants for major public buildings is a sophisticated process these days. There is a routine Request for Proposals advertised by public bodies at civic, provincial and federal levels of government so that they can take most of the politics out of consultant selection. Proposals are evaluated by selection committees on the basis of recorded experience and past work.

In the time from the Second World War until the 1970s architectural consultants obtained work based on personal contacts with the "movers and shakers" in the business community and their financial support of political leaders who held the reins of power. Architects are governed by a code of ethics which does not permit them to advertise.

After ten years of apprenticeship and qualifying for entry into the Saskatchewan Association of Architects, I left the firm of my mentors because we could not agree on terms for my participation in a partnership. Although experience and money were not an issue, my heritage as a Hungarian and lack of social standing or political connections were cited as reasons to not include my name in the firm as part of a new partnership agreement. When I announced my intention to set up my own practice the idea was met with a very negative response. "If you do that we'll beat the pants off you."

One of my first projects was to design a small office building for a steel pipe manufacturing plant in Saskatchewan for an industrial client from Dortmund, Germany. It was a small building but, as construction began, the company organized a sod-turning ceremony, inviting a group of interested government contacts along with engineering consultants. I was pleased to attend.

During the reception I engaged in conversation with a distinguished white-haired businessman, spending most of the time talking about the work of the United Nations, then about music, art and sculpture. We seemed to be on the same wavelength on cultural and international matters.

As we were about to part, he asked about my name and work. I said I was an architect practicing in Regina, whereupon he responded, "I'm David Cass-Beggs and have come to Regina to head up the Saskatchewan Power Corporation. You know, we are thinking about construction of a new head office building so that we can consolidate our staff who are now in several locations in Regina."

I knew about the project because it was widely assumed that the firm I had just left was expected to be appointed to be the architects due to their political connections. It was rumoured to become the largest building project in the province.

Cass-Beggs and I met on several occasions at art shows and symphony concerts over the next few months and shared ideas about various art forms, touching only lightly on the work of architects. I assumed the actual selection of consultants would turn in the rumoured direction.

I then received a phone call requesting my attendance at the office of the power corporation manager to talk specifically about the new building project. The interview went very well. "I want a piece of architecture, a 360-degree artistic work which will represent the most advanced use of energy, plus a building form characterizing the strength of the corporation."

I found out later that David Cass-Beggs had arranged an in-depth background check on my work and experience. At the time I was only 32 years of age and I didn't hold out much hope of being selected to design and direct the construction of such a prestigious building.

A month later, at about 5:45 one evening, I received a telephone call. The voice said, "I thought you would still be at the office. It's David Cass-Beggs. On my recommendation the Provincial Cabinet has just voted on a motion to appoint you as Architectural Consultant for our

In practice for over fifty years in the province of Saskatchewan, Joseph Pettick (FRAIC, SAA, LLD, SOM) is responsible for the design of many landmark buildings in addition to Sask Power, including the Regina City Hall, the Saskatchewan Government Insurance Head Office Building, the Moose Jaw Civic Centre and the Treaty Four Governance Centre in Fort Qu'Appelle.

Photo by Joseph Pettick.

new head office building. I'm looking forward to working with you." I was momentarily speechless. When I regained my composure, the first words were, "I don't know how to express my gratitude. You have my pledge that we will do everything in our power to prove that your trust was not misplaced."

The process of design and construction was an exciting and rewarding experience involving the combined effort of client and all specialist consultants. Although the project became a political football, it was completed under budget and was favorably accepted by political leaders and citizens of the province. There is recent talk about designating the building as an Architectural Heritage Site.

Cass-Beggs was a visionary client who was active in establishing the National Power Grid. He became a close friend and remained so until the time of his death.

In the Heart of the Pink Capital

by Annie Gérin

Annie Gérin, formerly of the University of Regina, is a curator and associate professor of art history and art theory at the Université du Québec à Montréal. Educated in Canada, Russia and the UK, her research interests encompass the areas of Canadian public art, Soviet art and art on the World Wide Web. She is especially concerned with art encountered by non-specialized publics, outside the gallery space.

After the first election of the Co-operative Commonwealth Federation (the CCF) under the leadership of Tommy Douglas in 1944, an era of change swept over Saskatchewan, and particularly over its capital city, Regina.

The CCF pioneered reforms that made Saskatchewan society both progressive and prosperous. Indeed, the CCF gave birth to the Canadian universal hospitalization system and Medicare, to the Crown Corporation Act, and to Canada's first Arts Board. Although this government was strongly supported for the badly needed social welfare measures it ratified, it also brought to Saskatchewan a left-liberal, continentalist outlook in education and culture, measures that were taken up a few years later by the 1951 Massey Report as recommendations to improve and support Canadian culture throughout the

nation. This important shift made the province the focal point of much social and cultural debate across North America, especially during the McCarthy period, when many left-leaning Canadian and American intellectuals and artists were drawn to Regina, some being offered key jobs in the University or the Provincial administration.

In Regina, then a city of 125,000, a modernist vision of urban space (which assumes a rationalistic understanding of urban design intended to develop and engage with all aspects of society) served to buttress the social and cultural reforms and anchor Regina in its position as North America's first socialist capital, the "Pink Capital," as it was nicknamed by the *New York Times* in 1944.[1]

As a subsequent *New York Times* article stressed, however, a glaring inconsistency was originally perceived between the potential for progressive politics and the small scale and remote location of Regina.

In 1944 the people of Saskatchewan, an overwhelmingly agricultural province of Canada, elected a Socialist Legislature, and set up the only Socialist government in the Americas. This [is] in contradiction to the Marxist idea of Socialism as a 'proletarian' movement [...][2]

The image of Saskatchewan as an agrarian backwater was immediately contested by an urban renovation movement that literally brought modernism to the central core of Regina. Throughout the '50s, '60s and '70s a number of buildings that synthesized modernist trends and local materials (such as Claybank bricks and Tyndall Stone quarried in the prairies) rose from the ground of Regina's downtown: Saskpower, the Central Public Library, the Saskatchewan Courthouse and Regina's City Hall are some of the best expressions of this development. Public art also appeared at a frenetic pace, much of it pointing to international modernist trends, symbolically establishing the city center as on par with that of international capitals. Examples of such works include the Ken Lochhead mural in the Legion, the Clifford Weins Shriners Hall mural, or the whimsical topiary by Russell Yuristy, standing along the northern wall of the Central Public Library.

The importance of the city center cannot be overstated in a context where the centralization of economic activity and human resources were the foremost goal of the CCF administration. Indeed Regina represented itself in documentary films, photographic displays and television commercials as a modernist utopia colonized by stylish skyscrapers. It showcased modernist structures dominating the horizon and forming a dense knot jutting from the even prairie, a dynamic economic and cultural vortex revolving tightly within and around the central core of the city.

The city of Regina made its first appearance in Canadian art history – and more particularly in the history

1 *New York Times*, 22 February 1944: 28.

2 Lewis Corey, "The Farmers Went Left," *New York Times*, 25 February 1951: 28.

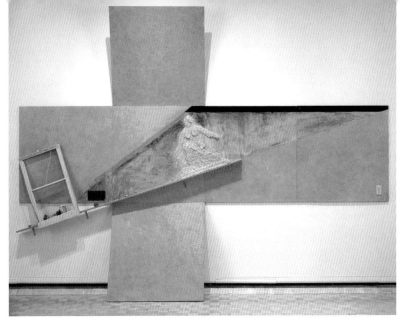

of modernism – during the same period, with an exhibition of large-scale abstract works by Ronald Bloore, Arthur McKay, Douglas Morton, Kenneth Lochhead and Ted Godwin, later to be known as the Regina Five. As the exhibition organised by the National Gallery toured across Canada in 1961 and 1962, the name of Regina increasingly became associated with progressive art trends as well as progressive politics.

For the first time in its rather short history, Regina's art scene transcended regional isolation to achieve a prominent standing within Canadian culture. Some of the artists involved in the Regina Five even attained international status after the American critic Clement Greenberg, invited to participate in the Emma Lake workshops in 1962, wrote a major article about prairie art in which he claimed that in terms of modernist art, Regina was New York's only true rival.[3] The attention that Regina's politics and culture warranted during these years served the purpose of renegotiating its status as a city on the margin of Canadian culture.

In 2003, Regina celebrated its first centenary. Appropriately, Regina's MacKenzie Art Gallery decided to celebrate the event by exploring current representations of the city in contemporary visual arts. The exhibition *That's My Wonderful Town*,[4] titled with reference to a decades-old CKCK-TV commercial that featured and celebrated the city,

opens with a monumental view of Regina's City Hall by David Thauberger. This work in which the slick modernist grid has espoused the subject matter of modernist architecture, presents an optimistic, almost utopian vision of the city. It celebrates the visual and symbolic pillar of Regina's downtown core and civic life.

But most of the other works included in *That's My Wonderful Town* propose a very different point of view. Theirs are dystopian visions, which evoke abandonment, alienation, and displacement. It seems, indeed, that in the view of many contemporary artists, Regina's modernist unifying center has dissolved.

In Edward Poitras's "Ledge," for example, the city represented as a modernist cube loosely unfolds as the pediment of the Legislature leans dangerously and the ornamental sculpture, symbol of the province's history, threatens to slide off, causing an irrecoverable loss of memory. In the photographic work titled "The Big Picture," also by Poitras, the no-longer-extant Café Utopia ironically stands in for the city. "The Big Picture" represents a ruin of sorts, an absence.

Wilf Perreault, who has built a career out of representing Regina, has turned his back completely on the symbols of Regina's modernity to paint suburban back alleys. The spatial orientation of the views represented here further suggest that the artist is looking north, south, east or

west, but always away from the downtown area. Works by Jeff Nachtigall, Brett Bell, Chris Gergley, Jeannie Mah, and others suggest similar feelings of disappointment and loss.

All these cultural and political concerns which also find their expression in the concrete spatial organisation of the city are concentrated in an installation work by Jen Hamilton. "Outskirts" consists of two large-scale photographs and an oversized extended table made of medium-density fiberboard.

The outskirts of Regina, as fixedly represented in the photographs shown, expose the frayed outlines of rapid development. This is a process that pushes the earth as a moraine ridge, slowly forcing back the smooth prairie landscape. This accumulation of gravel and dirt travels further every year as the exponential growth of the surface of the city (over 100 percent in 50 years) contradicts the modest population growth of 60,000 that has occurred since 1944. Regina's development is boundless in the absence of rivers, mountains or existing cities that might inhibit its expanding footprint.

For Hamilton, the table to which panels are constantly added suggests the coming together of people and communities in an awkward, organic growth of the city. But what is striking here is that, as the city limits skirt away from the center, the city fabric's unity becomes more and more tenuous. In other words, communities developing on the outskirts draw materials and resources from the communal downtown core to expand the city in ill-fitting segments that threaten to collapse. As the city extends, its own survival is compromised by the abandonment of its own core.

In Regina, civic expansion is promoted by a tax structure that favours the building of housing complexes, cultural and recreational outposts and large surface stores on the outskirts to the detriment of the now-decaying downtown, where vacancy rates are reaching new highs in spite of commercial and residential gentrification strategies developed by Regina Downtown (a non-profit business improvement organisation). This has nothing to do with practical imperatives. Indeed, the CCF believed it was prac-

tical to fund the creation of cultural capital in the city centre and hence foster a sense of shared ownership of space and collective identity. Regina now chooses a different kind of municipal self-representation. It promotes itself as one of the cheapest places in Canada for homeowners, a place where the urban sprawl proceeds at a frenetic pace without causing tax increases.

Regina, Hamilton shows us, is now at risk of becoming a suburb without a city. Having abandoned the path that built upon Tommy Douglas and CCF imagination, a city where centralization and the sharing of resources were the means to social and economic progress and well-being, Regina is becoming a place of margins on the margin.

There was certainly a dose of irony and sadness in the exhibition *That's My Wonderful Town*.[5] The pink capital, the art tells us, is losing its heart.

3 Clement Greenberg, "Clement Greenberg's View of Art on the Prairies," *Canadian Art* 84 (March-April 1963): 90-107.

4 September 20, 2003, to January 20, 2004, curated by Timothy Long.

5 The exhibition at the Mackenzie Art Gallery (and the writing of this text) sadly coincided with the collective efforts waged by Regina artists, intellectuals and citizens to save the Dunlop Art Gallery from closure. Regina's most central art venue, located in the Central Public Library, is dedicated to promoting contemporary art and visual literacy. Its downtown location has been an asset that has been instrumental to its mandate.

Friends of the Dunlop protest: "Ripping the Heart out of Regina," December 2003. Photo by Roy Antal.

Left: "Cubi XII" at David Smith's studio in Bolton Landing, N.Y. Photo by Joseph Pettick. Facing page: SaskPower building, still Smithless. Photo by Don Hall.

Smithless

by Mark Wihak

You see them as you wander through Regina, Russell Yuristy's "Rusty" by the central library, Kim Morgan's "Antsee" crawling over a tree in Victoria Park, "Reginald the Grasshopper" by Wilf Perreault on Albert Street, "Four Seasons" by Doug Bentham near the Centre of the Arts, Joe Fafard's "oskana kâ-asastêki" on Scarth Street and his "Le jardin de l'esprit" on the U of R campus just to the west of Lionel Peyachew's "Four Directions." These are some of Regina's public sculptures.

As you move through the city, you may also notice two triangular concrete platforms that frame the fountain in City Hall courtyard or a blank wedge of grass in front of the SaskPower building. These are some of Regina's monuments to caution.

When architect Joseph Pettick's design for Regina City Hall was approved, it included two sculptures to frame the courtyard fountain. After the triangular concrete sculpture platforms were put in place, city council withdrew the budget for the art work. Three decades on, the platforms still await their sculptures.

This was not Joe Pettick's first experience of public art falling victim to the counting of beans. His SaskPower building is the site of a legendary, lost opportunity to have a major piece of public art in the heart of the city.

In January 1963, the influential art critic Clement Greenberg wrote from New York to Ken Lochhead, head of Regina's College of Art, to tell him that "David Smith has told me he's willing to do an 18-foot piece for the SPC building at cost – because it's a socialist enterprise!"

David Smith, the subject of a 1957 retrospective at New York's Museum of Modern Art, was considered by many to be the most influential American sculptor of the twentieth century. Smith was to American sculpture what Jackson Pollock was to American painting – a big deal – and he, along with a number of prominent American artists of the period, knew about the political and cultural developments taking place in Saskatchewan.

A selection committee that included Lochhead and Pettick visited Smith's studio in Bolton Landing, New York, and chose "Cubi XII." A base was prepared for the

sculpture east of the fountain on Victoria Avenue, but the final arrangements were put on hold by SaskPower general manager David Cass-Beggs.

With the province going to the polls, Cass-Beggs was concerned that buying a large piece of American abstract sculpture — even from a major artist at a bargain price — might become an election issue. After the 1964 election of Ross Thatcher's Liberals, Cass-Beggs was relieved of his position at SaskPower. The arrangement for "Cubi XII" fell apart.

The following year, David Smith died in a car crash. "Cubi XII," which SaskPower could have purchased for $15,000, entered the collection of Washington's Hirshhorn Museum. In November 2005, a Smith sculpture from the same series, "Cubi XXVIII," set a record for post–World War II art, selling at auction for $23.8 million U.S.

Forty years after the squandered opportunity of "Cubi XII" and almost thirty years after the City Hall sculpture platforms were built, Regina finally acquired some New York–influenced "sculpture." Milton Glaser's 1976 logo, "I ♥ NY," was adapted as a marketing slogan for Regina and a metal structure (technically not a sculpture because that would have required the approval of the Regina Art Commission) was erected — though not on the sculpture platforms — in the courtyard of Regina City Hall.

Mark Wihak is a filmmaker and former SPC employee.

77

The Derrick

by Brett Bell

Brett Bell is a Regina-born-and-based filmmaker who has made several films since 1984. He graduated with a BFA from the University of Regina's Department of Film and Video (now Media Production & Studies) in 1990. When not making his own films, Brett has worked as a writer, director, composer, editor, and sound designer/editor on various film and television projects. His 2003 film, *Home Town*, is a serio-comic look at growing up in Regina.

My fascination with Regina's Derrick Building began with my mom taking me to her place of work, the radio studios of the Canadian Broadcasting Corporation, formerly on McIntyre Street. I remember the Derrick as being the huge, mysterious brown building across the street, five stories tall and filling half the block. Once or twice I snuck across the street to gape up the middle of the majestic front stairwell, and clap my hands to hear the long stony echoes.

One of Regina's few examples of unabashedly straightforward Modernist architecture, the Derrick was a crossroads for entities that built our physical and nationalistic infrastructures: it was constructed in 1955 for Imperial Oil's western Canadian headquarters, at a time when the energy industry had almost as much prominence in Saskatchewan as in Alberta. The Royal Canadian Mounted

Police had its "F" Division headquarters offices in the building for years, and the CBC had some of its offices there while awaiting completion of its new Broadcast Centre in 1983.

Dominion Bridge, the Department of National Health and Welfare, the Saskatchewan Construction Association and the Insurance Association of Canada all occupied space at one time or another. The Canadian Imperial Bank of Commerce had a branch in the building almost from the beginning. (A CIBC branch was located on McIntyre and 11th, with another branch located two blocks away at Vic and Albert! Remember the days when banks had branches within a couple of blocks of each other?)

However, due partly to the Regina office building construction boom of the mid-to-late 1980s, the building

was completely vacated by 1989. For more than ten years its only tenants were squatters and pigeons.

In the late 1990s there was talk of the Derrick being converted into a storage facility, as the cost to transform it into new office space was prohibitive, according to its owner at the time. Nor was additional office space needed, since commercial real estate vacancies in Regina were among the highest in Canada by decade's end.

But when it appeared the Derrick would be torn down, in 2004 it began its transformation into The Renaissance, a residential retirement complex. And with this transformation came the loss of its Modernist roots: with its newly added multiple architecture borrowings and bright fire-engine colours, it morphed from Modern to Postmodern practically overnight.

Internationally, there is a debate as to which examples of Modernist architecture are worth preserving, and which can slip away. In Regina, this debate appears to be a non-starter.

The Motherwell Building on Victoria Avenue is gradually being converted into condominium units, but still retains its Modernist foundations. The provincial government office building at 3211 Albert Street (often referred to, imaginatively enough, as "3211") had its Modernist skin peeled and a frosty blue glass facade slapped on in 2003, bringing it up to date with the year 1987. The Bay parkade — Regina's ersatz answer to Frank Lloyd Wright's Guggenheim Museum — met the wrecking ball in 2002, ironically replaced by a parking lot.[1]

The Renaissance — née The Derrick — is no longer empty, doomed to sit until its recovery became impossible: its new veneer may not be Modern, but to these eyes, it is not disagreeable. And preferable to yet another downtown parking lot.

Facing page: The Derrick Building, McIntyre Street at 11th Avenue.
This page: Interior of the Derrick, from Brett Bell's 2003 16-mm film, Home Town.

1 The Bay parkade's corkscrew driveway was shown off to great effect in Mark Wihak's tribute to Regina and punk rock, the film *The Ballad of Don Quinn* (1992). A long take follows two cyclists through a constant turn down the circular ramp.

Night Light: The Weather Tower of the Plains Hotel

by Gary Varro

Before I began writing this article about The Plains Hotel — well, it's really the tower on top of The Plains Hotel that is the main attraction — all I knew about the tower, and what I believe those that do know know, was what my father had explained to me about it as a child. It was a weather tower. This 'weather tower' — triangular in shape, tapering from the bottom to the top — is lit by bands of neon on each of its three sides in three colors, appearing in either green, orange, or blue, depending on the forecast. At one point

long ago, I knew what all the colors meant and what was in store weather-wise if the neon was moving up or down the tower.

The ability to look up at the tower and know what was 'forecast' weather-wise was quite thrilling for me at a young age, and made me feel like I had acquired an ability to 'see' what was yet to happen, if only in the case of weather. Of course, here in Saskatchewan, the weather is a powerful and much-discussed fact of life. The idea of being

able to know what lay ahead – a technologically assisted prediction of climatic conditions – was like a form of magic, a kind of crystal ball, in this case, in the form of colored gas know as neon. As a child, it was those neon colors – on a Friday or Saturday night, driving down Albert Street in the family station wagon with Mom and Dad and the three siblings – that really did make all the difference, and made weather watching all that more fun.

Now, in the course of doing some background research for this article – I thought what I had known and kept all these years as a fond childhood memory was good enough material – I discovered a few more interesting and perhaps secret facts that have given my nostalgia for the tower and this article a new and pleasant twist:

1) the tower was conceived as a service sign by Ted Godwin, better known as one of the Regina Five (the five Modernist painters that helped put Saskatchewan on the international art map in the 1960s);

2) in his earlier years Ted was a neon designer in Regina (the Ehrle Hotel sign at 11th Avenue and Osler Street also being one of his creations);

3) Ted proposed the idea for a tower to the Saskatchewan Wheat Pool in 1956 as a way to inform farmers of the coming days' weather as they drove home out of the city back to the farm;

4) his original plan had the tower at 350 feet high;

5) for some reason, the Wheat Pool decided not to go ahead with the structure;

6) the then owner of The Plains, however, agreed to have a 35-foot version installed on the top of the hotel at the corner of Albert Street and Victoria Avenue, right across from the Saskatchewan Wheat Pool building;

7) that was in 1962, the year the hotel was renovated and in the first year of my life.

So, The Plains hotel, or the original tower anyway, had a rural/urban association or relationship, was an idea put forth by one of Regina's better known and celebrated

artists, and continues to be a beacon of warning and reassurance in green, orange and blue for both farmers and city folk alike.

And as for the colours, here is what they mean:
- green: precipitation
- orange: unsettled
- blue: clear
- bands going up: the temperature is rising
- bands going down: the temperature is decreasing

Consequently, you can have green going up or green going down, or green staying steady, which means things are stable. The same applies to the other two colours.

And a few other historical facts about the hotel itself: It was originally called the Arlington House/Hotel. The House part was built in 1915 and the Hotel part in 1936. Regina lawyer E.W. Hinkson acquired the hotel in the 1930s. The hotel was demolished or burnt (depending who you talk to) and replaced with a new hotel in 1956 called The Plains. Frank Hinkson and Sons sold the hotel to former Saskatchewan Roughrider Larry Bird and partners in 1983, who in turn sold it in 2005.

I would like to thank Larry Bird and Ted Godwin for their time and assistance in writing this article and my father for explaining.

Opposite page: The Plains Hotel, Albert Street and Victoria Avenue, early morning. Above: daytime. Photos by Don Hall.

Gary Varro is a curator, visual artist and designer based in Regina and Toronto. In 1996 he established Queer City Cinema, the biennial international lesbian and gay media arts festival of Regina. Gary has also exhibited his installation artwork locally, provincially, and nationally, and has appeared in numerous performance artworks for the last fifteen years. In the film industry, Gary works as an art director and production designer, and is simultaneously the Director of Programming at Inside Out – Toronto Lesbian and Gay Film and Video Festival, and Queer City Cinema.

Of Reputations and Memories

by Ellen Moffat

Ellen Moffat is an installation artist and mobile cultural contract worker whose production explores notions of time, place and voice. She has been involved with public art, media and off-site events and has completed residencies with public galleries, artist-run centres and rural communities across the country. She lived in Regina from 1992-95.

"Wha'dya want go there for?"

"You might get knifed or something."

"You'll be lucky to get out alive!"

Such is the notoriety of the Plains Hotel, watering hole to bikers, lawyers, construction workers, veterans, writers, musicians, dancers, dealers, "deaders," civil servants, roadies, artists and others. An oasis for the thirsty located in the downtown core, the Plains was central. It also provided an alternative to mainstream bars and middle-class conversations: it was a place to escape to, un-reformable in its reputation and clientele despite attempts by its management to bar bikers from wearing their colours or to redecorate its interior with the hope of attracting a "higher calibre" of clientele, or the occasional raid from the police in search of drugs and dealers. Perhaps its reputation and its resistance to change enhanced its appeal. Milton Acorn might have spent time there, or Nelson Algren.

It is not to romanticize the margins. Rather, it is to acknowledge the role of that bar as a social hub for the arts community of Regina. For starters, it welcomed outsiders, warmly. Perhaps for a reason: newcomers provided new ears for old stories. And Regina has plenty of stories and storytellers.

I met Art McKay and Emily Givner at the Plains in 1992 and from them heard numerous chapters of local history, some of the stories a gold mine of fact, lore and myth: the Regina Five, Emma Lake – Clement Greenberg, John Cage's mushroom experience and getting lost, the letter of invitation to Picasso – early LSD experiments in Saskatchewan, Art's failed attempt to steal an airplane from the Moose Jaw Air Force Base, modernist aesthetics and literary theory. At the time, Art was no longer active as a painter and his physical health was deteriorating, but his mind and memory were sharp. Emily was an emerging writer, producing short stories, but getting limited recognition. I would often see her in coffee shops, table by the window, huddled over her manuscript, interchanging cigarette with coffee, lost within her preoccupation. Always intense and high-spirited, her curiosity was anxious. Art was kind of a mentor to Emily, his age and experience complemented

Art McKay (1926–2000) and Emily Givner (1966–2004).
Photos by James Tumblin.

her energy and creativity. They remained close even after both had left Regina, one to move to Vancouver, the other to Halifax. Both Art and Emily are dead now, Art after an extended period of poor health, Emily suddenly and unexpectedly due to a food allergy. Death is often untimely, but crueler when the person is young and in the prime of her life. Emily was beginning to reach her stride as a writer and her work was being published. Her death came much too soon.

These storytellers are gone, but not the stories or the place. The Plains is raunchy, most of its interior décor destroyed during brawls and in-house disagreements, but the bar is more that. It is a gathering place, a social central and a community centre that keeps reputations and memories alive.

Photo by Don Hall.

Shriners Hall Mural

by Clifford Wiens

Clifford Wiens was born at Glen Kerr, Saskatchewan, in 1926. He attended Rhode Island School of Design, Providence, Rhode Island, USA, and graduated in 1954 with a Bachelor of Science in Architecture. He practiced architecture in Regina from 1957 to 1995 and is currently engaged in writing and design in Vancouver, British Columbia.

I arrived in Regina as an architectural graduate from The Rhode Island School of Design in 1954. I made the rounds of architectural offices to introduce myself — with no real intention of staying in Saskatchewan. To my amazement I received employment offers from every architectural office in the city. I learned later that there was a chronic shortage of young draftsmen trained as architects in this hinterland.

I had worked my way through school, with part-time work in Providence, Rhode Island, and full time summer work back in Saskatchewan — as carpenter and eventually as construction foreman. The last project I had worked on was the new Kincaid Hospital, in southern Saskatchewan. This was known to the firm of Stock & Ramsay, as they had designed the new hospital, so it was not surprising that I was offered a job as construction inspector for the firm. The same day I returned to show my portfolio of student work, and I was offered a designer job with an increase in pay. This was all rather heady stuff. I accepted the job, and my life in Saskatchewan began to unfold.

As a new employee I was given, as my first assignment, the design of a ceramic tile mural for the exterior wall facing the street of the new Shriners Hall, designed by the firm I was now working for. This assignment was not what I expected. I was eager to work on the design of buildings.

The next instruction I was given was to include camels and palm trees and other Egyptian imagery. This I felt was beyond my abilities — should they not engage an artist for this task, with experience in ceramic mural work? Another scarcity in the city! So I made the attempt and soon convinced myself that, if the client would accept a more decorative and abstract design, I thought I could do it. To give my employers something to dream on I suggested that the fez could be a visual symbol in the design — the most current fez in the foreground with past potentates fading back in the design, as in history — all caught in a pattern of vertical columns. This background design was layered in the spirit of Egyptian décor of alternate banding, which suited the use of small square ceramic tile. After some study of how to actually construct this mural and communicate the design, I discovered that an interesting design could be achieved without cutting any tile. Now I could develop a pattern with a number system, making it possible for any tile company to lay out the design and a local tile contractor to do the work.

I had the singular honour of presenting my final design to the client in the boardroom. They liked it — to the surprise and delight of my employers.

Photo by Rory MacDonald.

Curb Works

by Rory MacDonald

Curbs Work is an attempt to develop and make tangible the idea of public craft. If it is possible to conceptualize a role for public art and intervention whose function is often to create a space for critique and dialogue concerning the history and use value of public spaces, so, too, is it possible to conceptualize a role for the crafts in a dialogue of public critique. The role of the crafts in this critique is grounded in the value of work and a concern for the material value of objects in space.

Curb Works identifies areas of decay in the public works of a city. The critique is not, however, a question of identifying the responsibility of the public works department and the city to fix every crack in the sidewalk, as much

as it is an attempt to question the value of materials and actions within abject public spaces. The efforts to repair the cavities of the city curbs with a material such as ceramics at once critiques the value of materials (ceramics being more expensive than concrete), as well as the effort involved in their creation. The effort of creation and the development of skill continue to be part of the foundation of craft practice. These works draw attention to the abject in our city environments. The curb is, as an 'object', neither here nor there, yet functions as the compartmentalization of the city landscape. As a true borderline, it is ideal for the exploration of public craft.

As a designer and artist, Rory MacDonald's work in ceramics explores the history of industrial ceramic production techniques. He is interested in the role of ceramics within the practice of design and art, concentrating on the development of new public audiences and spaces for ceramics, exploring the concept of public craft.

Modernist Gems

by Bernard Flaman

When I accepted the position of Heritage Architect with the provincial heritage branch, I was excited about the prospect of turning a casual interest in modernist architecture into something that might shape public opinion and extend the time period in architecture of what we commonly perceive as "heritage." Modernism, at least in Saskatchewan, refers generally to buildings constructed after the Second World War, but it could also be argued that grain elevators were our first modernist structures and actually influenced the development of the movement in Europe in

the early days of the twentieth century. I had the pleasure of co-curating a small exhibition on the topic at the Mendel Art Gallery in 2004 that included the grain elevator at Fleming, Saskatchewan (the oldest standing wood-crib elevator in Canada) and the highlights from the early 1960s modernist heyday: the Mendel Art Gallery itself, the Saskatchewan Power Corporation headquarters, the College of Law at the University of Saskatchewan, and the Chapel at Silton by one of the province's best modernists, Clifford Wiens.

Two architectural gems that couldn't be included in the exhibition due to space considerations were the Regina Court of Queen's Bench building and the Regina Public Library. Completed in 1961 and 1962 respectively, both replaced older buildings and, in the case of the library, one that was not yet 40 years old, both are clad in stone—the courthouse in Tyndall stone and the library in granite—and finally, both buildings incorporate two of my favourite building entrances. Both are essentially simple boxes, but are enlivened by generous windows and stylish canopies.

Designed by the architectural firm Izumi, Arnott, Sugiyama, the library is the extrovert of the two. The double height box with generous areas of windows modulated by sunscreens must have made for a spectacular space before the mezzanine was added. A smaller, secondary box housing the Dunlop Art Gallery is articulated separately and clad in very unusual split granite tile set into panels. The entrance is truly wonderful, forming a generous, public and inviting gesture on the corner of Victoria Park, and shines like a beacon on even a cold, snowy winter evening. The courthouse, by the firm Portnall and Grolle, is more restrained and dignified, yet the entrance canopy evokes what I like to think of as the "cocktail" era of architecture. Like a free-standing table top, the canopy is supported on four elegant tapered legs. A low vestibule allows the visitor

Above: Regina Public Library, ca. 1960. Courtesy of the City of Regina Archives, B-0996.
Opposite page: Court of Queen's Bench. Photo by Daniel Lapointe, Government of Saskatchewan.

to move from the canopy shelter to the lobby, where one is greeted with an Italian mosaic tile mural by John Miller.

On the northwest corner of the courthouse lawn and at the entrance to the library, token decorative stone elements are incorporated from the Romanesque and Classical Revival buildings that they replaced. The library, now just over forty years old and indeed older than its 1912 predecessor when it was demolished, is at an awkward age for buildings — a little run-down and shabby, but not yet appreciated or recognized for its heritage value. A closer look reveals a beautifully designed building, clad in the finest materials that would likely be unaffordable today. Hopefully the various boards, planners and councillors charting the future course for the library will take a look down the road at the new/old Winnipeg library. It is a successful renovation and expansion of an existing building that supports the downtown and avoids the embarrassment, not to mention the environmental and cultural tragedy, of demolishing relatively new buildings.

Bernie Flaman joined Culture, Youth and Recreation in 2003 as Heritage Architect for the Province of Saskatchewan. He co-curated the exhibition "Character and Controversy" at the Mendel Art Gallery in the fall of 2004, examining the development of Modernist architecture in Saskatchewan.

Cynie Lewin (née Ratner) was born in Regina. She lives in Israel but recently spends many months each year in Regina. She greatly thanks many individual persons for their help, plus employees of the Saskatchewan Archives Board for their guidance.

Below and facing page, photos 1, 2, 4, 5 and 11 by Jeannie Mah; photo 6 by Ed Jones; photos 3, 14, and inset photo this page by Cynie Lewin.

From the time I was young I liked to go exploring. I would roam open fields, bicycle-ride through parks and residential neighbourhoods, walk or take the streetcar downtown and join the busy people and the action. With visual landmarks charted, familiar Regina became home.

I still have that same curiosity. As I go around the city, I love to look at its buildings and parks, learning more all the time about the architects and artists, locating their structures and installations, and then searching for others. I keep finding not only interesting design motifs and elements, spotting styles and ornaments, but I also notice the different building materials used, especially recognizing local materials brought to enrich the mosaic of the city from their place on the prairie, reflecting and revealing the age in which they were formed.

Everyday, simply moving about the city, exciting adventures full of discoveries can belong to everyone. My own increasing knowledge of the city's visual textures, colours, and patterns has given me a great awareness and appreciation of the beauty of Regina.

Here are some of the things, much abbreviated, I like to look for and identify. Perhaps you do, too? There are infinitely more....

An Urban Adventure – Sighting Extraordinary Regina

by Cynie Lewin

SASKATCHEWAN FIELDSTONE (glacial erratic granites, spotted pink, black, grey, and white, directly off the pristine prairie) • low property walls and gateposts at 3200 Albert Street • foundations and/or chimneys at 2815 19th Avenue (Figure 1), 53 and 55 Leopold Crescent, corner of Regina Avenue and Albert Street, corner of Broad Street and College Avenue, and St. Paul's Anglican Cathedral at 1861 McIntyre Street (Figure 2).

CLAYBANK BRICK PLANT 1912–1989 • façade on Hotel Saskatchewan (Tapestry, yellowish) (Figure 3), Balfour Apartments, Legislative Powerhouse (Tee-Pee Moka, speckled with iron spots) (Figure 4), and Darke Hall (Ruff-Tex, copper-like) (Figure 5).

PILOT BUTTE BRICK • façade of St. Paul's Anglican Cathedral (yellow) (Figure 6).

MANITOBA TYNDALL STONE (cross-cutting reveals beautiful fossils, some huge, others hidden) • entire façade of Legislative Building, Federal Building, T.C. Douglas Building, CBC Building, First Nations University of Canada (in brick form), Canadian Western Place at Cornwall Street and 12th Avenue (Figure 7)

- trim of doorways and windows at 3022 Victoria Avenue and Mayfair Apartments, 2915 14th Avenue.

GRANITE • Trafalgar Fountain, Wascana Park (red, more vibrant when wet) • Central Library (multi-tone bricks) • façade on SaskTel building at 12th Avenue and Lorne Street (emerald pearl, Sweden) (Figure 8).

MARBLE • frieze on Land Titles Building (white with grey streaks).

LIMESTONE (from Bedford, Indiana) • detail trim on Regina College building, 2155 College Avenue, and Telephone Exchange Building, 12th Avenue and Lorne Street (Figure 9).

TERRA COTTA • multi-coloured lotus flower balustrades and streetlights on Albert Street Memorial Bridge • tiles on Saskatchewan Revenue Building, 2350 12th Avenue, and The Gilmore Block, 1825 Scarth Street • roof-tiles on 2728 McCallum Avenue and Frontenac Apartments, 2022–2024 Lorne Street • white façade on Leader Building, 1853 Hamilton Street, and Canada Life Assurance Building, 2201 11th Avenue (Figure 10) • detailing and sculpture on St. Chad's, College Avenue at Halifax Street (Figure 11) • motifs of four beavers, shells, acorns, rose on Yaeger Block, 2425 11th Avenue.

BRASS (shiny golden glow) • fittings in foyer, doors, window frames, pair of exquisite outdoor lights on Federal Building (Figures 12 and 13) • lobby mailbox and outdoor clock on Hotel Saskatchewan • doors on Union Station.

COPPER (oxidized to green) • roof of Old Post Office/Globe Theatre Building.

TIN • ceiling of Bushwakker Brewpub, 2206 Dewdney Avenue • corrugated façade and roof on building at 7th Avenue and Halifax Street.

IRON • grillwork railing of bullrushes on Old Funeral Home, 1951 Toronto Street • mini "widow's walk" at 1134 Victoria Avenue and Old Post Office/Globe Theatre Building • stylized letters "VE" under front window at 3374 Albert Street (residence of architect William G. Van Egmond) • grillwork hearts and fire ladder on Akerman Building, 2128 Dewdney Avenue • window bars with floral medallions on Canada Life Assurance Building • weathervane ship at sea on Kenora Apartments, 2601 14th Avenue.

WOOD • roof shingles on Qu'Appelle Diocese Buildings, 1500–1700 Block College Avenue and Old No. 1 Firehall, 1654 11th Avenue • Doric columns, building 2700 College Avenue.

STAINED GLASS • windows of St. Paul's Anglican Cathedral (rose, at west end), Darke Hall (crests of Universities), Royal Canadian Legion Memorial Hall, 1820 Cornwall Street (blue-green, with poppy flower border) (Figure 14 and poppy detail, inset, facing page).

Above, photos 7, 8, 9, 10, 12, 13 by Don Hall.

Buildings and planned open spaces are the historical footprint of a city, as precious as any natural wonder or heritage site. The best ought to be cherished and saved for they represent social development and creativity. Demolishing them is no better than destroying a great monument or work of art. They belong to the people. A balance between land sale revenues for renewal and preservation of these heritage icons should be the priority.

Photo by Don Hall.

Regina Public Library's Sunken Garden

by Helen Marzolf

Helen Marzolf lived in Regina for fifteen years. It formed her sensibility as a curator, educator and arts administrator. Currently, Helen lives and works in Victoria, British Columbia, where she is director of Open Space Arts Society and tries to appreciate a wet cold.

The Regina Public Library building is a place of habit, and as such, its architectural graces have receded into obscurity. Consider the "sunken garden" on the northeast corner of the building. You walk over it to enter the library from Twelfth Avenue and you pass by it on your way down to the Film Theatre or the children's area.

At one time, it must have been a marvel to library visitors. Lined on two sides with polished granite offset by opposing glazed walls, it is a nearly square inner courtyard set about eight feet below grade. Though it is a dry garden,

a couple of wiry Siberian elms reach upward and outward through two stories of space capped by the library roof. Coarse gravel covers the garden floor — I have often wondered about this choice. Was it selected for its economy or its ability to camouflage the thousands of cigarette butts flicked in from the street and the pedestrian bridge? To be truthful, I don't know what deliberations prefaced the choice of gravel. I like to imagine the garden with carefully raked pea stone or sand, black or maybe a deep red.

When I worked at the Library, I'd sometimes take a coffee down to the lower stairwell, and stare into the garden. It was a welcome change, and I liked the garden's obscurity and its elegant proportions. I wondered how a prairie library acquired this special garden.

The architectural firm Izumi, Arnott and Sugiyama designed the Regina Public Library building, but Miss Marjorie Dunlop, the chief librarian who built it, spoke only of Kiyoshi Izumi. Izumi would have calculated the effect of the sunken garden carefully. I wonder if he had to argue for it. Probably not: it is a practical architectural flourish. In a deft move, Izumi brought natural light into the lower level. The morning sun always shines through the garden, illuminating the fish tank and brightening the shiny covers of the children's books.

The sunken garden is rarely animated: the library staff plants annuals for the summer and, on a couple of occasions, New Dance Horizons has performed in it. Recently, Monika Napier's sculptural installation "mad, mad, mad, mad world," a network of extension-cord pods, settled in among the remnants of the former Carnegie Library's columns, which have always been part of the garden. The columns are artifacts, or ruins, held in a quiet place, locked away. It was an odd move for a Modernist architect, to footnote the site's history in this way. Izumi may not have created a Zen garden, but his overlooked space, always available to contemplation, is cool, distant, and just a little enigmatic.

Large mammoths and mastodons vanished from the plains long ago, so Reginans are especially protective of their one and only elephant and are determined it will not suffer the same fate. Snuggled comfortably in the trees on the north side of the Regina Public Library – on 12th Avenue, between Lorne and Smith – "Rusty" the elephant gives a shy and appreciative nod to those who drive and walk by his permanent and protected home.

He got his name from the grades three and four kids at Rosemont School in the early '80s. Baptism felicitous! It echoes his dad's name: Russell Yuristy. In 1981 Yuristy welded the elephant from iron bar, which is prone to rust. A plaque tells us that, along with the names of the kids at the baptism. Long since grown, they surely remember as well as an elephant that important day: Claire Booth, Kelly Bossenberry, Scott Johnson, Kevin Kyle, Melreen Moggey, Ramona Uytterhaegen, Nancy Wagman and Darren Yurkiw. Rusty's actual adoption took place in 1983, when Reginans, the Saskatchewan Arts Board, and the Canada Council made him an official member of our civic family.

Rusty stays close to his clan. The library and the government building across the street shelter him from cold winds that blow out of the north. Public art, Rusty's taught us, is occasionally designed with the people in mind, so Reginans smile respectfully at the sign that says, "PLEASE DO NOT CLIMB" me.

He's big. You can't miss him. One wonders if, upon seeing him, readers coming out of the library are reminded of Barbara Gowdy's *The White Bone* or Jeffrey Moussaieff Mason and Susan McCarthy's book about the emotional lives of animals, *When Elephants Weep*. Better still, one wonders if they've known the joy in reading

If an Elephant Could Speak

by Heather Hodgson and Béla Szabados

Milton Acorn's poem, "The Elephant's Five Pound Brain?" Here's an excerpt:

> ...In the elephant's five-pound brain
> The entire Oxford dictionary'd be too small
> To contain all the concepts which after all are too weighty
> Each individually ever to be mentioned;
> Thus of course the beast has no language
> Only an eternal pondering hesitation...

Wait a minute, Milton! What if an elephant could speak? What would Rusty say? Our guess is that he wouldn't hesitate for a second! Instead, he'd trumpet all the readers, the movie goers, and the art lovers in the Regina Public Library.

Rusty has called 12th Avenue his home in Regina for more than twenty years. That's a long time. Good thing elephants never forget!

Heather Hodgson and Béla Szabados love Regina's wild life: the anteater and the gopher in Les Sherman Park, the frog on the lawns of the College Avenue campus, the buffalo at the corner of 18th and Garnet, and the grasshopper at Leopold and Albert. They are especially fond of "Rusty," the shy elephant hiding in the trees beside the Regina Public Library where Milton Acorn's "The Elephant's Five Pound Brain" can be found in the library stacks. The poem is on page 111 of his collection, *Dig Up My Heart: Selected Poems 1952-83* (Toronto: McClelland & Stewart, 1983).

PROPOSED SVBDIVISION of PROPERTY and LAY OVT of GROVNDS for LIEVTENANT GOVERNORS RESIDENCE REGINA SASKATCHEWAN

A History of Follies

by Lorne Beug

Lorne Beug first established a reputation as part of the Regina Clay scene in the 1970s. Since then he has produced mixed media sculptures and architectural photocollages. He also creates digitally printed artist books, one of which is included in the 2006 *Biennale* and collection of Bibliotheca Alexandrina, Egypt.

In a very young city like Regina, "built from scratch" in only a century, the importance of Vision is especially apparent. Think of the 300,000 trees planted on the plains, which make central Regina a veritable oasis. Or the artificial lake and islands, the core of Wascana Park, one of the largest urban parks in North America, created from a mere trickle of a creek. Spanning it, we have the Egyptian Revival, Albert Memorial Bridge, a truly amazing folly in the heart of the city. Indeed, it was dubbed "Bryant's Folly," after the then incumbent minister of public works, for its $250,000 price tag.

A general definition of a folly might be such: unnecessary, excessive building; building for its own sake; or "architectural nonsense." Whereas "classic" European follies were aristocratic in origin, ours might be called "socially constructive" follies. Both Wascana Lake and the Bridge, and the Federal Building — also a folly by the above definition — were conceived as make-work projects after the

stock market crash in 1929. Some visions remained unbuilt, such as Thomas Mawson's proposed site for the Lieutenant Governor's Residence (now the site of Wascana Place), rendered in watercolour in the City Beautiful style of the day. The First Nations University of Canada building by Douglas Cardinal, while probably not quite within most definitions of a folly, certainly must have confounded the rectilinear notions of most contractors upon first sight of the drawings. It is an amazing thing to have built, and one hopes it will eventually have its glass teepee in front.

Unnecessary though they were, these follies provide the core of Regina's character today and some of the key reasons that people stay or move here. If this is the case, surely we must cultivate visions for the future as a means of ensuring the health of our city.

While a welcome project, the Big Dig of 2004 that dredged Wascana Lake of accumulated sediment was perhaps more in the nature of routine maintenance than truly visionary. A more far-sighted plan for the twenty-first century might have been modeled on the Bear River Waste Water Treatment Plant in Nova Scotia, a man-made system of linked ponds where sewage is conducted through a series of mini-ecosystems providing natural filtration and purification. This might even include greenhouses for plants and swimming at the outflow end. Perhaps the time has come for another socially and ecologically conscious folly.

What Regina really needs to make life more livable is a glassed-in or covered winter space. What about covering the Scarth St. Mall and Victoria Park with an air-supported translucent dome? Remember the pneumatic tennis courts just off Wascana Parkway between the Archives building and Lakeshore IGA? We have the technology. It would even be possible to make portions of this envelope removable or retractable for the warmer months.

On a sunny summer day the Scarth St. Mall and Victoria Park is as vibrant and diversely populated a space as you will find anywhere. But contrast this with the rest of

the year, dominated by winter, where the towers turn the area into a wind tunnel. Saskatoon has a conservatory attached to the Mendel Art Gallery, and Calgary has its 15 kilometers of covered walkways linking the downtown buildings. We do have the Regina Floral Conservatory (1450 B 4th Avenue), a refreshing spot to visit especially in winter, but it is small, out of the way and largely unknown. In the 1990s a wonderful folly was begun there, the "Elephant Pit," a sunken garden combining large tropical plants and decorative stones from old Regina buildings. Sadly, this has been abandoned and filled in, but it would be a great feature to have in the hothouse of the future. There are also atriums in some office buildings and malls, but they are not public spaces where skateboarders, coffee drinkers, people watchers, wanderers and plant lovers can hang out and mingle freely.

I like the older, poetic term "Winter Garden." In Regina, we have winter in abundance, but it needs a garden.

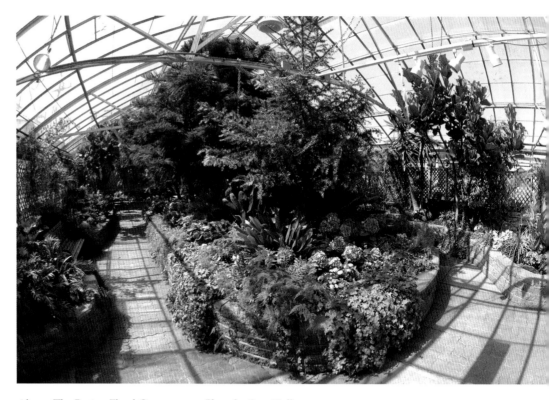

Above: The Regina Floral Conservatory. Photo by Don Hall.

Below: Artist's conception of possible Winter Garden covering Victoria Park and Scarth St. Mall.

Facing page: The Mawson Plan, Saskatchewan Archives Board B620.11 (map).

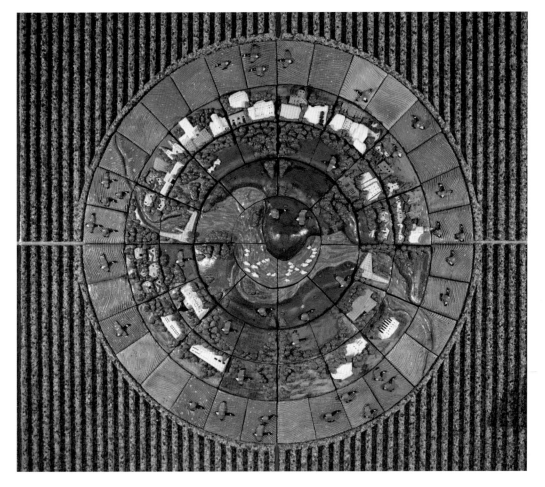

That's My Wonderful Town

by Timothy Long

As Head Curator for the MacKenzie Art Gallery, Timothy Long has curated a number of exhibitions which draw inspiration from Regina arts and culture, including *That's My Wonderful Town*, *Regina Clay: Worlds in the Making* and *A Better Place*.

Nineteen seventy-eight was the year of my Grade Twelve graduation from Scott Collegiate, a momentous occasion for which I bought a blue and silver polyester tie to match my baby blue polyester suit. At that point in my life, Regina was my world, and if there was anything that summed it up, it was the CKCK-TV commercial, "That's My Wonderful Town." Like Carol Gay Bell, who composed the lyrics to the song, I felt that Regina was a complete city. Nineteen seventy-eight was also the year that Victor Cicansky gave form to similar feelings in his proposed ceramic mural "Regina, My World," which now graces the lobby of The Co-operators building on College Avenue. It is, to my mind, the first major attempt to encapsulate what Regina means as a city.

Since that time, my view of the city has been challenged, living in New York and traveling abroad; each time I return to Regina, it seems a little smaller. Like a recurring high school reunion, the experience can be bittersweet.

And yet, it still has everything the song describes. "Tree-lined streets, museums and symphony, home of CKCK-TV." There is something compelling in the idea that this city, despite its size, has "one of everything" — a sprawling urban park, an oil refinery, the representative cultural institutions, a major league team — all of the civic amenities mentioned in the song. In fact, I have come to the conclusion that Regina is the smallest complete city in North America. Driving into town, the skyline has the same aesthetic wholeness and definition, if not grandeur, of a mini-Manhattan.

In 2003, as part of the City of Regina's Centenary and the Fiftieth Anniversary of the MacKenzie Art Gallery, I had the chance to organize an exhibition titled "That's My Wonderful Town." The exhibition explored the premise that Regina's graspable size and completeness made it an ideal site for reflecting on urbanization and the changes that have reshaped our globe. A sense of aesthetic completeness was echoed in the works which marked the entrance to the exhibition: David Thauberger's images of old and new City Hall and Victor Cicansky's "Regina, My World." These long-established Regina artists both "discovered" the city in the 1970s, transforming it into a world that is both familiar and strange.

That sense of seeing Regina through the eyes of an outsider-insider is common to the work of many of the artists in the exhibition. For instance, in Gerri Ann Siwek's comic strip "Bigfoot in the City," Regina's hemp-loving, peace-demonstrating lefties offer a big prairie welcome to a wandering Sasquatch who, like many a visitor before him, finds himself immersed in a swirl of social activities before he knows it. A real life example of an overnight visit ending up in a life-long attachment is found in the work of Landon

Mackenzie, an artist who has lived seemingly everywhere in Canada except Saskatchewan. Ever since stopping over in Regina on a bus trip in the early 1990s, Mackenzie's imagination has been haunted by this province. Unlike Cicansky, however, her map of Regina is fragmented, with a dotted line marking the wanderings of this stranger in a strange land.

As artist Lorne Beug has pointed out, Regina's strangeness — and beauty — owes much to its status as a "bypassed area," to use the terminology of urban sociologist Jane Jacobs. For many years, Beug has mined the "fossils of urbanism" found in local architecture to create a vision of a future past. Wilf Perreault's back alleys function in a similar way as an archive of a sense of community that has survived suburbanization. Other artists extend the search for traces of history through their photographs of overlooked urban and industrial spaces. Don Hall's quiet silver-toned photographs cast an eye on various relics of modernism, such as the streamlined Modern Radiator building, while Chris Gergley makes visible the remains of an older communal order among the leaning picket fences and graffitied garages of Regina's east side.

Growth has happened slowly in Regina, a fact which lends a peculiar quality to memory in a city where every loss is catalogued and directions are more often than not prefaced by "you know where the old so-and-so used to be?" In Brett Bell's short film, *Home Town*, the filmmaker (son of lyricist Carol Gay Bell) provides an elegy to lost childhood landmarks, whether his favorite teenage ten-speed route, now blocked by Lewvan Drive, or the gracious old McCallum Hill Building, which was leveled by developers in the name of progress. Jen Hamilton's crazy-legged

Facing page: Victor Cicansky (Canadian, born 1935), "Regina: My World," 1979, ceramic, 274.3 x 274.3 x 6.0 cm. Collection of The Cooperators (located in the lobby of their corporate office, 1920 College Avenue, Regina). Photo by Don Hall, courtesy of the MacKenzie Art Gallery.

This page: Landon Mackenzie (Canadian, born 1954), "she cruises....(Park, Regina)", 1993, acrylic, resin, and beeswax varnish on canvas, 121.9 x 152.4 cm. Collection of the MacKenzie Art Gallery, gift of the artist. Photo by Don Hall, courtesy of the MacKenzie Art Gallery.

"Wonderful Town"

lyrics by Carol Gay Bell

Wonderful town, wonderful people
Places to go, things to see
My love is Regina
That's my Wonderful Town

Beautiful homes, schools and churches
Entertainment, places to shop
My heart's in Regina
That's my Wonderful Town

Once they called Regina "Pile o' Bones"
Now she's the Queen City of the plains
Tree-lined streets, museums and symphony
Home of CKCK-TV

Regina is Canada's curling capital
We've got the Riders . . . the team to see
My love is Regina
That's my Wonderful Town

Regina is the capital of the province
It's the home of the R.C.M.P.
We have the Exhibition and in addition
Regina has CKCK-TV

You can take the scenic drive around
 Wascana
At Regina campus get a degree
Folks who till the soil or drill for oil
They watch CKCK-TV

Hillsdale and Rosemont and Lakeview
Churchill Place and River Heights agree
In Whitmore Park, Douglas Park, Regent
 Park too
They watch CKCK-TV

Regina, Saskatchewan
That's my Wonderful Town

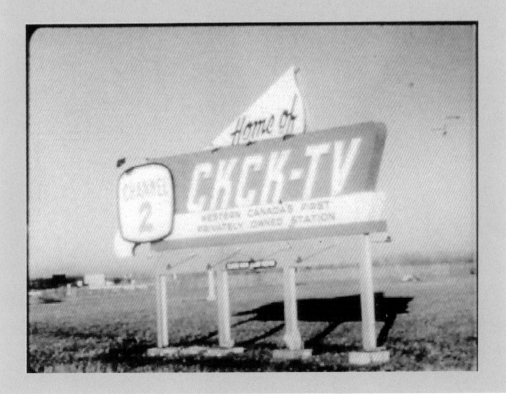

table, with missing leaves in the centre and awkwardly angled additions hinged around the edges, provides a perfect metaphor for a city where unsightly suburban expansion has been accompanied by an emptying of the urban core. The incongruities produced by Regina's development are also central to Seema Goel's animated short film, *Public Works*, which chronicles the evolution of Wascana Park. In her film, Goel points out the irony of efforts to transform a wetland teeming with waterfowl into a park where one can see, artfully displayed in a natural history museum, the taxidermied remains of the wildlife that once lived there.

Whatever its merits, urban expansion has come largely through immigration, including in-migration from Saskatchewan's First Nations reserves. In his book *New Moon at Batoche*, cultural theorist George Melnyk describes this immigration as a positive development: "Visible minorities are a growing force in the Western cities. ...Immigrants traditionally settle in cities where they can find government services, educational facilities, employment and fellow immigrants. Aboriginal people, especially in Regina and Winnipeg, are an expanding population seeking new opportunities for economic and social growth. All of this continues to give prairie cities an internationalism and multiculturalism that they have had from their beginnings."[1] While the emergence of Aboriginal artists, such as Edward Poitras, Neal McLeod and Gabriel Yahyahkeekoot, is evidence of progress, their work, for the most part, is a survey of colonial wreckage. Poitras' "Ledge," an off-kilter version of the pediment which graces the entrance to the provincial legislature, points to the origins of the problem right at the foundation of the city and province. As the artist reveals, the arms of the central figure of Progress are open only to the immigrants on her left, not to the First Nations people who kneel to her right (although the original drawings for the pediment showed her arms open to both groups!). As a

1 Melnyk, George. 1999. *New Moon at Batoche: Reflections on the Urban Prairie*. Banff, Alberta: Banff Centre Press.

result, Regina has become a "Wihtikow City," as artist Neal McLeod calls it. His expressionist urban landscape painting is filled with harrowing images of the soul-destroying *Wihtikow*, the Cree equivalent of the European vampire. Gabriel Yahyahkeekoot's video, "A Moment of Clarity," translates this mythological vision into the rap idiom of contemporary Aboriginal youth in a darkly poetic exploration of life in "The Hood." For immigrants, the most obvious danger is assimilation, a fact which Jeannie Mah makes clear in a work alluding to her Chinese-Canadian upbringing. This point is made with great poignancy in a series of delicate ceramic vessels onto which she has transferred images of her Chinese father, an entrepreneur who tried all his life to fit the image of a prosperous Canadian businessman, and of the artist herself, a peripatetic "citizen of the world" who has nevertheless remained attached to the city of her upbringing.

At the extreme end of the spectrum are the artists who have chosen to project an apocalyptic view of Regina. In Jeff Nachtigall's mural-size painting, "Pile," the cyclone which flattened Regina in 1912 returns to finish the job, recalling the constant battle against the elements that has been part of the city's identity since the days when it was known as "Pile-o'-Bones." The threat is more distant in Jack Severson's snapshots, in which a small fleet of UFOs descend on Regina's homes and gardens. Although the alien vessels are just produce stickers, the league of nations represented by these little labels reminds us that our everyday lives have been successfully invaded by global commerce.

Splendidly isolated, but never isolationist, Regina boasts an artistic milieu that has made the most out of the least. Regina, similar to its larger counterparts, has suffered most of the ills of twentieth-century urbanization. Nevertheless, it retains qualities that have nurtured and inspired a remarkable community of artists. Through their work we are offered a better understanding of the many changes that have transformed our urban landscape and altered Regina's place within wider cultural spheres. And that's a great thing about my Wonderful Town.

Artists exhibited in *That's My Wonderful Town*: Brett Bell, Lorne Beug, Victor Cicansky, Chris Gergley, Seema Goel, Don Hall, Jen Hamilton, Landon Mackenzie, Jeannie Mah, Neal McLeod, Jeff Nachtigall, Wilf Perreault, Edward Poitras, Jack Severson, Gerri Ann Siwek, David Thauberger, and Gabriel Yahyahkeekoot.

Margaret Bessai is a visual artist who examines the humour of everyday life. She has documented the snow people of Regina since 1991. She has hosted Radio del Arte on CJTR and Splice TV on Cable Regina, and created the sock puppets in "Life is Like Lint" (1999), a film by Gerald Saul.

What are we in line for? Canada's first bank machine!

by Margaret Bessai

Left: The "second" Rex Theatre (no longer open when this photograph was taken), 1784 Hamilton Street, 1962. Courtesy of the City of Regina Archives, E-5.154. Far left: Allie McDonnell (Wihak), in Victoria Park, 1944. Photo by Lennie Wilson. Capitol Theatre sign can be seen in the background.

Going to the Movies

by Allie Wihak and Mark Wihak

Going to the movies was very much part of **my**[1] life in the 1930s and '40s. It was quite normal for children from the age of nine or ten to find their own way to Regina's downtown theatres on a Saturday afternoon. Of the five or six located in a four-block radius, **The Rex**[2] was the favourite destination for the younger crowd because it featured wild-west serials with lots of noise and action. It also had **Mr. Harry Bercovich**,[3] who was a genius at handling the unaccompanied youngsters. To clear the seats at the end of the first matinee to make room for the impatient crowd waiting to get in, he would announce there was candy for everyone as they left the theatre. He was just as creative at dealing with adult audiences in the evening. Competition for patrons was stiff among the theatres and, generally speaking, on a cold winter's night what movie was playing was a secondary consideration to just getting into the theatre. I recall being in the line-ups at *The Rex* when Mr. Bercovich joined the shivering prospective patrons on the sidewalk, charming us into staying "just a little bit longer."

1 Alice (Allie) Margaret McDonnell, born December 15, 1923, Grey Nuns Hospital (the Pasqua Hospital since 1973), the second of three daughters born to Grace and Frank McDonnell. Allie grew up on the "north side," at 1308 Queen Street. At the time, there were only three houses on the west side of the 1300 block Queen and the wooden sidewalk ran south from 7th Avenue only as far as the third house. On wet, muddy days, to reach the streetcar stop on Dewdney Avenue, Allie would have to walk up to 7th and cross over to the east side of Queen, where the sidewalk ran all the way to Dewdney.

2 *The Rex Theatre* — built 1912, destroyed by fire 1938, and re-built in 1939. It closed November 7, 1959. *The Rex* was located on the west side of the 1700 block Hamilton. The apartment building now on that site, The Palliser, was for a period during the 1980s, the home of filmmaker, mentor and leading bohemian Jean Oser. Jean started his film career in Berlin in the 1920s. He appeared in the Dadaist classic *Ghosts Before Breakfast,* directed by Hans Richter, and was the film editor for GW Pabst on films including *Three Penny Opera* and *Kameradshaft*. With the rise of the Nazis, Jean moved to France and then to the United States. In the 1970s he arrived in Regina, where he helped get the film program going at the University of Regina and inspired a couple of generations of "film nuts." Jean was an exhilarating teacher. He'd worked with some of the greatest directors in the history of the medium and directed an Oscar winning short film about Vermeer. Every film was a vivid experience for Jean, worthy of his focused attention and enthusiasm, whether it was the latest Kurosawa or a student's first two-minute effort. From his apartment in The Palliser, Jean would make a weekly circuit that included taking in a film or usually two at the RPL Film Theatre, followed by a Cognac and a piece of cheesecake at the Copper Kettle on Scarth Street, where he'd sit beneath a painting by another of Regina's leading artists and bohemians, Arthur Fortescue McKay, and tell stories about Jean Renoir and Bertolt Brecht and his six-decade love affair with moving pictures.

3 For more on Harry Bercovich, see Christine Ramsay, "'Broadway Scottie' Bercovich" on pages 102 and 103.

Left: Capitol Theatre decorated for NWMP premiere, Saskatchewan Archives Board (SAB) R-A8903-2; Bottom left: NWMP premiere parade down Scarth Street, SAB R-A6535-4; Inset: Madeleine Carroll in parade, SAB R-A6536-1; Bottom right: Regina's "other" long-time popcorn stand, Cudmore's, ca. 1940s, located on the north side of 12th Avenue, near Rose Street. The building seen behind the stand is the Alexandra School building which was demolished in 1955, SAB R-A8951-1.

Allie Wihak has traveled on five continents and lived in Calgary, Edmonton and Sydney, Australia. She has also lived in Regina for almost 8/10s of its history. In addition to raising seven kids, and being an active volunteer in the community, Allie is a master of the art of the handwritten letter.

Mark Wihak is a filmmaker who grew up in a pink house on the west side of Regina.

In 1940, the *Capitol Theatre*[4] hosted the world premiere of the film **North West Mounted Police**[5]. The studio sent the female star, **Madeleine Carroll**,[6] and several supporting actors for the occasion. They were **paraded**[7] through the streets of Regina in open cars, without any sort of barrier between them and the excited movie fans. I got right up close to **Robert Preston**[8] — he was wearing a beautiful camel hair coat — and I blurted out, "Would you like to have my autograph?" He rewarded my impudence with a big smile.

Like all the theatre lobbies in Regina, *The Metropolitan's*[10] was small and utilitarian, but beyond a set of French doors, a broad stairway led down to a spacious, carpeted lounge. It was lit by wall sconces and furnished with upholstered chesterfields and chairs, which were reflected in mirrored pillars. It was very little used and one evening in the 1960s, a group of six women were the only occupants, as we waited for the early show and intermission to end. The six, known as **"Club,"**[12] had been friends since childhood, and it was a mystery to our families how we continued to find so much to talk and laugh about. Predictably, in the comfort of the Met lounge, we lost track of the time and the nine o'clock show was well underway when an usher was sent down to ask the ladies to please come upstairs to the movie or go home.

Margaret's Mitchell's **novel**[13] *Gone with the Wind* had been widely circulated among the teenagers at Regina Beach that summer of 1939 — mostly for the racy bits. That fall, the film version opened in Regina at the *Capitol Theatre* on a glorious September afternoon. High school classes in Regina were missing more than a few students as we filled the pavement on Scarth Street outside the *Cap*, reminiscing about the summer and wildly anticipating seeing Clark Gable and Vivien Leigh bring Rhett Butler and Scarlett O'Hara to life on the screen. They did not disappoint — but even as we watched Scarlett's world of wealth and privilege being destroyed by the American Civil War, our own youthful world of long and carefree summers was coming to an end with the outbreak of the Second World War.

4 *Capitol Theatre* — built in 1921 at the corner of Scarth Street and 12th Avenue, capacity 1500. It was divided into two auditoriums in 1975 and if the movie in the adjoining theatre was a loud one, you could hear it through the walls. In the film *The Ballad of Don Quinn*, shot in the fall of 1990, Don Quinn and Ziggy Panzer are walking to Don's job at a parking lot on Rose Street. They pass the boarded-up train station (now Casino Regina) and walk down the alley behind the then closed *Cap* theatre. By the time the film was released in 1992, the *Capitol* had been demolished.

5 *North West Mounted Police*: Directed by Cecil B. DeMille. Starring Gary Cooper, Madeleine Carroll, Paulette Goddard, Robert Preston and Lynne Overman. Shot in California, the film tells the fictional story of a Texas Ranger who finds himself in Canada during the North-West Resistance. The film received five Oscar nominations in the craft categories and Anne Bauchens won the Oscar for best film editing. It is not available on video or DVD.

6 Madeleine Carroll, Robert Preston, Lynne Overman and associate producer William Fine traveled by train from Los Angeles for the premiere and were greeted by 5,000 fans on their morning arrival at Regina's train station. They spent three days in Regina and pushed WW II [9] off the front pages of the *Leader-Post*. The world premiere was hosted by four theatres, *The Capitol*, *The Grand*, *The Metropolitan* and *The Rex*, and the stars made appearances at all the theatres on opening night, Monday, October 21, 1940. The Premiere Ball was held at the armories on Elphinstone.

7 On October 21, an estimated 35,000[10] turned out to view a parade featuring the stars that wound through the downtown and past the *Capitol Theatre* whose façade was done up like a western fort. In the parade were Jocko Robinson of the NWMP who cut the fetters off Louis Riel before he was hanged and the first class of 300 airmen from Regina's No. 2 Initial Training School on College Avenue, now the home of the Canada/Saskatchewan Production Studios. Allie's future husband, Fred Wihak, would be a recruit at No. 2 ITS before heading overseas with the RCAF.

8 Robert Preston played Ronnie Logan in *North West Mounted Police* and would go on to greater fame as Harold Hill in *The Music Man*. Allie would go on to own several camel hair coats.

9 Madeleine Carroll was mourning her sister, killed that autumn in a German bombing attack on London. She would put her acting career on hold to work as a nurse in field hospitals in Italy and France. France awarded her the *Legion d'Honneur* for her wartime service.

10 The Dominion Bureau of Statistics listed Regina's 1941 population as 58,245.

11 *The Metropolitan Theatre* at the corner of Broad and 11th opened in 1918 as the *Allen*. It closed for a week in 1923 and re-opened as *The Metropolitan*. It closed for good on November 29, 1981, and was converted into a parking lot in 1987.

Just south of the *Met* was the tiny popcorn stand owned and run by John Alecxe and his sons, Harry and Tom. Established in 1938 and in business for over 40 years, the Broadway Popcorn Stand was a popular stop for movie patrons heading to the nearby *Met*, *Roxy*, and *Broadway*. The stand also made appearances on Hamilton and Scarth Streets. In the winter, the windows of the small booth would be fogged up, one of the Alecxes barely visible behind the cascading pile of popcorn next to the chipped enamel kettle full of melted butter. As you walked away with your popcorn, steaming in the winter air, the butter would turn the edges of the brown paper bag translucent.

12 *Club*: Eileen Brewer, Agnes Campbell, Rita Keith, Kay King, May McPhee and Allie met when attending Sacred Heart School on Elphinstone during the 1930s. In 2005, four of the surviving members are still having "Club."

13 The last movie I[14] saw at the *Capitol* was based on a best selling novel, Tom Wolfe's *Bonfire of The Vanities*. Brian De Palma's much hyped film version starring Tom Hanks and Melanie Griffith opened at the *Cap* on Friday, December 21, 1990, in the midst of a week-long cold snap. The high that day was minus 29, and it was much colder that night. I decided to go to the film at the last moment, and because there wasn't time to wait for a bus, my friends and I ran from the Crescents through the empty streets. We arrived minutes before the film started to find an almost empty theatre. The theatre was probably empty because of the cold, but it could have been an omen as well. Unlike *Gone with the Wind*, *Bonfire of the Vanities* was a critical flop and did miserable business in cities much warmer than Regina.

14 Mark Frederick McDonnell Wihak, born March 26, 1962, at the Grey Nun's Hospital, the sixth of seven children born to Allie and Fred Wihak.

"Broadway Scottie" Bercovich

by Christine Ramsay

Dr. Christine Ramsay is Associate Professor in Film Studies in the Department of Media Production and Studies (University of Regina). She is currently working on a history of the Yorkton Shortfilm and Video Festival. Past President of the Film Studies Association of Canada, she is a member of the editorial board of *Topia: Canadian Journal of Cultural Studies* and is also host of Saskatchewan Communication Network's *Prairie Night at the Movies*.

From the southwest corner of the intersection of Victoria Avenue and Broad Street, take a short two-block walk north. When you reach the corner of Broad and 11th Avenue, turn to face northeast. Close your eyes, click your heels three times, and open your eyes. You're not in Kansas anymore, Dorothy. It's March 13, 1942, early evening on a crisp Friday night. Spring is just around the corner, and downtown Regina is a happening place. Studebakers, Chryslers and DeSotos rule the road. Nevertheless, the Queen City is still a walking culture, and in the heart of its bustling entertainment district, lines are forming around the block for the grand re-opening of the newly remodeled Broadway Theatre.

Built at 1773 Broad Street in 1930 by Harry A. Bercovich as the city's first "all talkie"[1] movie palace, then closed in 1932 for a decade due to the lean years of the Great Depression, the 700-seat Broadway is back with H.C. Potter's zany musical comedy smash hit *Hellzapoppin'*, and Bercovich, the "grand old man of the movie business in Regina,"[2] is once again at the helm. Take your place in the queue. Nicknamed for his inimitable bagpipe stylings, it won't be long before "Scottie" appears and makes his rounds. On nights like this, Harry Bercovich is at his "genial best,"[3] shaking hands and talking up the crowds. If tonight is your birthday, the world is your oyster, since it's Broadway Scottie's policy that anyone celebrating a birthday gets a free pass. But then, anyone who knows him knows that freebies are Scottie's forte. Just ask the paperboys who have scored complimentary neckties as the dapper Scottie culls his famous collection twice a year, or the kids who

can't afford a movie ticket whom he lets in gratis. Once you've bought your popcorn and taken your seat, tilt your head back before the lights go down on Martha Raye, Ole Olsen, Chic Johnson and their crazy hijinx in what just may be the funniest Hollywood movie ever made (Bob Hope's road movies excepted), and marvel at the sky blue vaulted ceiling, which, through a projector and special lighting effects, appears to be moving gently with the spring breeze. "It actually looked like billows of clouds moving across the sky," says Scottie's son Murray, who worked at the Broadway as an usher and doorman in his youth. "It was very beautiful."[4]

By his own estimation, Harry Bercovich hosted 14 million Regina movie-goers over the years — whether at the Broadway, or at the Allen, the Rose or the Rex, which he also managed — and he loved every minute of the show business life. Scottie Bercovich died in 1959 at the age of 67. The Broadway outlived him by 22 years, closing in 1981. Still, while unfortunately the building is no more, the man will be remembered as someone who contributed greatly to the life of downtown Regina and cared deeply about the soul of this community. He is a touchstone for those of us concerned about preserving our history and heritage in the Queen City, and a model for bringing quality of life, energy, and heart back to Regina's downtown.

1 Bruce Johnstone, "The Last Curtain Call," *Leader-Post* 28 November 1981, 2-3.

2 "Whatever happened to......Broadway Theatre? *Leader-Post* 12 January, 1991, B2.

3 Bruce Peacock, "He's had 40 years in show business," *Leader-Post* 17 June, 1957, [np].

4 Johnstone, "The Last Curtain Call," 2.

Thoughts on the Antechamber

by Jason Cawood

Jason Cawood has a BFA in film & video from the University of Regina, and continues to live and work in his hometown. Although primarily focused on photography, Cawood has worked in such diverse disciplines as video art, writing, music, drawing, and radio, and has collaborated with several local performance groups including the Curtain Razors, New Dance Horizons, and Fadadance.

If you live anywhere long enough, you will inevitably reach that stage where you begin to speak fondly and authoritatively about your city's heydays and memorable eras. Much like the seasoned New Yorker who remembers Times Square before it became a branch of Disneyland or recounts stories about the early days of Studio 54, I've witnessed the rise and fall of several famous and infamous Regina nightspots, performance spaces and hangouts, including the Utopia Cafe, the Black Market, and Soul Food. While most of our cultural venues, such as the Dunlop Art Gallery, Neutral Ground, and the RPL Film Theatre have had, thankfully, better luck in terms of longevity, The Antechamber Gallery and Cinematheque (which operated for

two years at 1943 Scarth Street) has become another name to add to the list of the city's great defunct establishments.

Opened and operated by four film students from the University of Regina (Rob Pytlyk, Brett Kashmere, Alex Rogalski, and me) the Antechamber was intended to be a meeting place for visual art and film, two disciplines which are usually dealt with and exhibited separately. The name "Antechamber" (inspired by Tom Sherman's essay "Thoughts from the Antechamber") referred specifically to the space's unique layout, with the art gallery and film theater on either side of a dividing wall. In essence, each room was an antechamber to the other, thus bringing film into the realm of art, and vice versa.

If this concept wasn't entirely apparent to everyone at first, it didn't seem to matter to the several hundred people who showed up for the May 1999 grand opening, an event that has, over the years, acquired its own near-legendary status. No doubt, more than a few skeptics showed up out of sheer curiosity just to see if we could actually pull it off, and if they weren't convinced at the opening, they may have been after the following months of operation. With bold, focused curating that leaned unashamedly (perhaps even a little unfashionably) towards modernism and minimalism, patrons were confronted with work that was by equal turns perplexing and engaging. Likewise, programing in the cinematheque favoured avant-garde and experimental fare, culminating in the epic screening of Bruce Elder's 40-hour film cycle *The Book of All the Dead* (only the fourth time the work had ever been shown, after New York, Italy and Toronto, in its entirety.)

With such lofty and challenging work on display, it is easy to forget that the Antechamber had a looser, more congenial side: the live jazz bands, the all-night fundraiser parties, the opening receptions where collectors and university professors mingled with street kids hovering around the food platters. At its peak, the gallery was an unlikely, yet successful, convergence of art world sophistication and make-shift DIY aesthetics, the kind of space that only four nervy art school kids, with considerably more ambition than experience, could have sustained. People have often told me that it is this aspect of the space they miss the most.

When funding difficulties forced the gallery to close its doors in early 2001 (O'Hanlon's Bar and Michi Restaurant would later take over the space), it was clear that the Antechamber would endure as more than a mere footnote in the chronology of Regina's artistic community, and I feel fortunate to have been a part of this unique chapter in the city's history.

Facing page: Sign on Scarth Street. Photo by Jason Cawood.

This page, top: Opening reception in the main gallery; bottom: Gallery interior. Photos by Robert Pytlyk.

Photo by Don Hall.

An Appreciation of the RPL Film Theatre

by Jeannie Mah

The RPL Film Theatre is the life-blood of film lovers of Regina. It began in 1975 as the brainchild of Regina Public Library's Gary Deanne and was a welcome addition to the RPL's cultural programming. Screening only one film per week, the European Film Series was very enthusiastically received.

This was not by chance. The groundwork had been laid. Reginans have been keen film-goers almost since the invention of cinema, but in the years prior to the library series, Reginans had been cultivating a taste for international films.

Jean Oser, a French-German filmmaker and editor, came to Regina in the 1970s to become professor of film at the University of Regina.[1] Jean's evening classes were legendary. With a 16-mm projector whirring in the back of a dark room in the old Fine Arts building on College Avenue, we sat on chairs and any available floor space. Students and non-students alike were all made welcome. Infected by Jean's enthusiasm, we became aware that the art of film was much more than Hollywood offerings, but Hollywood films were discussed with equal seriousness. A city and a generation became "film nuts," as Jean would say.

At the same time, Bohdan Szuchewycz ran a film series of popular, political, and alternative films in the Education Auditorium at the University, often to full audiences.

In 1972, Jean Oser organized an Ingmar Bergman summer film series, and suddenly this city seemed to be more than a small prairie city. These films were a revelation in the art of film and the art of storytelling! The following year, Fellini's *Satyricon* and Pasolini's *The Gospel According to St. Matthew* was the double bill at the Roxy on the evening before I left Regina. I considered this to be a great send-off and an intriguing introduction to my first year abroad.

In the early 1970s, despite our small population and geographical isolation, we in Regina had a rich choice in film and film venues, with five downtown movie houses, a student series, and classes in the study of film. I returned to Regina just as the RPL Film Theatre began, and I was impressed to see the current films of Eric Rhomer, Claude Chabrol, and Alain Tanner.

Today, the RPL Film Theatre is the only place in downtown Regina to see films. Every purpose-built cinema has been demolished! Happily, the RPL Film Theatre continues to attract a diverse and dedicated audience for international and art house films.

I have now spent a 'lifetime' in cinemas in Cambridge, Vancouver, Perpignan, and Regina. I have rediscovered the joys of film classes in France and again in Regina. A favourite Regina moment on film is the bicycle scene, free-wheeling down the ramp of the Bay parkade, à la *Jules et Jim*[2] in Mark Wihak's film, *The Ballad of Don Quinn*.[3] A perfect Regina film moment for me happened during the first exhibition of The Antechamber in May 1999.[4] On a tranquil summer evening, as the sun faded, we sat in the park and heard the soundtrack from Jean-Luc Godard's 1959 *Au Bout de Souffle* (*Breathless*), playing on a small monitor in the storefront of the gallery. I sighed with happiness! This touch of Paris, in our own Victoria Park in downtown Regina, is the legacy of the innovative and progessive RPL Film Theatre, which truly does bring us the world.

Jeannie Mah has studied film at the feet of Jean Oser, Michel Cadé and Sheila Petty. She agreed to return to Regina because of the RPL Film Theatre.

1 See Mark Wihak, "Going to the Movies," page 99, footnote 2.

2 A film by François Truffaut (1962).

3 A film by Mark Wihak (1990). (See Brett Bell, "The Derrick," on pages 78 and 79; Mike Burns, "The Schnitzel Haus," on pages 174 and 175; and Mark Wihak, "Going to the Movies," on pages 99–101.)

4 See Jason Cawood, "Thoughts on the Antechamber," on pages 104 and 105.

VICTORIA AVENUE VICTORIA AVENUE

13TH AVENUE

ⓘ

ⓙ

ANGUS STREET

Ⓑ

ROBINSON STREET

BROAD STREET

COLLEGE AVENUE

GARNET STREET

Ⓓ

ANGUS CRESCENT

Ⓔ

18TH AVE.

ALBERT STREET

Wascana Lake

Ⓒ Ⓖ

REGINA AVENUE

20TH AVENUE

RETALLACK STREET

Ⓐ

QUINN DRIVE

Ⓕ

Ⓗ

MCCALLUM AVENUE

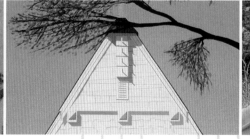

Neighbourhood

Photo by Don Hall.

Retallack Street

by Marlis Wesseler

Marlis Wesseler is working on her fifth book, a novel called *The Man Haters of Pleasant Manor*. Her previous books include two collections of stories, *Life Skills* and *Imitating Art,* and two novels, *Elvis Unplugged* and *South of the Border*.

I've always liked the sound of the name Retallack: something about the mix of hard and soft consonants, the peculiarity of the name itself. I'm sure no other city in the world has a Retallack Street, but as I sometimes say to my family without meaning it, I could be wrong.

Ever since we bought our first house in the North Central area, a small 1912 bungalow with a poor foundation and indestructible green siding, we've lived on or near this street. Retallack runs straight through Regina from Coronation Park in the north, through our old neighbourhood (now known as the Hood), through gentrified Cathedral and on through what we used to think of as posh Lakeview, ends just past Hill Avenue, and then picks up again for one short bit of street south of Parliament Avenue. We bought our second home in Lakeview, one house in from Retallack. Now we've moved again, but only two blocks north, and it's still part of our address: we can say we're right between Retallack and Robinson.

Until I was able to look it up on the internet, I was too lazy to do any research on Retallack Street and imagined various origins. Was it a Cree name for buffalo skull? Was it the name of some sort of rock they'd struck digging foundations in the Regina clay? Was it a type of grain developed to withstand prairie winters? The truth is even more pedestrian: it's the name of a Scotsman from Ontario, a financier of the Canadian Pacific Railway who, as an investor, visited Regina as a guest of William B. Scarth. Scarth named several Regina streets after his travelling companions, including Rae, Robinson and Cameron. Presumably Angus, Garnet and Athol were investors as well. My husband has noted perhaps once too often that because of his German accent, it's just as well we don't live on Athol Street.

I love living in Lakeview. Houses are older and eclectic and don't feature garages as their main attraction. Most of my friends live here or across the creek in Cathedral. The centre of town is within walking distance. Best of all, Wascana Park is right here. Every weekday I pick up my friend Connie, who lives (where else) on Retallack Street, for a walk in the park.

But I loved our little old house on 961 Retallack too. It was cozy. The neighbours liked us. Anything we did to that house and yard, no matter how sloppy or amateurish, was an improvement. Only after I glanced out the window one day and noticed a policeman kneeling in my mint patch aiming a rifle at the back alley did we decide to sell. The new owner immediately demolished the house but was able to recycle most of its parts. The green siding, for example, now graces a house across the street.

We make slap-dash repairs to our house and neglect our lawn here in Lakeview, too, and it doesn't seem right, somehow. There's a faint guilt associated with letting down the neighbourhood. But I take comfort in the fact that it would be far worse in the suburbs.

Retallack is anything but a suburban street. It cuts through the heart of the city, which sounds like a cliché, but there you are. And here, happily near Retallack Street, is where I am, still.

Photo by Don Hall.

In 1968 there was no student housing on the University of Regina campus. Instead, two- and three-storey houses throughout the College Avenue area served as student rooming houses. My friend Sherry and I lived on the third floor of 2228 Angus Street in a tiny attic apartment with a hotplate for a stove. We came into Regina in July with Sherry's parents and found the apartment through an ad in the paper. Sherry's parents didn't quite approve of the neighbourhood, but they did approve of the fact that the landlord and his wife lived on the main floor of the house and could keep an eye on us. They were Greek — Tim and Barbara — and seemed years older than us even though they probably weren't. Before we went back to Swift Current that day, we made a side trip to the old Bay on Hamilton Street and bought tickets to an upcoming Eric Burdon and the Animals concert. There was a picture of the two of us in the *Leader-Post*, standing at the ticket kiosk in the Bay wearing cut-off jeans and sporting Mia Farrow haircuts.

The summer of 1968 I worked pumping gas at an Esso on the Number One highway. They were twinning the highway that summer and the smell of hot asphalt filled the air while the radio blared songs from Britain and the United States, chronicling the '60s in full swing. I lived in a place where the '60s hadn't really happened yet. I worked with boys at the Esso who slicked back their hair and talked about their cars and beer and Saturday night action. They weren't going to university in the fall and they didn't have much to say to me because I was. All summer I pumped gas and watched the paving crew and daydreamed about the apartment on Angus Street and the start of my real life.

At the end of August, our parents drove us to Regina and we unloaded suitcases and boxes of bedding and towels and cleaning products and carried them up the

2228 Angus Street
by Dianne Warren

narrow staircase to the third floor. Our fathers chatted with Tim the landlord and assured themselves that we were in good hands, that we were safe in the big city, and that the 2200 block of Angus was really a decent part of town even though the housing was cheap. My father told me to phone him if I found out there were drugs at the university. That night, Sherry and I went to see Eric Burdon and the Animals in the old Stadium on the fair grounds, and then we went back to our apartment and slept under the slanted ceiling rather than under our parents' roofs. I imagine hundreds of other young people from towns and farms in Saskatchewan did the same thing on that day in 1968 — went to their first rock concert and then made their way to small apartments in the attics of old houses in Regina's core. Student Bohemia, Saskatchewan-style.

Dianne Warren is a fiction writer who has lived for twenty years in the same house in Regina, just around the corner from Angus Street. She has won several awards for her fiction, including the Marian Engel Award, the Western Magazine Award, National Magazine Gold Award and the City of Regina Writing Award. Her most recent book is *A Reckless Moon*, published by Raincoast Books.

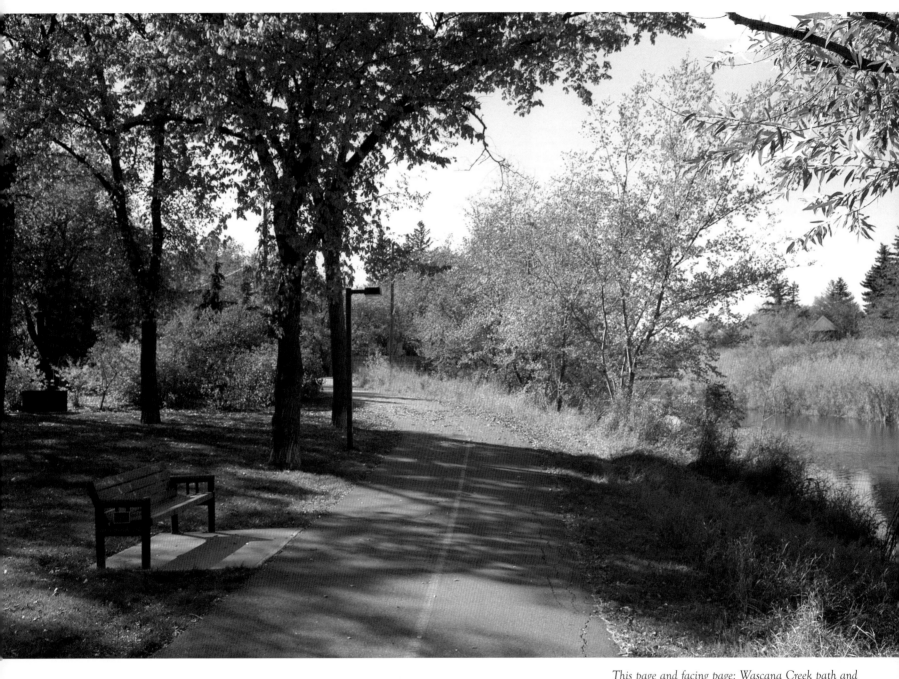

*This page and facing page: Wascana Creek path and
bench west of Albert Street. Photos by Don Hall.*

Reflections on Wascana Creek

by Gail Bowen

From my office on the second floor of our house on Retallack Street, I can see my friend Kathy's house on Regina Avenue and just past it, Wascana Creek. We have lived here 27 years now, and my walks past Kathy's house to the creek must number in the tens of thousands, but each one brings the zing of discovery.

In spring, summer and fall, the creek is a place of rushing water and intense animal and bird life. Because we are on a migration path, the variety of birds that comes our way is dazzling. When they were little, our children started a collective bird list that ended when one of the collective's members insisted on recording every single sighting of a duck. Suddenly, page after page was splashed with the angry notation: 'Duck! Duck! Duck!' scribbled by a young and progressively more frustrated hand.

After that, we moved onto mammals, and learned the rewards of stillness and patience. Standing quietly on the bank of Wascana Creek at twilight, we have witnessed the everyday wonder of beavers and muskrats going about the ordinary business of their lives. And there has been high drama. Once my kids and I witnessed a battle between a beaver and a small dog that showed us that even when animals live five minutes from downtown Regina, Nature is red in tooth and claw.

There have been gentler lessons. In winter, the creek freezes over, and its snow-slick banks are a tobogganer's dream. Every Boxing Day since we moved into Old Lakeview, my friend Kathy and her family have shoveled off a rink in the ice behind their house and invited the neighbours in for an afternoon of skating, tobogganing, gingerbread and hot chocolate. On those winter afternoons as our kids burned off their post-Christmas sugar highs, the grownups would sip wine and trade news about marriages, jobs, houses and — when they were safely out of earshot — children. Often the only time we would really talk to our neighbours would be at these Boxing Day parties. If, in mid-

summer we would happen upon each other jogging or dog-walking, we would pick up where we left off when we had said goodbye to one another at Kathy's party on the creek.

When Kathy died much too soon, much too young, her family continued the Boxing Day parties, and all of us learned a lesson about community and continuance. After her death, Kathy's husband built a bench that looked over the patch of Wascana Creek she could see from her house. On the side of the bench is a small plaque with Kathy's name and the simple statement. "She loved this place." Last Boxing Day, my granddaughters and I slipped away from the festivities, put on our boots and jackets and trudged through the snow to Kathy's bench. My granddaughters wanted to scope out the terrain to find a place where their toboggans would fly down the bank, across the icy creek and up the other side. Kathy, who lived life as a great adventure, would have loved that.

Gail Bowen is an Associate Professor of English at First Nations University of Canada, a playwright and an occasional essayist. Like Joanne Kilbourn, the protagonist of her ten mystery novels, Gail and her family feel that kismet led them to choose a house near Wascana Creek.

The Angus Crescent Roll

by Ken Mitchell

Back in the 1980s, a serendipitous ritual appeared along the curving length of Angus Crescent, one of Regina's most beautiful streetscapes. It was called the Angus Crescent Roll. The crescent's quarter-mile of stately elms cannot be walked down without feeling admiration for the foresight of city planners in 1905. Their urban plan created "the crescents" which shape the Cathedral area, Regina's verdant inner-city community.

It's a little hard to find — the plan was designed to discourage traffic — but cut up any back lane, and you are bound to cross Angus, the middle crescent. The inner one is Connaught, a short half-crescent that ends at Davin School. Leopold, the outer crescent, is entered from Albert Street, sweeping past Wilf Perreault's magnificent topiary sculpture, Reginald the Grasshopper, gazing grassily from his mound of bright petunias.

The Angus Crescent Roll was initiated one perfect Saturday afternoon in August 1985, the brainchild of Nick Russell, who lived in the grand house at the corner of Angus Crescent and Retallack. The Russells were joined by

the Hetheringtons, the Fenses, the Hacks, the Conways, the Stewarts, and just about everybody else along the great concourse of elms. The idea was a four-block-long neighborhood picnic that would roll up and down the crescent every year. The organizers got the city permit after two-thirds of the residents signed a petition to have the street closed for a day.

At four o'clock, barricades go up at either end, to ensure the safety of children and seniors from traffic. Immediately residents begin to stroll back and forth across the crescent. Neighbours pool their cups and glasses, carry out the extra lawn chairs. Children bring their friends. Bicycles begin zigging and zagging along the pavement.

Families haul out their supplies of serviettes, marshmallows, ketchup and stir sticks, all heading for the centre of the action. Dozens of neighbours will meet today for the first time — the newer arrivals get a special burst of hospitality. There are no porta-potties, either. Various households have opened their washrooms to the throngs. Volunteers at a table register participants and families for a $5 fee. Over there a group of grandmothers has set their aluminum chairs on the lawn of "the Douglas home," the large white house where Tommy lived when he was the premier of Saskatchewan (1944–1962).

In the middle of the street, the centre of attention is a huge iron barbecue, now smoking up a storm. It is an ancient hunk of metal, battered and scorched, the size of a small motorboat, whose ownership and history is uncertain. It is owned by "the community," so no one is in charge of it. It takes months to find every year, working backward through the Kiwanis and the Oddfellows and the Girl Guides, to track it down from the August before. Beside it

the potluck table groans under its mound of chilis and casseroles, countless bowls of potato salad, cooler tanks full of a variety of drinks — for it's another hot afternoon in August.

There are kids' games, and face-painting artists are parked along the curb. The sounds and smells permeate the crescents like a cloud of incense: the aroma of lamb chops sizzling on the grill, charcoal glowing red through the smoke. Just when you can't handle another shred of stimulation, a wail of sirens shatters the feast. The men in the crowd snap shut the lids of their plastic coolers, just in case.

"Fire engine!" a child shrieks. "Fire!" the cry goes up. "Fire!" But it's not a fire. It's a big red pumper truck, rolling up to the barricade, chrome gleaming. The firemen have been invited by the Roll organizers, our final call to the party in the street. Now everyone is here, watching the kids clamber all over the big truck, while grinning firemen show off its various mechanical tricks.

So it goes on through the evening, the afternoon fading to dusk 'til the street lights are lit, and the kids invent a whole new game of tag, with endlessly complicated rules for the dark. And the Roll went on, year after year, even through the disastrous rainstorm of 1993. It only ended when the big black barbecue fell off the back of a volunteer's truck one year onto the old Lumsden Highway and utterly demolished itself.

Maybe next year we will find a replacement, and fire up for the Angus Crescent Roll again. Our neighbours on Connaught Crescent had a block party last year. Perhaps the party will continue to swerve down the crescents, bringing the families out to celebrate their neighbourhood communion. May the good times roll again.

Ken Mitchell is a Moose Jaw native who has lived in Regina for 47 years, mostly teaching English at the University of Regina. He has published over 25 books of poetry, fiction, drama and history, the most recent being *The Jazz Province: The Story of Jazz in Saskatchewan* (2005).

The Buffalo Stone

by *Guy Albert and Melissa Blind*

The buffalo were everything to the First Nations who first traversed the Great Plains. These animals were vital to the people of our past (*kayâs*) and continue to have great spiritual significance today. Buffalo ensured the survival of the First Nations, providing them with food, shelter and clothing. Nothing was wasted as the buffalo gave everything to those in need, from its flesh for food to its hides for warmth and bones for tools. These were the life blood of the Plains and an integral part of the lives of the First Nations people. However, over the passage of time and the urbanization of the Great Plains, the buffalo have been pushed beyond the boundaries of our daily lives. Therefore, it may come as some sur-

paskwâwi-mostoswasiniy

Cree translation by Guy Albert, edited by Jean Okimâsis and Arok Wolvengrey

paskwâwi-mostoswa kahkiyaw kîkway kî-ohci-aspêyimototawêwak iyiniwak ka-isi-pimâcihikocik ôta kâ-kî-taskamâcihocik mâna misti-paskwâhk. êkoni ôhi pisiskiwa mistahi ê-kî-pakosêyimototawâcik ayisiyiniwak kayâs ohci êkwa, kêyâpic anohc êkwa mistahi kihcêyihtâkosiyiwa manitôhkêwinihk. êwakoni anihi paskwâwi-mostoswa kâ-kî-pimâcihikocik iyiniwak, êkota ohci mîciwin mîna kîkway ka-osîhtamâsocik mîkiwâhpa, êkwa mîna ayiwinisa. namôya kîkway ohci-mêstinikâniwiw, kahkiyaw kîkway paskwâwi-mostos ohci kî-âpacihtâwak aniki kâ-kwêtamâcik; wiyâs ta-mîcicik, pahkêkinwa ta-kîsôsicik êkwa nanâtohk âpacihcikana otoskana ohci. tâpwê piko êkoni ôhi ê-kî-wîcihikocik tahto-kîsikâw ta-pimâcihikocik paskwâwiyiniwak. mâka kayâs aspin ohci môniyâwak kî-pê-wîkiwak ôta misti-paskwâhk êkwa paskwâwi-mostoswak kî-ati-mêscihâwak, êkosi kî-ati-pôni-aspêyimototawâwak. êkosi êkwa ka-mâmaskâcikâtêw ka-wâpamiht awa asinîwi-paskwâwi-mostos ê-mamihcisiwikâpawit

prise to see the massive stone buffalo standing proudly at the corner of 18th Avenue and Garnet Street — a sight otherwise unseen in the Crescents.

Carved from white rock, this symbol of our history brings stories of the legendary white buffalo to life; paying homage to our forbears who teach that even rock is animate and alive. Stones, the oldest of the grandfathers, centres of our sweatlodges, pass the stories of our ancestors down through generations. They release their spirits in the lodge and as the steam rises take our prayers to the Creator. The vision and skill of the artist who freed Regina's white buffalo from the stone gives us cause for pause and admiration as it invigorates those who gaze upon it. As you draw near, the energy of the stone's creation reassures your spirit, filling you with a sense of awe and wonder.

At this quiet corner we find a bridge between two cultures: one which is largely European and the other, First Nations. Wascana Creek is a mere stone's throw away, making us wonder if this hand-hewn buffalo was fated to stand proud watch over another testament to the power of prairie dreams: the largest man-made lake ever built. We offer you this as invitation to see the strength, pride, and majesty born from the cooperation of our worlds, as foretold by Regina's Great White Buffalo.

êkota ôma *18th Avenue* êkwa *Garnet Street*, ayisk namôya wîhkâc kâh-pêhtamwak ômatowihk.

wâpiskasiniy ohci kâ-wiyihkocikâsot, awa paskwâwi-mostos nôkohtâw tâpiskôc anita kayâs âcimowina êkwa tâpiskôc kâwi ê-pimâtisit kâ-kistêyihtâkosit kâ-wâpiskisit paskwâwi-mostos, ê-kistêyimihcik kêhte-ayak kâ-kakêskimikoyahkok tâpwê ahpô ana asiniy ê-waskawît êkwa ê-pimâtisit. asiniyak kâ-mâwaci-kêhtê-ayiwicik ispîhci kotakak kâ-kî-omosômiyahk, tâwâyihk matotisânihk kâ-apicik, êwakonik aniki wiyawâw kâ-âsônamâkoyahkok âcimowina kitâniskocâpâninawak ohci. pakiciwêpinêwak mâna otahcahkowâwa matotisânihk êkwa kâ-ati-pîkisêyâpahtêk êkota kitayamihêwininawa ispimihk otihtikow omâmaw-ôhtâwîmâw. kâ-kî-isi-wâpahtahk êkwa kâ-kî-isi-nihtâwisîhtât awa owiyihkocikêw asinîhk ohci kâ-kî-wîhkwacihât anihi wâpi-paskwâwi-mostoswa ôta oskana kâ-asastêki kimiyikonaw kwayask miywêyihtamowin ayisk ê-maskawisîhikocik aniki kâ-kitâpamâcik. cîki êkota kâ-ati-takohtêyan, kimôsihtân awa kâ-wiyihkotiht asiniy osôhkâtisiwin êkwa tâpwê kimâmaskâtamihikon kitahcahkohk.

êkota ôma ohci kimiskênaw ê-âniskopitamihk nîso pîtos pimâcihowina: opîtatowêwak êkwa mîna iyiniwak. namôya wâhyaw êkota ohci kâ-pimiciwahk oskana sîpîsis êkwa êkosi kâ-mâmitonê-yihtamahk matwân cî awa kâ-kî-mosci-wiyihkotiht paskwâwi-mostos tâpwê ê-kî-itêyihtâkosit êkota ka-mamihcisikâpawit ka-asawâpahtahk kotak kîkway ôhi ayisiyiniwa kâ-kî-nitawêyihtamiyit ôta paskwâhk: kâ-mâwaci-misâk sâkahikanihkân ayisiyiniw kâ-kî-mosci-osîhtât. kinitomitinân ôma ka-pê-wâpahtamêk maskawisîwin, mamihcimisowin êkwa kihc-ôkimâwiwin kâ-kî-pê-osîhtâhk ê-kî-mâmawohkamâtoyahk, môniyâwak êkwa iyiniwak, tâpiskôc kâ-kî-isi-osâpahtahk ana kihci-wâpi-paskwâwi-mostos ôta oskana kâ-asastêki.

Guy Albert is a fluent speaker and writer of the Plains Cree language. He was born and raised on the Ahtahkakoop First Nation in Treaty Six and has lived in Regina for six years while completing his degree in Cree Language Studies at the First Nations University of Canada.

Melissa Blind is of Plains Cree ancestry from Gordon's First Nation. Melissa holds a Bachelor of Arts (Honours) in Indigenous Studies and is currently working towards her Master of Arts in Indigenous Studies at the University of Regina with Dr. Neal McLeod. Melissa's interest in oral narratives stems from her desire to understand Indigenous people's history from the perspective of Indigenous people.

Buried Treasure

by Ryan Arnott

A visual artist for thirty-five years, Ryan Arnott was a founding member of Neutral Ground, The Bridge Artists' Co-op and the Flatland Artists' Studios. For sixteen years Arnott has looked after the Saskatchewan Legislative Building Art Collection and he was the consultant for two major projects that were unveiled by Her Majesty Queen Elizabeth II in 2005: The Queen's Golden Jubilee Statue by Susan Velder and the Saskatchewan Centennial Mural by Roger Jerome.

For me, one of life's forgotten milestones occurred when I, as a young child, became old enough to memorize my home address. I learned that I had a place in the world and could answer the big question, "Where do *you* live?"

Thinking about it now, the special character of where I had the fortune to grow up in Regina seems reflected in the fact that our home address was a little rhyming poem:

Thirty, thirty-five
Quinn Drive.

Our house was the seventh in a row of eight modern homes on Quinn Drive, designed in the mid-1950s by the architectural firm that my dad was part of, Izumi, Arnott and Sugiyama. All three partners, with their wives and growing families, lived on Quinn Drive: Joe and Amy Izumi in the first house, Jim and Mary Sugiyama in the fifth, and Gordon and Alva Arnott in the seventh.[1]

Joe Izumi, my dad and Jim Sugiyama had studied together at the University of Manitoba in the late 1940s, and in 1953, Joe, who was living in Regina, invited Gordon to join him to work together.[2] Flying from Vancouver, our family moved to Regina in December 1953. My sister Leah, only six days old, was the youngest passenger on Trans Canada Air Lines that year. I was one-and-a-half years old and, reportedly, the sight of snow in Regina made me cry!

During the construction of the houses on Quinn Drive our family lived in a home on Portnall Avenue, which we rented from the mayor of Regina, Gordon Grant. At that time Portnall Avenue was the outskirts of the city and I remember the wood sidewalks, which got very slippery when wet. In 1955, while we were still living on Portnall, my brother Duane was born.

Of all things, my earliest, most delicious memories are of the building smells that wafted around the construction site of our house on Quinn Drive — black earth newly turned, freshly poured concrete, wood and sawdust, enamel paint and turpentine. Indoors a most beautiful aroma was that of the cork floor tiles and the caramel-coloured adhesive used to glue them down. And to top it all off, the flat roofs of our house were covered with black tar and gravel.

We moved into 3035 Quinn Drive in 1956, a little prematurely it turned out, because the house had five entrances but only the front door had been installed. As construction continued, the other doorways were covered with plywood each night.

Although all eight homes were the same design in plan, every second house plan was flipped, like an opposite hand. Yet each building exterior was unique – our house was finished with brick, horizontal cedar siding, and brown trim. The front yard had a driveway with an open carport and to the right was our front door. The houses were early examples of a type of split-level: from the vestibule at the front entrance one could go upstairs to the bedrooms or downstairs to the main floor, which had an open plan living room/dining room, a kitchen, a laundry room and a playroom for the kids.

The living room had an open-beam ceiling and the walls were treated with the same cedar siding that was on the *exterior* of the house. The floor was made of golden brown cork.[3] A feature aspect of the living room was the large picture windows which looked south into the back yard. On the outside of the house were wood cantilevered louvers to shade these windows from the sun.

Behind these homes, across the alley, was a large, open field which extended to Wascana Lake, so the neighbourhood children had a piece of prairie for a playground. It was perfect for catching grasshoppers and butterflies in glass jars. And there were those large, grey "locusts" (that I've not seen since), which were hard to catch. They were invisible on the dry earth and when you got close, they would fly away, imitating the yellow wings and black stripe of a butterfly, and then disappear again.

Life was idyllic in this natural environment. There were crickets and flowers and gophers and meadowlarks in the field; and water bugs, frogs and red-winged blackbirds down at the lake. One summer we even found a large turtle.

Our play was "Charlie Brown" simple: plastic trucks and dinky toys in the sandbox, making forts and climbing trees on Broad Street, and after riding our bikes we'd play hide-and-seek outside until sundown. One hot summer we made a dug-out in the field and covered it with plywood, then camouflaged it with clumps of dirt and dried prairie grass. In this hideout it was dark, damp and cool.

Indoors, I liked to draw, and fondly recall carving a horse out of a bar of soap. Dad would bring home scrap paper from the office, mimeographed on one side with purple type, to use as drawing paper. However, following my first visit to the Norman MacKenzie Art Gallery with my father, I informed Mom that I needed bigger paper to draw on! At school one day, a classmate had a brand new package of 64 colour crayons – *that* was special. Later, with crayons of our own, my brother Duane and I transformed pebbles into treasure by colouring them silver and gold. We had tapped into a key aspect of all art — transcendence.

So it is that all these years later, I work in an office at the Saskatchewan Centre of the Arts, the last building that Izumi, Arnott and Sugiyama designed together, and it is located only blocks away from Quinn Drive. Heading home from work, I see where the formerly bare field is covered and built up with grassy hills, trees, barbeques and picnic tables. And occasionally I turn off Broad Street onto Quinn Drive, proceeding slowly... at 3035, I'm amazed — fifty years of growth has hidden our home behind massive evergreen trees.

Inset: Ryan's crayon drawing of himself, Leah and Duane coming in from playing in the snow, circa 1958.

1 Joe Izumi, whom I always knew as "Uncle Joe," returned to using his first name, Kiyoshi, after leaving Regina in 1968. Allan Smith, another architect in the firm in the 1950s, and his wife Beth still live in the sixth Quinn Drive home.

2 In 1954, Jim Sugiyama, a structural engineer, moved to Regina and the Izumi, Arnott and Sugiyama partnership was formed.

3 Cork tile was an innovative flooring product and was used by Izumi, Arnott and Sugiyama for the addition to the Norman MacKenzie Art Gallery in 1957.

119

Photo by Don Hall.

Thirteen Ways of Viewing a Public Park

by Judith Krause

Judith Krause is an award-winning Regina writer, editor and teacher. Her most recent book is *Silk Routes of the Body* (Coteau, 2001). She hopes her fourth collection, which has had too many tentative titles to name one here, soon makes its way into print.

Rotary Park is one of Regina's hidden parks. For the home-owners whose properties back onto this narrow green space, it functions much of the year like a private park. Or did. Once the Devonian Path extended cycling/walking options to the Albert Street Bridge, the beauty of this small park became an open secret.

1 The roar of spring run-off. The year of the big flood, people paddling canoes up and down Regina Avenue. The way a dog laps up water at the creek's edge.

2 The way toddlers squeal when it's time to feed the goslings. The way the mothers of both species move quickly to protect their young.

3 How a new gazebo needs to be erected every year to replace the one torn down for firewood by late night partiers.

4 The way the purple martins dive-bomb you, if you get too close to their condo birdhouse. The way songbirds call the park home.

5 The year beavers chewed every tree along the creek bed.

6 The rotten egg smell that fills the air when the ice breaks up.

7 The place under the bridge where a man's body was found, one of the oldest unsolved crimes in the city.

8 The way fireworks douse the park with light. The way lovers park, lights off, engines running.

9 The way police drove up and down the snowy lane on a January night in 1984 looking for signs of a neigh-bour's murderer.

10 How tadpoles invite you to shed shoes and socks. And how, on a hot day, the fountain in the paddling pool, invites you to shed even more.

11 How a sudden bloom of dragonflies becomes an irides-cent veil, a living scarf, floating through the evening air.

12 The sound your bicycle makes as you clank clank your way over the wooden footbridge. The call of a wild swan flying low over the slow moving waters.

13 The way leaves — new or falling — muffle the sound of city noise. The way the wind rustles only the tops of trees. The green light you bathe in.

A Regina-based and nationally recognized dance presentor, Robin Poitras is one of Saskatchewan's most prolific dance and performance creators. Creating dance, performance and installation works, Robin has been actively engaged in contemporary dance practice since the early '80s. In 1986 she co-founded New Dance Horizons in Regina, where she continues to act as Artistic Director.

Lindy McIntyre was born and raised in Regina. She studied English literature at the University of Regina and creative writing through various mentorship programs and workshops offered by the Saskatchewan Writers Guild. Published work includes a creative non-fiction story in the Canadian anthology *Wrestling with the Angel* from Red Deer Press.

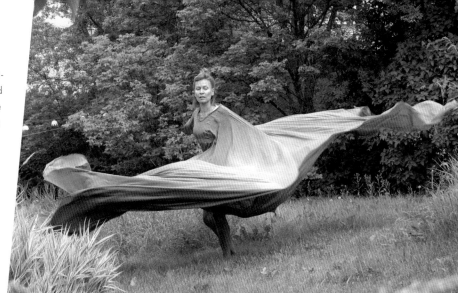

Gardens, dance

by Lindy McIntyre

The gate opens wide to invite you into gardens, and all it takes is a light step to the ground, then next you can't stop the why and how, and what's this and this, you can't stop the touching that and that, your bare feet spinning down grass, never mind the clematis, iris, narcissus and rose, lavender, bergenia, hydrangea, mock orange, they're this but much more than that, they're water lilies smuggled from India, ancient blooms clasped tight over seas in a black leather purse, or this little prairie slough in the middle of the city, so cunning in its design as to trick a stray deer on a sleepy Sunday; see the hoof-mark evidence in the fence, or these burnished key sculptures like unburied treasures, or this fragile fortress of willow, weaved seven feet high, or, yes, that old couple, who giggled, said they still swayed cheek to cheek in the sweet of the shade, and they're really the fact that there's more romance in the linger of this chandelier dangling over bricks by the pond by smashed china speckled in pots by a worn wooden door hidden by overgrown vines than not, and you'll remember them, smuggled lilies, embracing couple, dangling chandelier, worn door, these gardens, their dance, their willingness to share their whole life in a season, and always their season begins without end as you step in time over and around and out through the gate, see your prints disappear when the grass waves back.

Robin Poitras in Lorne Beug's garden. Photos by Don Hall.

David Thauberger (Canadian, born 1948), "Doll's House," 1988, acrylic, glitter, and letraset on canvas, 142.2 x 142.2 cm, collection of Mr. and Mrs. Franklin Silverstone, Montreal. Photo by Don Hall, courtesy of the MacKenzie Art Gallery.

Regina Houses

by David Thauberger

Painter David Thauberger lives and works in Regina, and continues to be inspired by the city.

Choosing a favourite or special location in a city when the city itself is a "favourite" subject is impossible. I believe my paintings show best how I think of Regina. For me, it is an "ideal" city: all parts of it are necessary to make the whole.

With this idea of Regina as "ideal city," my paintings since the 1980s have shown, or have intended to show, history (both mine and the city's), as well as transition and more recent renewal.

Regina structures have been the subject of many of my paintings, some now gone, a few renewed, and dozens of houses in all parts of the city, as well as commercial and gov-

ernment buildings. As I paint them, all of these structures not only illustrate my appreciation of the "built" environment, but confirm my affection for this "place," Regina.

When people look at my paintings they sometimes know people/friends who have lived in these homes, worked in these businesses, and between us we can create a kind of shared history of the place.

Some buildings are gone. Regina, in a fit of modernizing, bulldozed the old CITY HALL, a grand place still lamented and fondly remembered. I remember it as a child when we came to the city; I recall the old men congregating

Right: David Thauberger, "Late Bloomer," 1986, acrylic and glitter on canvas, 111.8 x 137.2 cm, Canada Mortgage and Housing Corporation. Photo by Don Hall, courtesy of the MacKenzie Art Gallery.

around the park benches on the grounds, my first experience with public washrooms: the gigantic urinals that posed much more of a "threat" than a "comfort" to a 7-year-old boy from Holdfast! Also recently gone, the wonderful COMMERCIAL PRINTERS building on Albert Street, the covering ivy showing the changes of the seasons to passing motorists.

Other favoured places still remain. My grandfather's home ALONG COLLEGE is still there, although the two gigantic spruce trees which used to "front" it are long gone. The "breakfast nook" which doubled as a kitchen table and provided a wonderful opportunity for visiting grandchildren to re-imagine as a "fort" or some other piece of "playground" apparatus is, I believe, still in use. The old firehall on 11th Ave, restored-renovated and now serving as space for community activity, remains.

WAITING for the RAIN with the McCallum St. DOLL'S HOUSE in the distance recalls a series of paintings of architecturally "eccentric" homes I painted, including one, GARDENER'S HOUSE, for the designer's gardener. He designed DOLL'S HOUSE as a wedding present for his daughter.

I have become much enamoured of the '50s and '60s homes in Hillsdale and Whitmore Park. The split-level WINTER WONDERLAND puts me in mind of the memories of Regina our kids will have as they grow older.

My paintings of Regina are more than a simple "record" of a place, they are a "reminder" of Regina as an "idea," manageable in scale, a place to travel from, a place to return to, a place to call "home."

Right: David Thauberger, "Winter Wonderland," 2003, acrylic on canvas, 43" x 56". Photo by Don Hall.

Below: David Thauberger, "Commercial Printers," 2002, acrylic on canvas, 43" x 56". Photo by Don Hall.

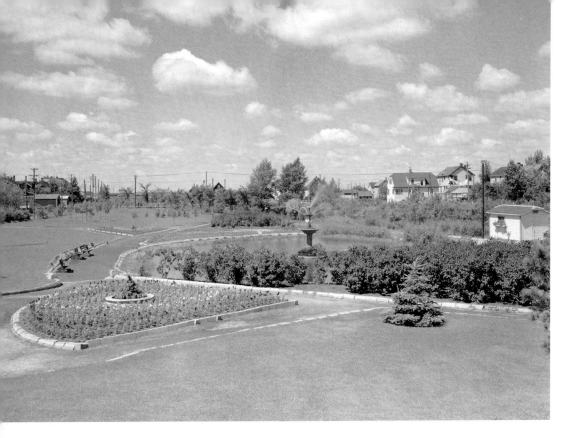

The Tumultuous History of the Victoria Park Fountain

by Maggie Siggins

Maggie Siggins is a journalist, author and filmmaker. She has published nine books, including *A Canadian Tragedy* and the Governor General Award winner, *Revenge of the Land,* both of which were made into television mini-series. She has also written and produced some fifteen documentaries.

It was like something you'd put atop a cake. The water gushed out of a doodad, flowed into a saucer, then into a bowl and down the pedestal to the rather elaborate base. A circular pool caught the overflow. Rather elegant, not pretentious, the Victoria Park Fountain marked a time when Regina longed for Edwardian refinement.

The fountain entered my life on my dog walks through Rotary Park. It was in bad shape by then. Painted a rather hideous turquoise blue, the plaster was chipped and only occasionally did it do any spouting. A shame, I used to think, because it was still pretty, in fact, had once been considered the apogee of our city's childhood beauty.

Regina's original planners had set aside a chunk of land in the heart of the new city as a park. Trees were to be imported there, lawns nicely laid out and a band shell constructed. (Although how sincere city fathers were about the open space is in doubt since twice they offered the space to developers; twice, the developers turned it down.) Finally, in 1907 the city hired landscape architect Frederick Todd to design Victoria Park, of which the focal point was to be a handsome fountain. A contest was held among architects and the result, our elegant cake ornament.

It sat there serenely until after World War I when a Cenotaph commemorating fallen war heroes was considered a more appropriate city centre than a statue that now seemed insubstantial, even silly. It was unceremoniously carted away to a warehouse.

It would be another twenty-five years before our fountain would see the light of day again and, when it did emerge, its prestige had been considerably diminished. It was placed in the Rotary Park near the Albert Street Bridge, a nice spot but out of the limelight. The *Leader Post* decided that it had once been dedicated to the local Member of Parliament, the illustrious Nicholas Flood Davin, and took

Facing page: left, Victoria Park fountain in Rotary Park, Saskatchewan Archives Board R-B8672; right, the fountain during its life as a platform for skateboarders and a canvas for graffiti artists. Photo by Lorne Beug.

This page, right: Postcard showing Fountain in Victoria Park. In background, second building from right is St. Mary's Church (later renamed Blessed Sacrament Church), 2049 Scarth Street, and to the left of the church is St. Mary School (southeast corner of Scarth Street and Victoria Avenue). Postcard courtesy of Judy Brown.

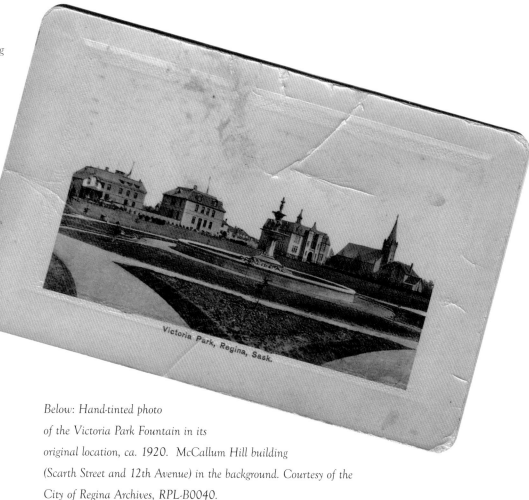

Victoria Park, Regina, Sask.

to calling it Davin Fountain. In fact no such honour had been officially bestowed on Mr. Davin; the legitimate name is still the Victoria Park Fountain.

In the late 1990s it took on a new life — a venue for skateboarders. Since water seldom spouted forth, the catch pool provided the perfect sloping, smooth surface to perform front side crooked grinds and the like. Nobody seemed to mind these young people much; they always were having such a good time. But along with the skateboarders came graffiti artists. Soon the fountain's sea-blue surface was covered with black, green and blue paint in the form of drawings — one I remember showed a smiling fat man with his teeth missing — words from rap songs, squiggles of no particular significance.

At first it seemed an eyesore. I winced that such a nicety from our British heritage could be so defaced. But then I thought, "Why not? A graffiti gallery is more interesting than a cake decoration," and I looked forward on my daily walks to interesting new additions.

Apparently the rest of the neighbourhood didn't agree with me. In the dark of night, a truck arrived, dismantled Victoria Park Fountain, and transported it off to storage once again.

I'm sure it'll reappear again one day, but by then our city will be sophisticated enough to allow expressions of art to sprout out spontaneously, even if it's on the face of Edwardian refinement.

Below: Hand-tinted photo of the Victoria Park Fountain in its original location, ca. 1920. McCallum Hill building (Scarth Street and 12th Avenue) in the background. Courtesy of the City of Regina Archives, RPL-B0040.

On defining secret spaces

by Rory MacDonald

The notion of secrets in public space is an idea that continues to captivate my thinking and my work. I was quick to suggest, upon arriving in Regina, that this is a public city. My reference point was Halifax, and with the closed streets and confined spaces of Halifax's downtown and urban neighbourhoods, Regina's open spaces caught my imagination. The sense of publicness is by design: the Legislative Building, Wascana Park, and the large boulevards are public spaces, and the sprawling gridded plan on a flat plane leaves little hiding place under the sun.

I am continually caught between two key notions in the relationship of secrets within public space. The first is the idea that the limits placed on freedom, through surveillance of space, make secrets more and more difficult to keep. The second idea, which identifies surveillance as a force which opposes the ability to keep a secret, reinforces a collective sense of an unidentifiable group, a group on the other side of the lens, a secret group — so, in asking how we define a secret space, we must also consider from whom are we keeping it secret.

It would be simple to say that secret places are common to everyone; within a daily walk there are places unique or special to us all. I am interested in the activity of creating secret spaces, and the energy required to maintain a sense of secrecy. I would propose that a secret space is an active space, a self-defined space where we combine memories and actions with locations. I am interested in the spaces we define as secret within public space, and in how we define or keep spaces secret, in the public realm.

I have an invested interest in public space, whether secret or not. Any artist interested in public art, or site-specific work, has a fascination with the meaning of public spaces. It may be that I am simply hoping for more engagement in public space, or, more importantly, I have a desire to think that there is a public or audience for work which exists outside the gallery walls, an audience which need not be invited, but which simply happens.

INSTALLATION

I am fond of word play within the titles of artworks, and this piece is simply called "secret public installation." These paper and stick structures are designed to integrate into public space. They appear to have an unstated public function, although what this might be is not immediately apparent. In their fragile construction, they are designed to dissolve and disappear — to be a temporary measure.

We are bombarded by stories of secret facilities, mostly based in the sciences or in the military (for I have not heard of the secret humanities facilities, possibly simply because they are better at keeping themselves from public view, better at keeping secrets). The war in Iraq, we are told, was in part due to secret supplies and facilities for the production and storage of weapons of mass destruction. As more information emerged about the nature of these secret places, they passed from secret to imagined in the blink of an eye, or the pass of a satellite. One may not be faulted for believing that imagined spaces are far more dangerous than secret spaces, only because such an example is a clear and concise presentation of fiction.

In a secret, there is the underlining concept of threat and power. With the development of aerial photography and the increasingly accurate systems of global satellites, the notion of secret places or secret installations moves from a question of remote facilities out of the public view, to a question of misdirection. A sugar factory becomes an enrichment facility, a children's orphanage becomes a military prison. A small complex above ground hides a larger secret underground facility, all built and designed under the watchful eye.

My secrets are much the same: facilities built in my living room under closed curtains, which are deployed on the city to question the urban landscape. These secret public installations provide a moment of disruption of our understanding of the function of public works.

As a designer and artist, Rory MacDonald's work in ceramics and temporary site-specific installations explores the role and value of materials and structures in public space. He is interested in the function of the public artwork within the city.

Community

by Dave Margoshes

Three in the morning, there's no place
lonelier than the Safeway lot, its ragged carts
lined up under the fluttering phosphorous
like children at a Romanian orphanage,
jagged as teeth grinning in the open mouth
of a sleeping drunk, the community sleeping
not like a drunk, not like a baby
but like a *drunken* baby, its face
blurred with grease paint, its fists curled
in an innocence they haven't thought
of yet at the bagel shop, the bakery
or the tea room, leering at each other
through windows heavy with sleep.

Tonight, Cathedral is sleeping, its head
in the creek, feet on the tracks, both arms
stretched into jumbled traffic, a worried frown
creasing its smooth face as it tosses
and turns. It worries about tomorrow, about
who will clean the litter from its streets,
strip the grafittied posters from the walls,
write the words we've been expecting,
the words in the letter from home, the home
we've left and cannot return to, the absence
at the centre of the page. Instead, we look
across the street to our neighbours,

the blustery people with the barking dog,
the teenagers and the midnight stereo.
The scent of their cabbage rises
into the air like the perfume of lilacs
about to burst into flame
all across the neighbourhood.

In her sleep, one child curls and uncurls
her hand like a damp flower, her face
still red as a bruise from the parade.
It is Paul's child or Brenda's, or Bruce's.
She is dreaming of the fair tomorrow,
the dragon she will be, the tub of water
the pitch will douse her in. She is dreaming
of the woman she will be, the boy
who will haunt her, his muffled car
parked beneath the broken light
in the Safeway lot. She is dreaming
of shopping carts, the empty ones
that grin at her, their teeth filled with seeds,
the full ones that bring her home to the house
on the corner with the cats and the broken
fence, her arms filled with promise.
She is dreaming,
though she doesn't know it,
of community.

Mullin Hardware (no longer open), 13th Avenue. Photo by Don Hall.

Mullin's

by Dave Margoshes

If Mullin's Hardware is really
the centre of the city
as the oldtimers say, forget
the maps, the city plan,
then what of the Centre
of the Arts, Queensbury Downs,
what about Market Square?
They're deserted tonight, empty
as the shells of gypsy moths, their
eyes alight with visions of the city
trembling in their wake, a naked
city, its bum bare as the day
it was born.

Tonight, the city's pulse runs
ragged along 13th, a red current
of light leading – where else? – but
to Mullin's, not just the centre
of the city but the universe,
to hell with the maps
and compasses, to Mullin's,
where a woman in a red bandanna
is dancing alone in the shadow
of the cathedral, its hands thrown up
in joy, her eyes filled with light
reflected from the sputtering streetlamp,
her feet just barely touching
the ground. You and I
are getting to know each other
in ways they haven't dreamed of
at the track or the Superstore,
in ways explained for a dime
in the hardware, third aisle
at the end.

Dave Margoshes is a fiction writer and poet who's lived in Regina for twenty years. His poetry and stories widely appear in Canadian literary magazines and he's published a dozen books. His most recent book of poetry is *Purity of Absence* (Beach Holme Publishing, 2001).

Inside the Quality Tea Room

by Bruce Rice

Inside the Quality Tea Room

...regulars come in from the crisp morning air and the week-end, peer past eye-level curtains as a vapor trail quickens the sky, an inkling of frost in the air — but it's September isn't it? — as the waitress keeps pouring coffee into bottomless cups, her white slacks from Zellers picking up smoke and the smell of the kitchen.

A half lemon pie shines out from its shelf. Two native silk-screens dream up a past on the peach-colored wall. There are three wide-angle prints of Regina, horizons stacking one above the other like upside-down saucers as they make their mental exits left and right of the frame. In the picture on top Percherons wait, air rolls over their necks in a wave, their steady bodies, a prize team of perfectly repeating forms by the side of a train-less station.

In pictures below, the town's been made over the way the Quality Tea Room's been made over from corner store and coffee bar, a top-loaded cooler humming away like a red vault in a victory fortress of canned food and Brillo Pads until the owner and the wire windings of the motor gave way to old age, the buck

 sky-rocket inflation, the kid

 the car

 the Hearing Aid Plan

confused socialism

 and anti-smoking bylaw color-theory décor.

There's a Spanish courtyard where inserted birch trees grow up toward a square blue hole. Their skins are pale as the Czarina's children and they appear to be dying

 of too much shade

 who they are

 and other romantic diseases.

But inside the Quality Tea Room plates clatter. Bored kids scuff their feet in time on the floor as they hunch over tables, chins on their hands and sound games going on in the backs of their mouths

Ladder ladder ladder Stop that.

Ladder ladder ladder *ladder ladder ladder ladder*

Stop That: in this

day after Labor Day cafe where regulars talk Roughriders of '89, the lean years, the Lancaster dynasty. One of the boys wears a green and white hat that says Leask, Saskatchewan. The Safeway meat manager perched at the counter pours over his paper, opens it so, putting finger to thumb with Buddha-like flare.

At quarter past ten the backlit arm of the Co-op clock swings round to a grazing herd of pythagorian cows. One of them raises her head, right ear cocked as she listens to the music of the neighbourhood. She dreams she lives under a cork tree where bands of Moorish gypsies strum their blue guitars and pass through tragic landscapes on their journey into exile.

Then morning swirls in like a dime-a-dance girl and glides to her seat, taking some refuge and maybe some tea. There's no need to ask if she's been here before. She just looks in your cup stirring the leaves.

Pools of violet light drain from the nineteen-cent vases. As the confessional of the coffee booth gives way to dissolving chains of connection, a man slides to his seat in his perfect Valentino, his monogrammed handkerchief D.H.T., with the letters D and H pressed to his lips.

There's a change in the music, a complex Segovian

 beat of invisible fingers

tapping on panes.

Inside the Quality Tea Room the smells and the colors go on in a rain that has lasted for years.

Bruce Rice is a poet living in Regina's Cathedral neighbourhood, not far from the now-vanished Quality Tea Room. He has published three books of poetry. He has received numerous awards including the Canadian Authors Association Award. His most recent book, *The Illustrated Statue of Liberty*, won a Saskatchewan Book Award.

Bigfoot in the City

by Gerri Ann Siwek

132

Gerri Ann Siwek, born in Hamilton, Ontario, has been a Regina resident since 1981. She studied at the Ontario College of Art, the Art Students' League of New York, and the University of Regina. Exploring themes of illusion, belief, and phenomena, her humourous and decorative works have been in numerous exhibitions and the subject of various documentaries. Her "Funomena Mobile Museum of the Weird and Strange" can been seen at www.funomena.com. Her art portfolio can be seen at www.gasiwek.ca.

Editors' Note: Sadly, Buzzword Books (panel 2) and the Orange Popsicle (panel 3) have recently closed — both now "past secrets" of our fair city.

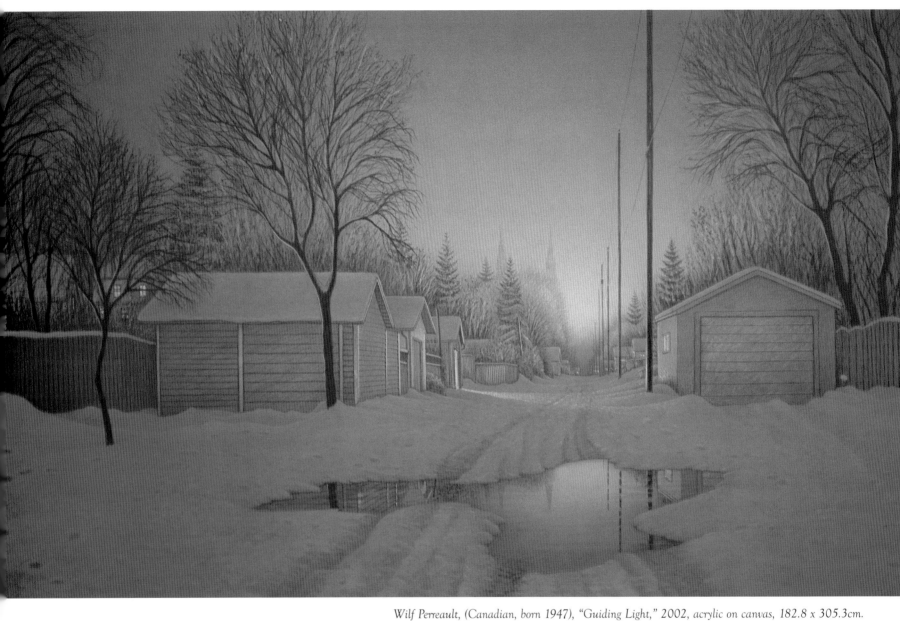

Wilf Perreault, (Canadian, born 1947), "Guiding Light," 2002, acrylic on canvas, 182.8 x 305.3cm.
Collection of the MacKenzie Art Gallery, purchased with funds donated by the Barootes family in honour of
Betty Barootes. Photo by Don Hall, courtesy of the MacKenzie Art Gallery.

The Back Alleys

by Wilf Perreault

Wilf Perreault is a talented, skilled
Saskatchewan artist who is best known for
capturing the hidden beauty found in the
least expected areas of the urban and
rural world — the back streets and roads.

Wilf Perreault, "Reflective Light," 2003, acrylic on canvas, 47.75" x 36". Private collection.

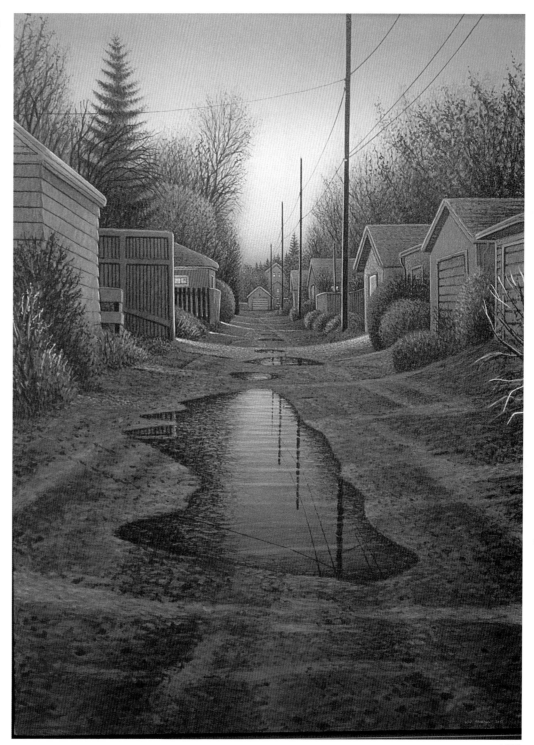

I love Regina back alleys. It is hard to believe that I've been painting them for more than thirty years. I'm probably the only person who paints Regina alleys almost every day, and continues to be stimulated and excited by them.

I usually research the dumpster-lined alleys of Lakeview, Cathedral, the Crescents, as well as parts of East Regina. I do prefer the older, more established areas that, for me, have more character and patina, with their weathered landscapes and mature trees.

In East Regina, in the old area called "German Town," or "Garlic Flats," as Vic Cicansky calls his home area, back yards are generally treeless, with most yards devoted to vegetable gardens. When you walk down these alleys you feel more exposure to a prairie landscape.

Cathedral, Lakeview and the Crescents areas feel more intimate and protected, with overhanging trees and longer fence lines.

Unseen from front sidewalks, the backs of properties show more individuality and the creativity of city dwellers, while the front yards have a more uniform face.

My Regina landscape usually has a horizon line with one-point perspective, drawing your eye by the many receding fences, telephone and power lines.

I do not know this for a fact, but I have been told that Quinn Drive, which backs onto Wascana Park, has the longest uninterrupted lane in the world.

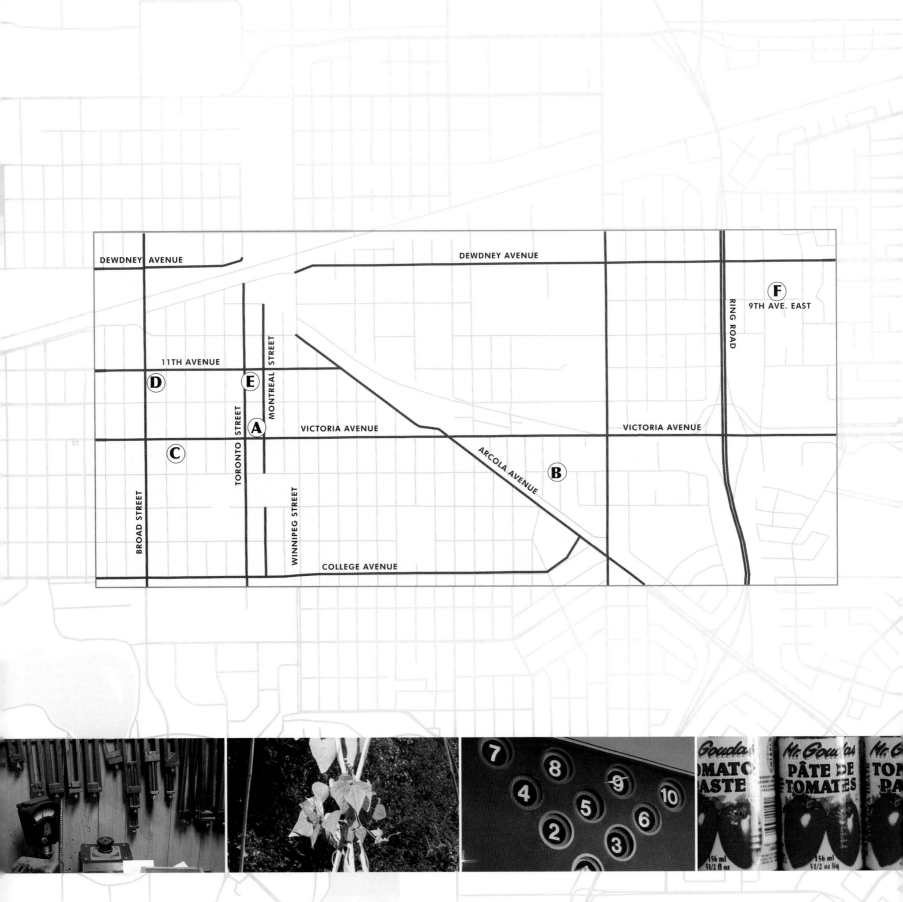

East End

Below: Phil Ambrosi gathering Ludlow mats (matrices) from a Ludlow case.

Right, top: detail of Ludlow mats in the case as Phil selects each piece for the text.

Right, centre: Ludlow composing stick into which the mats are locked up prior to casting.

Right, bottom: the Ludlow (where the metal cast of the text is made) and some of the shop's many Ludlow casting sticks arranged on the wall.

Facing page: detail of Ludlow mats waiting to be locked up in casting stick. The text reads, "as early as possible."

Photos by Seema Goel.

Ambrosi Printers

by Seema Goel

Ambrosi: root Ambrosia, Greek, noun — the drink conferring immortality.

The sound of the Heidelberg press wind-milling its arms, towers of type cases filled with Ludlow type, the feeling of every space being used so that even the air has the smell of ink pressed into it — this is my lasting impression of Ambrosi Printers.

The first time I visited Phil Ambrosi's print shop, I was reminded of fairytales in which the unsuspecting protagonist enters magical worlds through small, unexpected openings. The shop is a labyrinth of towers of type cases, printing machines, type casting equipment, stacks of paper, neatly wrapped packages of completed orders, meticulously crafted wooden shelves and boxes, and piles of supplies. Phil is, above all things, organized. The path weaving through the five rooms making up the studio, workroom and office, is wide enough for one person who is carrying a box to walk through. Waste not, want not.

As the last full-time, exclusively letterpress printer in Saskatchewan, Phil is something of an oddity. His business requires a patient, meticulous, yet quick persona. Having been on the job for 56 years, he is encyclopaedic in his knowledge of printing. Letterpress printing involves creating a metal cast of each word to be used in the text, then laying out all the words, and finally inking and literally pressing the metal and paper together. This is the traditional, mostly forgotten, nothing-virtual, hands-on, the-thing-that-shaped-the-modern-world way of doing things.

My visits often occasion print jobs. Phil allows me to follow him around as he gathers the Ludlow type from one of the angled metal drawers, each labelled with the name and point size of the type (in their corresponding font). Ludlow type, correctly called a matrix, is an impressed mould from which Phil will cast a negative that will be used to print a positive of the word. He offers me a gift, "we will print your name for you." Opening the drawer, he calls out each letter as he gathers it: S E E M A. His hand darts into the correct compartment of the drawer with the corresponding letter as he speaks it aloud. These are added to the stack he holds in their correct sequence. He slides the drawer closed and hurries to the counter to block up the text. Finally, the five letters are cast in a metal alloy (tin, antimony, and lead) which is kept in a liquid molten-hot state in a small crucible on the casting machine.

All of this may seem like simply too much in our current times. Why, after all, spend all that time when my laptop can spit out Century Gothic in any point size? I promise you it is not the same. We have lost touch with both the necessity and the beauty of the real printing press. It is not just a matter of reproducing a string of letters, nor is it a simple case of romancing the past. The letterpress has a different kind of limitation and therefore demands a different kind of imagination. It is full of attention to detail, precision, and nuance.

The last time I visited Phil, he did a debossing job for me, impressing 2,500 cards with an uninked metal plate to produce the text pressed 1/32th of an inch into the paper. He examined the first test card.

"Enough?" he asks, "Or heavier?" The result is sublime, subtle, tactile.

"Enough," I say.

Seema Goel is an artist and writer from Regina. She holds a B.Sc. in biology from McGill, an Associate Arts Degree in fine arts from Ontario College of Art and Design, and an MFA in sculpture from the Rhode Island School of Design.

Pickling Secrets

by Vic Cicansky

When I open a jar of homemade pickles and savour the earthy smells of dill and garlic, it sends me back in my memory to my childhood in the "Garlic Flats." That's where my adventure with pickles started.

When I drive through my old neighbourhood on the way to the big box stores in East Regina, I often wonder how much, if any, of the Garlic Flats survived. With fall harvest in the air and several gallons of freshly pickled cucum-

bers fermenting on my kitchen counter, I went looking for the locations where I first developed a sense of place, where I first learned about gardening and developed a taste for pickles.

I drove east on Victoria Avenue and parked the van. Over the years I had witnessed how Victoria Avenue, where I lived for a time, had gradually morphed into a noisy strip mall community. The ash- and cinder-covered streets I

lived on as a boy, Abbott, Fleury, Harvey, have been paved over for some time now. The two railroads, the CN heading east paralleling Victoria Avenue on the north and the CP crossing Victoria Avenue at Arcola going southeast, defined the boundaries of the wedge of land we called the Garlic Flats. You won't find it on a city map and the tracks have been moved to the industrial area north of here.

Officially the large area of east Regina that enclosed the multicultural Garlic Flats was called Tuxedo Park. The empty spaces that surrounded our small houses and gave us the freedom of the open prairie to make our own trails criss-crossing the neighbourhood have been filled in with houses served by a grid of paved roads. Restaurants and fast-food joints with names like Windsor Castle, Enjoy Gardens and Subway occupy the places where our houses once stood. The luxurious gardens we planted in our front yards and adjacent lots, where flowers grew next to cabbages and trellised cucumbers hung thick and heavy from vines, have been reduced to lawns and parking lots. In a few backyards, where people still love vegetable gardening, pocket-size plots of tomatoes, corn, beans and potatoes attest to the resilience of the ancient and productive earth that was ours to use for a short time.

The only evidence of pickles were dull lumpish shapes in stainless steel trays at fast-food joints. Instead of the smell of pickling brine infused with garlic and dill, exhaust fumes now fill the air. The sounds of squealing tires and big trucks have replaced the brittle sound of trellised cucumber leaves stirring in the wind. The years have transformed the Garlic Flats beyond recognition even as they transformed me.

The experience of growing up there in my formative years has had lasting effects on my art and life. My early exposure to gardening has grown into a love for the earth, an enduring passion for the backyard garden and Bunica's* pickles. It was from her that I learned how pickles were made. I watched her stuff a bunch of dill with flower heads attached into the bottom of gallon jars along with a fresh piece of horseradish and small horseradish leaves. Next, she'd pack the cucumbers in the jars and sprinkle a half cup of pickling salt throughout and insert five or six cloves of garlic and a couple of bay leaves in the spaces between. The jars were then filled with cold water leaving a two-inch space at the top for brine to form. The jars were covered with cheese cloth and allowed to ferment for three or four days. Froth that formed on the top was skimmed off. As the pungent aroma of fermenting pickles developed on the summer kitchen table, the temptation to nab one was more than I could resist. A powerful urge compelled me to participate in a ritual as old as the history of pickling itself. I lifted the cheese cloth covering one of the jars and helped myself to the first pickle of the season.

I grasp the pickle now dripping with brine firmly between my fingers. I bite into it. I close my eyes. I see the history of gardening unfold, smell the freshly turned soil, feel its moist warmth, suddenly understanding the meaning of my grandmother's ancient rituals and traditions of planting, honouring the seasons for the gifts of harvesting and preserving.

Nothing sounds or tastes like that first pickle. Nothing recalls this world more than the first tongue-tingling homemade pickle, plucked reverently from a brimming jar.

*Bunica – Romanian for "Grandmother."

Victor Cicansky (Czekanski) (B.Ed., B.A., M.F.A.) was born and raised in Regina. After extensive studies, he taught at the University of Regina for over twenty years. He exhibits his clay and bronze works nationally and internationally, and is represented in major public and private collections. Although the garden experience is firmly planted in his imagination, it is the garden of the mind which captures his attention.

Details

by Sandra Butel

Facing page:

Top: *"Paste $2.69," Italian Star Deli.*

Bottom left: *"The Waiting room," Blue Mantle.*

Bottom right: *"Kitsch & casseroles," Italian Star Deli.*

Photos by Sandra Butel.

The subtleties of life, of culture and of personal diversity and the process of getting to know the intricacies of the one-of-a-kind, out-of-the-way places, are so much a part of my experience of living here in Regina. My city is made up of a myriad of details that, again and again, bring me back to solid ground and a clear sense of place and community.

Details, like the smile on Linda's face at Thu Thuy Coffee Shop as I walk in with my sweetheart for yet another round of special seafood soup and chicken with Thai sweet chili sauce: the cook's *hello* sings out in the lower ranges, and then he returns to whatever conversation he was having with the group that is normally gathered here. As I do not recognize the literal meaning of the words that are spoken in rapid-fire succession I am left to my own intuition and creativity to create the body of the story and the nature of the exchange. Are they discussing the future of the world, the latest details of their lives or more simply the quality of the performances on the karaoke show that fills in the spaces between their mysterious words? This small room with fewer than twenty-five seats is so full of life that it makes me remember my high school math and principles of inverse proportion.

Details, like the clear tone of the bell as I cross the threshold into the smells and sounds and friendliness of the Italian Star Deli: this family-run institution is spoken of in pure reverence by the secret searchers and foodies of my town, as together we re-experience the fresh olives, the wide variety of cheeses and breads, the deep dark coffee and various other speciality items we can only find here. After a pause and a thought (and some mouth watering) for these foods, everyone inevitably talks about the people who have made that place home, like Carlo and his melodic and rich "how ya' doin'" and his never-failing ability to recollect details about each one of the customers that enter the warmth of the deli.

Details, like the ease with which I have been given status as one of the "regulars" in these places, and others like them, that are scattered throughout my town; I am always welcomed simply and sincerely, my favourite things are remembered, and I am asked about my family, my work, my life. I return again and again to experience not only the fresh and flavourful foods and the richness and diversity of the culture of the people that offer them, but also this gift of being remembered as an individual, as someone whose tastes and experiences matter.

These one-of-a-kind places remind me that I am a part of a community that is made up of subtle shifts in difference like the shifts of colour in a prairie landscape. This profound beauty only reveals itself to those who show great patience, as we take it all in, one detail at a time.

Sandra Butel has been capturing her love of light on film since she was a little girl. Her work, which has varied from subtle black & white to vibrant colour, has been seen around the province in cafes, restaurants and galleries. In 2004, as part of the celebration of 100 years of the city of Regina, Sandra turned her eye and her camera to the streets of Regina – to places she likes to call home and to the vibrancy and life that can be found in the most unlikely places.

The Ukrainian Cultural Centre

by Bob Ivanochko

144

In the heart of Regina's Core area, which is also historically known as Germantown, is the unpretentious building at 1809 Toronto Street, the Ukrainian Cultural Centre. The building is the local office of the Association of United Ukrainian Canadians (AUUC), a branch of the national progressive Ukrainian-Canadian cultural organization. The Regina AUUC is the sponsoring organization of the Poltava Ensemble of Song, Music, and Dance that performs locally and provincially but has established a reputation nationally and internationally for their dynamic performances. The Poltava Ensemble is the only Ukrainian dance ensemble in Saskatchewan that performs with a live orchestra and is one of very few outside Ukraine to do so.

At present the Ukrainian Cultural Centre also houses a school for several Ukrainian dance classes (for various age groups) and a mandolin class. The Poltava Ensemble practices in the building but uses the Performing Arts Centre at 4th Avenue and Angus Street for most local performances, including the Poltava Pavilion during Mosaic.

The present cultural activities are dynamic and important, but even more interesting from a cultural perspective is the history of the neighbourhood in general and of the life of the building in particular. Germantown was the ghetto for the Central and East European working class who immigrated to Canada in the early part of the twentieth century. They took the dirty, poor-paying labour jobs that were essential to building the infrastructure of the rapidly growing city. They built their churches and cultural institutions in this neighbourhood where many original and modern versions still exist. Ukrainians were part of this mix of immigrants, and were known originally as Ruthenians, Galicians, Bukovinians, or more often as "Bohunks," since Ukraine didn't exist until after the Russian Revolution.

One block north along Toronto Street is the Ukrainian Catholic Church, their rectory and parish hall. One block south is the Ukrainian Orthodox Church and rectory. Other Ukrainian halls and businesses are also nearby. The Ukrainian Cultural Centre was built in 1928 by volunteer labour to replace the original building at 726 Victoria Street. It was called the Ukrainian Labour Temple, one of more than seventy branches of the Ukrainian Labour Farmer Temple Association (ULFTA) across Canada. The ULFTA grew out of the Ukrainian socialist movement in Canada and was inspired by the success of the proletariat in the new Union of Soviet Socialist Republics. Their political views were not appreciated by their nearby churches or by the RCMP, which kept them under surveillance. Their political position in support of workers drew active members from other ethnic groups.

The Labour Temple was constantly in use as a social, educational and cultural centre. Immigrants took English classes, children were taught the Ukrainian language. Ukrainian language drama was performed; a mandolin orchestra, choirs and dancers performed. As the Soviet Union became more open, Ukrainian films were shown, and international performers sang and played in the hall. It was also a meeting place for political discussion and was used by the On-to-Ottawa trekkers during their stop in Regina in 1935.

The Core area has changed as later generations moved to the suburbs, the pioneers died and new migrants and immigrants arrived in the city. The hall is still a cultural centre, although most of the participants come from outlying parts of the city. As part of urban renewal the City of Regina has cleared many houses from the area and a new park above a storm water tank surrounds the Ukrainian Cultural Centre. The centre still comes to life most evenings during the cultural year (September to Mosaic) and still houses costumes, instruments, and cultural artifacts. Performance schedules are planned for folk festivals and exhibitions in Vancouver, Disneyworld, and Yalta. The Poltava Ensemble has been invited and is planning to perform in Cuba.

Facing page: Ukrainian Cultural Centre, 1809 Toronto Street. Photos by Don Hall.

Originally from the Ukrainian farming area near Ituna, Bob Ivanochko is a librarian who has recently done research at the Canadian Plains Research Center. He has been involved in political, labour, and cultural organizations in Regina and has served on the executive of the Association of United Ukrainian Canadians in Saskatchewan.

Bolodrome

by Julie Heinrich

Early in 2005, in search of a fresh experience on a winter evening, some friends and I opted to try our hands at ten-pin bowling. Having never explored this entertainment option in Regina, I was undeniably fascinated upon entering the city's only venue for the sport, the Glencairn Bolodrome. From its unassuming exterior and somewhat out-of-the-way location on 9th Avenue East, this place most likely goes unnoticed more times than not, nestled just before the ever-expanding sprawl of East Regina. However, having been lucky enough to embark on a ten-pin

adventure on a cold Saturday night, I discovered what I straightaway considered to be a warm and inviting bowling oasis.

Upon entering the building, I was immediately welcomed by furnishings that make it quite apparent that this business belongs to another era. Square orange lockers stand opposite bright blue canteen counters, while mix-and-match retro chairs and tables provide the bowler with a relaxing spot to slip into those not-so-comfortable rental shoes. Here, amid the rows of shelves containing giant

Julie Heinrich was born in Calgary and moved to Regina in 1992 at the age of fourteen. Although she has always had a strong interest in the arts, it was during her studies at the University of Regina that she developed a serious commitment to pursuing a career in the visual arts. She graduated with a Bachelor's degree in Fine Arts in the spring of 2004, with a major in printmaking.

bowling balls and benches still sporting built-in ashtrays, I found myself situated between two impressive sights. Rows of gleaming, lacquered bowling lanes lie on either side of me, five-pin on the left and ten on the right. Enormous murals of starbursts and lightening bolts cover each of the expansive yellow walls towering over the alleys. Green banners adorn the ceiling lines, celebrating a rich bowling history in Regina. Parked at the forefront of each lane is a vibrant blue ball return, styled with shiny bands of stainless steel, not unlike those found on a classic car. From here each ball emerges, completing its journey from the bowlers hand to toppling pins and back again, illuminating numbers on the brightly coloured scoreboards above each time contact is made.

Glencairn Bolodrome, 1620 9th Avenue East. Photos by Julie Heinrich.

The somewhat dazzling, colourful atmosphere of the Glencairn Bolodrome evoked a certain sentiment within me that had long been buried in my subconscious; memories that I associate with a perceivably *authentic* bowling experience. In my mind I revisit the age of seven, gap-toothed with a bowl haircut and clad in a bright green polyester shirt, standing at the line with a bowling ball gripped tightly in my two hands. Then, and now, as I watch the ball travel slowly down the lane in search of a choir of pins, I am overcome with excitement and anticipation.

147

4TH AVENUE

BROAD STREET

M

DEWDNEY AVENUE

E G

B

K H

D

J

L

8TH AVENUE

I

A

LEWVAN DRIVE

F

C

SASKATCHEWAN DRIVE

ELPHINSTONE STREET

ALBERT STREET

VICTORIA AVENUE

BROAD STREET

WINNIPEG STREET

A

13TH AVENUE

COLLEGE AVENUE

The Tracks and North

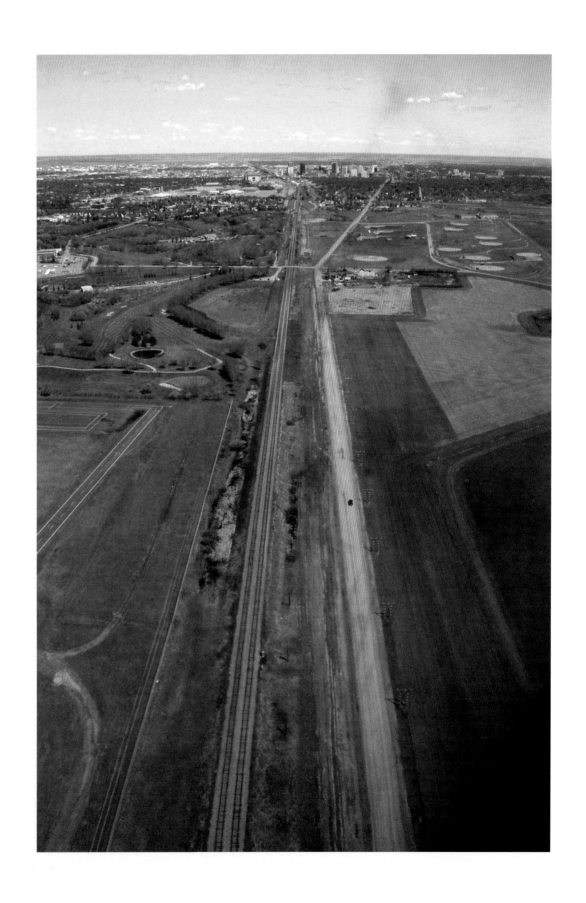

The Tracks

by Charlie Fox

There are the rumours — I don't know what is fact anymore, maybe this is all nothing more than just big-town legend. But this is how I imagine the story.

It happened somewhere in London, England. Or was it Montreal? Toronto, maybe. It would have been a place where money and big plans reside, side by side.

The pencil hovers in the air, sharp point poised to push aside any molecules that might get in the way of the pending trajectory.

A flattened piece of paper has been laid upon a table. A map. In an office full of tables and big paper rolls: rolls and rolls of maps.

This will be simple, this will be easy. Memories of Superior's challenges lay behind and the bulwark of the Rockies were still months ahead. This map is so different, as there are very few marks to indicate contours of elevation, streams, rivers or lakes. This large territory is nothing but a flat, empty space. Blank. Vast. Empty. Nothing on this map should stand in the way of the railway. Not on this part of the map, anyway, and certainly not this railway.

The paper anxiously waits.

A straight-edge ruler is laid on the flat piece of paper. A pencil is steadied in an anonymous hand, the arc from air to paper is traversed, and a straight line is drawn following the ruler's edge across the seemingly blank area of the map. Then the ruler's scale is consulted. The train will need to stop every so many miles, to take on fresh water for recharging the steam engine's boiler. An eye fixes on a point of the scale, the pencil again descends through the air towards the surface of the map and the hand that holds the pencil, connected to the mind that is concentrating on a point of the scale, marks an "x" on the straight line now coursing across the blank cartography.

A pigeon coos outside on a windowsill of the office, horse-drawn carriages clatter and creak as the hooves rise and fall on the street below, mingling with the muffled sounds of people's conversations, talking money and big plans. All seem to be oblivious to this birth of a place that would become a gathering of people and buildings and roads and dreams and disappointments, hardships and happiness.

A town, a home. Not with a river, but instead with a railway running through it.

A line. A line coursing across a huge plain of shortly clipped prairie grasses, no trees to be seen, kept groomed by hundreds of thousands of roaming bison. Traversed by people moving through the landscape, people who for thousands of years moved without a railway. A place of profound, nuanced connections between the people, plants and animals, the clouds and the starlight, the rise and fall of the sun, the moon, the wind and the arc of seasons. A place where one could see and hear all of these things, all at once yet all alone.

A line from which a matrix of grids would grow, pushing away the original people and animals and plants, altering the landscape across horizons with geometric precision. A line along which trains could stop and pass, along which bison bones and human bones were once stacked in huge, cubic piles: bound for money and big plans. A line, which now — at the "x" — defines North and South in a town that really is several towns, those with money and big plans and those without.

There are the rumours and there could be some facts, but this is how one might imagine the story.

Charles Fox is an interdisciplinary artist. Artworks in audio, film, video and multimedia installation have been produced and exhibited in Canada and abroad since 1974. This artwork reflects ongoing interests in social issues, cultural activism and the environment. An Associate Professor in the Faculty of Fine Arts at the University of Regina, he has made Regina his home since 1996.

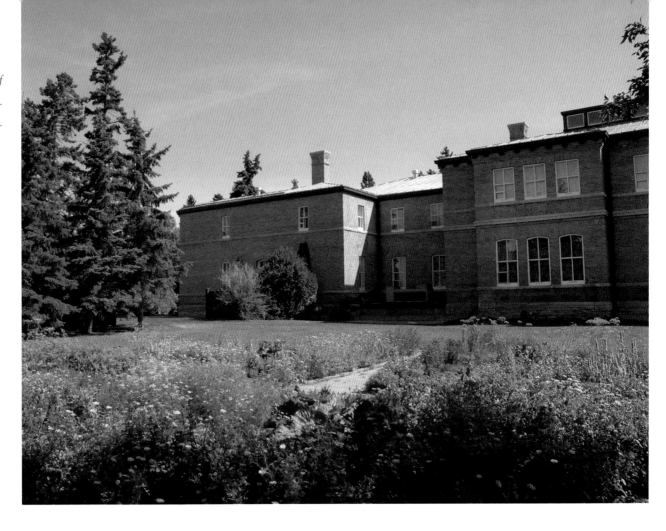

Ghost-house

by Tim Lilburn

Tim Lilburn's most recent book, *Kill-site*, won the Governor General's Award for Poetry in 2003. He has published five previous poetry collections, including *To the River* (1999), *Moosewood Sandhills* (1994), *Tourist to Ecstasy* (1989), and the book of essays, *Living in the World as if It Were Home* (1999). He was born in Regina and taught for fourteen years at St. Peter's College, in Muenster, Saskatchewan. He now teaches at the University of Victoria.

It's 1961 or '62, and we're living on Dewdney Avenue across from a field which, in five years, will be a multi-storey seniors' complex; now there's only grass and a belt of trees to the south. To the west is a park we call the Guvs and Government House. The building is abandoned now; earlier it had been a home for veterans, men in wheelchairs smoking and bull-shitting kids under the arch where the guests of the lieutenant-governor years ago would have been dropped off; later the mansion will be an upgrading school, teaching typing and offering classes to adults who want to get their grade twelve.

Now we look through window dust and see a wooden spoon left on a counter, bread dough still clinging to it; we see dimly the staircase bending into a higher darkness; we see bars on a basement window, one mark like a webbed footprint in the grime. The mansion holds the dead and is haunted; we are beside ourselves all summer.

This is the rural edge of the city: walk through the Government Grounds, the prairie wool of Luther College's one football practice field and you are at Wascana Creek. My brother and I and our friends are gone all day, building rafts and poling them on the green, wind-purpled water; if you wanted, you could start walking from where we are west, through Grassick Park, past a cluster of shacks, then Duck's farm and on to Pinkie. The days are cathedralic. Milk and ice are still delivered by horse; the drivers drop a large circle of iron in the street, an anchor for the horses, while the men disappear into houses. Nothing is happening, the last glacial maximum waits in the shoulders and at the back of the skull. We're eating Borden's Bread, at home, at supper, chewing slowly.

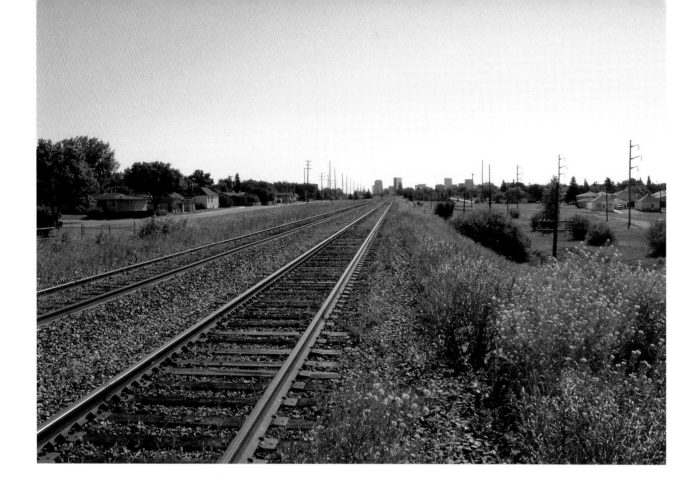

Tracks west of Regina, looking east
back to the downtown area.
Photo by Don Hall.

The C.P.R. on the West Side of Regina

by Trevor Herriot

If there are places where the spiritual reality of the land erupts through the physical realm available to eye and ear, the one that exists in every prairie town is the railway. The whole of Regina, streets, parks, and buildings, may feel like a lid on the land, encrusted with all that obscures the more-than-material presences of creation, but when you walk the rail line on the edge of town, if you are quiet and attentive you may detect a numinous force of nature, weak and persistent as gravity, and every bit as real: the spirit that brought buffalo and wheatgrass into the light of day.

The piece of the rail line I like best is where the Canadian Pacific Railway leaves the city west of the Lewvan – in particular, from Connaught Street west all the way to where Courtney Street runs past the R.C.M.P. fields and crosses the rails. When the C.P.R. was built in the 1880s, they claimed a wide easement all across the plains that for the most part has been left undeveloped – which means that the syndicate that transported settlers and their ploughs to the ancient grasslands, over time destroying 80 percent of the bioregion's native habitat, has inadvertently helped to conserve narrow strips of that same habitat. The small tatters of mixed grass prairie running along the south side of Regina's portion of the C.P.R. are fast disappearing beneath the advance of smooth brome grass and other aliens, but for now they are virtually the last spots where the old growth grass can be found within city limits.

If you go, and if you can ignore the lumber, old tires, and other junk along your walk, each glimpse of three-flowered avens, each phrase of meadowlark song will take you one step nearer the world we have forsaken. It is a piece of unloved and leftover land, not beautiful by any conventional aesthetic, yet it remains a testimony to our passage in this region, and a place, too rare in this city, where the earth can be heard to speak above the clamour of human agency.

Trevor Herriot is a naturalist and non-fiction writer who has published two books: *River in a Dry Land* and *Jacob's Wound*. In the summer of 2006 CBC Radio's *Ideas* produced his two-part documentary on grassland birds. Herriot is currently writing a book on the same subject. He lives with his wife, Karen, and their four children in central Regina, where downtown and the first meadowlark song on the edge of town are both a short walk away.

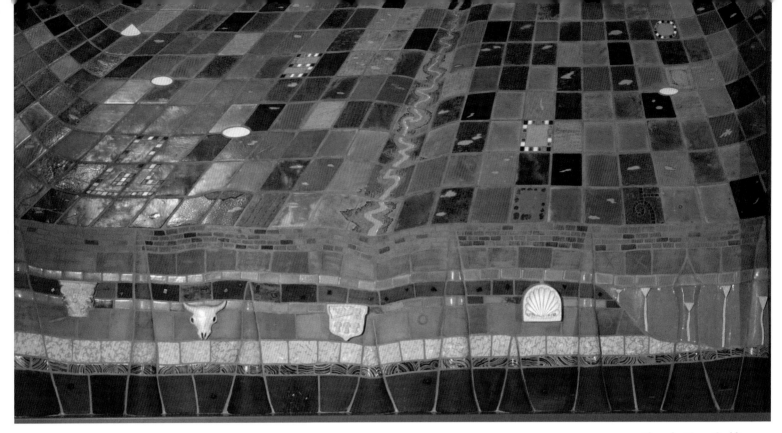

Photo by Terry Cuddington.

Lorne Beug's "Patterned Ground"

by Jeannie Mah

* "Patterned Ground" was a commission made for the City of Regina Civic Art Collection.

Jeannie Mah is a ceramic artist whose work is exhibited nationally and internationally. She has studied in Regina, Vancouver, Banff, Perpignan and Paris, and has done independent research in London and Cambridge, England. She maintains a studio in Regina (near Wascana Pool and the RPL Film Theatre, both within easy biking distance).

Lorne Beug's ceramic mural at the Lawson Pool/Fieldhouse is my favourite work of public art in Regina.

"Patterned Ground"* (1987) is prairie landscape as open book. Subterranean and aerial views of a prairie landscape acknowledge that geography and geology are the foundations of our knowledge of this region. A glacial-cut river valley meanders down the middle of this flat chequerboard prairie, to become the centre of the open book. Underneath the man-made patterns on the surface of the earth are geological strata, each acting as a "page," embedded with historical, mineral, and cultural icons. Bricks from Claybank are immediately beneath the cultivated surface of this imagined landscape. Immediately under the bricks is a scattered layer of crisp mason-cut stone, bearing the carved Roman letters A E R X Y, which leave a cryptic underground message. Buried further below are found a Corinthian Column, remnant of European history and philosophy which migrated and took root in North America; a buffalo skull from the region; the Saskatchewan Crest, with its British Lion and three wheat sheaves, laying claim to dominion and empire; and a shell niche along with prehistoric plants which may refer to Saskatchewan when it was a former inland sea, as well as to the domestic space of home and settlement. The other layers — molten lava, Tyndall stone, crystallite shapes and malachite, or perhaps an underground aquafer — all emphasize that our knowledge and history are founded upon landscape, location, and geology.

References to its site, the Regina Field House and Lawson Pool, are depicted by fields and ponds on the land, so that the field and pool are "cultured," first, by the cultivation of the natural prairie, and second, by their *re*-creation in the city and indoors. The cultivation of the land sustains our bodies with nourishment; recreation sustains our bodies and minds through physical exercise and activity, and art sustains our reflective spirit.

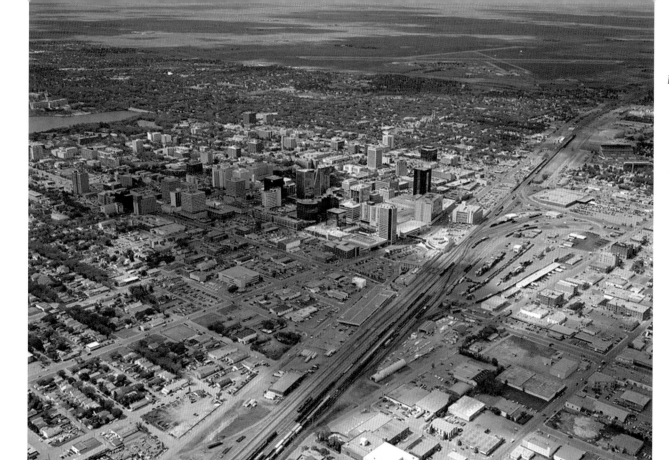

Photo by Don Hall.

Regina, Capital of the 21st Century

by John McCullough

PART I - FIREWORKS

On an early summer evening in 2003, Reginans gathered around Wascana Lake to celebrate the city's centenary (it was incorporated June 19, 1903). On the south shore, the provincial legislative building was resplendent. Its design is English Renaissance, and it has always boldly proclaimed its imperial intensions. Construction began in 1908 and, though interrupted by the tornado of 1912, the building was completed in 1914. In 2003, from the north side of the lake, the building's reflection was stunning, lit as it was for grand, dramatic effect. The event itself was billed as an "historic" event, for it was to feature the province's most spec-

tacular fireworks display. As for the lake, Wascana was "man-made," reportedly by 2,100 men with hand tools as part of a 1930s dustbowl relief project. But it was dug only one-and-a-half metres deep. In this centenary year, the lake was to get "expanded" to 5 metres. In part, this was to avoid the weed growth which annually clogs the lake with vegetation through much of the summer. As for the fireworks, they were worth the wait. As bursts of sulfur and flame reflected off the lake's surface, silhouetting the variety of kayakers and canoeists who had a prime seat for the spectacle, loudspeakers pumped music and a spoken word history of the city throughout the park. This triumphant narrative

John McCullough teaches in the Department of Film at York University. He has a PhD in Social and Political Thought and he was the first coordinator of the graduate programs in Interdisciplinary Studies in Fine Arts at the University of Regina. His current research includes analysis of popular Hollywood films, Canadian regional television production, and the utopian and resistant characteristics of contemporary indigenous and First Nations culture. He was born and raised in downtown Regina.

Wascana Park. Photo by Don Hall.

lyrics which passionately describe the plight of dispossessed youth, describing in the chorus their "teenage wasteland." This counter-culture anthem is often recalled as a precursor to the punk movement of the late 1970s, but it seemed a curious choice to conclude a celebration of a century-old city. But the trick was that, while the show appropriated the triumphal spirit of the instrumental section, the fireworks were timed so as to conclude just before the first lyrics were sung. You may remember that the lyrics go something like this: "Don't cry, don't raise your eyes, it's only teenage wasteland…"

I am still perplexed by the generalized indifference to the profound connotation that this confusing event suggests (both on the part of the producers and the assembled throng), but it does speak to postmodern conditioning and indifference within media culture. The cruelest irony, though, is that a "teenage wasteland" is exactly what Regina represents for the young, whose rates of unemployment run as high as 20 percent ("Natives in Canada"). Even the Russian Space Agency, which recently deemed the desolate and empty rural landscape around Regina suitable for satellite crash landings, is imagining the region generally as a wasteland (Spears). Regardless, what is most striking about this wasteland is that it is fully integrated within the cybernetic network of contemporary and cutting-edge technology design and service infrastructure — it is "on the grid." Increasingly, as the earth's surface is at a premium, Saskatchewan serves a unique role in providing large tracts of abandoned land that are nonetheless serviced by urban centres specializing in high technology and science research. This situation has developed as the province's population, which has stayed roughly the same for seventy years, has become urban-bound. The province's two largest cities (Saskatoon and Regina) have slowly expanded to now accommodate approximately half the province's population, leaving thousands of square miles of land for experimentation by agri-business and earth and space science projects. While the cities are illustrations of the discourse of progress, the rest of the province tends to experience forms

was accompanied by an increasingly spectacular light show, and it concluded with an explosive celebration of the city's progress in its hundred years.

The show came off without a hitch, people cheered, and then quickly ran across Albert Street Bridge, to their homes and cars. It is worth noting that the bridge is rumoured to be the longest bridge span over the smallest stretch of water — Wascana Creek. There is an implication of overdevelopment in this story, and one might also want to think of it as an illustration of the phrase, "much ado about nothing." Curiously, the song which accompanied the finale, the British rock group The Who's "Baba O'Reilly," points in the opposite direction towards *underdevelopment* and, though it did not deflate the moment, to my mind, its sub-textual resonance said more than all the self-promotional historiography. For those who know the song, the long instrumental introduction leads to a series of

of devolution, provocatively illustrated by the extraordinary increase in the number of ghost towns that now exist in the province. This type of uneven development speaks to fundamental issues in globalization and neo-liberal economic restructuring of the world, but for residents it sends a fairly unambiguous message about the future of Saskatchewan. In brief, the province (once considered the "breadbasket of the world" and a world leader in social democracy) is becoming irrelevant as a jurisdiction in global affairs, but its nodes of development (for example, the cities) and its expanses of underdevelopment are being folded into the larger logic of the new global order. This zone is transforming into a model of instrumentalized space in the twenty-first century. I can only imagine that on their way home from the centenary celebrations that night, young and old alike were singing the words (in their heads) of "Baba O'Reilly," coming to a conclusion about Regina that was shockingly accurate and potentially subversive, but one that could not be consciously expressed for fear of rupturing the euphoria of celebratory regionalism, as it is stage-managed by local business and distant owners, politicians and policymakers. Teenage wasteland, indeed.

The use of this region to control and rationalize space is not a new phenomenon. In its role as an anchor in the British and Canadian colonization of the central plains of North America, Regina was built as a CPR "train town" (along with Virden, Manitoba, and Fort Qu'Appelle and Moose Jaw, Saskatchewan) and, by most accounts, had no discerning traits other than its wretchedness. As the Manitoba *Free Press* editorialized:

> Situated in the midst of a vast plain of inferior soil, with hardly a tree to be seen as far as the eye can range, and with about enough water in the miserable creek to wash a sheep, it would scarcely make a respectable farm, to say nothing of being fixed upon as the site of the capital of a great province (cited in Nader, 296).

Among the various prairie CPR sites, Regina was reputedly the one most despised by the crews. Nonetheless, by the time of the arrival of the CPR in 1882, the site was already designated the capital of the North-West Territories. It was registered as a town in 1883, incorporated as a city with its current name in 1903, and then became capital of Saskatchewan when the province was founded in 1905. The CPR main line intersects with the downtown centre at Hamilton Street, and it was here that the train company built its station which, after being abandoned in the 1970s, was refurbished and expanded to house Casino Regina. This site is the epicentre of colonialism's heritage in Regina: it is the heart of "shock corridor."

PART II – SHOCK CORRIDOR

Throughout Regina's history, this section of downtown has come to serve as a boundary between haves and have-nots, in a relatively transparent but highly effective strategy of containment. "Shock corridor" is a strategy for colonial control: it is a physical barrier, to be sure, but it is also a metaphor that actually shapes the way Regina is imagined by its citizenry, and how power relations are legitimated in the city. Built away from First Nations settlements, which were typically in valleys and close to trees and bodies of running water, Regina was organized by the logic of "the grid" of transportation science, topographical rationalism and speculation, as well as colonialism's "rule from a distance." In this sense, right from the beginning, the centre of Regina, "shock corridor," has served as the horizon of meaning in the city. It runs parallel to the CPR mainline, from east of the downtown core to the Royal Canadian Mounted Police (RCMP) training facility on the west end of town. The geopolitical value of this parcel of land is directly related to its role as a barrier between Regina's north and south ends. Over the years, Regina's original urban planning has assured an extraordinary degree of regimentation and rationalization of neighbourhoods, services and residents.

In 1935, in the midst of the Depression, when unemployment for young men ran above 20 percent, Regina played host to one of the most notorious and violent repressions of populist rebellion in Canadian history. In

fact, Regina has a record of such repression. Although minimal in terms of the number of events, this history is notable for the significance, the "quality," of the events. For example, in 1885, the colonial government, represented by Lieutenant-Governor Dewdney (who gave his name to the street that serves as the northern border of "shock corridor"), hanged Louis Riel for leading a rebellion against dominion rule in the region. Although the battles took place in Batoche (400 kilometers north of the capital), it was Regina that captured international media attention when Riel's incarceration and trial were moved there in May. With media eyes watching, Louis Riel (Roman Catholic, Métis and from Manitoba) was convicted of treason by a jury of local white Protestants, and hanged on November 16, 1885. Until recently, Riel's trial was re-enacted annually at Saskatchewan House on Dewdney Avenue, the former centre for colonial territorial rule. Just a little southwest of that, on the far west end of "shock corridor," the RCMP Museum still displays the noose that was around his neck on that day. This violent act sealed the colonial project in blood and signaled the intention, on the part of the British and Canadian ruling elite, to pursue not only land control and acquisition, but also an intensification of the capitalization of the prairies. This meant "clearing the land," and we can see that the propaganda effect of Riel's execution (although many have suggested that this was actually a political assassination) sent a message, to use contemporary lingo, of "shock and awe."

This strategy of law and order shock effect was mobilized again fifty years down the road, and again to powerful propagandistic effect. During the early evening of July 1, 1935, local police and members of the RCMP assembled east of what is now considered the city's downtown, in Market Square, by police headquarters and the fire hall. Their intention was to monitor and control a large rally in support of the extraordinary anti-poverty initiative called the "On-to-Ottawa Trek." The trek was a unique grassroots political project initiated by unionists, the unemployed, and Common Front activists. It began in the federal govern-

ment relief camps in British Columbia, and moved east along the CP railway to Alberta, gathering hundreds of supporters on its way to Ottawa and an eventual showdown with Prime Minister Bennett. The march was delayed on June 14 in Regina, when the trains were stopped at the Elphinstone street crossing: at that stage, the trek had barely entered "shock corridor." The trekkers were moved off the train cars and housed in animal stalls at the Exhibition Grounds, and negotiations began in an attempt to arrange for the resumption of the trek.

Unbeknownst to most of the trekkers, Ottawa had given orders to halt the march, and Regina was seen as a strategically expedient site for the dismemberment of the protest. On the one hand, the authorities had access to a monopoly of military might, including massive police manpower. In particular, with the RCMP training facility at the the west end of the city, where the recruits were housed, there were significant numbers of dominion troops. The other feature of police strength and presence was they could easily surveil and control not only the space where the trekkers were bunked, but also the spaces where they held marches and meetings. This was in part due to the fact that the RCMP were located both in the west end and in the centre, where their 'F' Division cells and offices were located. Additionally, municipal police were located on the east end of "shock corridor," CPR police operated out of the station at the centre of town, and a federal military armory was located at Exhibition Grounds, in the west. The trekkers were in the city for two weeks before the Market Square rally, living in barns, jobless and homeless for many months, contained by police and military presence. The July 1st rally ended in violence and the "Regina Riot." One policeman died and several hundred police, citizens, and trekkers suffered a variety of injuries. The repression of the protest was successful and the last report of trekkers leaving town was July 5th — the trek to Ottawa was history. Property damage was significant, especially along 11th Avenue, the main route of the moving riot (*see* Figure 1, page 159). Proof that the riot was anticipated by the population was the

record of increased purchases of "riot insurance" by the merchants along 11th Avenue, only days before the rally (Howard, 160).

In all respects, the government had used its control of space in highly strategic ways, and I want to suggest that, as well as being a physical space, "shock corridor" is a conceptual and cultural space which has helped legitimate colonialism to the present day. For instance, because of the city's original conservative urban planning, "south of the tracks" is still a term used to designate the residential and recreational space of the city's professional middle-class and ruling elites. This reflects the logic of speculation by financiers and investors in the 1880s, who invested in the lands that lay south of the proposed trans-Canada CPR track. In the case of any Canadian "train town" that is divided by the track east to west, the south side of downtown and the original built environment will typically represent a distinct class privilege over the north side, while the east side of such cities typically marks the first sites of settlement and communal residence (for example, in the case of Regina, so-called Germantown, an early community in the area, lies slightly east of what is currently thought of as "downtown").

PART III – A TALE OF TWO CITIES

In Regina, the city centre is understood to be the uneasy boundary zone between two worlds, and those with social aspirations try to avoid ending up "north of the tracks." On the south side of the corridor is the downtown district, which has the City Hall, the Cornwall Centre, the Scarth Street Mall, the Regina Public Library main branch, and several government and industry office towers. Not surprisingly, various attempts to revitalize the city core have ultimately been attempts to forestall the progressive underdevelopment of "shock corridor," and the possible leakage of the poor into the south end of town. Historically, the area north of the tracks, now known as "North Central," was a mix of residential, commercial and industrial space, predominantly working-class with a sizeable lower middle class population (e.g., teachers, contractors, bureaucrats). The working population in the neighbourhood was employed in railway work, warehouse labour, and a variety of industrial shops in the zone from Winnipeg Street to Albert Street, north of Dewdney Avenue to 4th Avenue (including, for more than a decade, a General Motors assembly plant that was closed in 1939). Suburbanization of

Figure 1. Map of Regina Riot route, July 1, 1935.

industry and housing in the 1960s created a "core burn-out" effect that was fuelled by subsequent underdevelopment of downtown. Very quickly, houses in the core were sold for quick exits to the northwest and sometimes south. These core houses tended to fall into a cycle of short-term ownerships, absentee landlordism, and value degradation — this followed standard U.S.–style "burn-out" and "white flight" patterns. Services declined or disappeared along streets like Dewdney Avenue, Albert Street, and 4th Avenue where, until the 1970s, there were a number of grocery stores, butchers, bakers, medical offices, convenience stores, and light industrial shops (for example, light metal and electrical works, gas stations with mechanics, lumberyards). In fact, Dick Assman (who gained international notoriety for his name through David Letterman) is a good example of this tendency, as he moved from running a service station with mechanics on Dewdney at Garnet in the 1970s to owning a station in the east end on the highway out of town, come the millennium.

In the late 1970s, the core became universally associated with underdevelopment and dilapidation, not just working-class "low-brow taste." The development of affordable family-size houses in the suburbs and the suburbanization of most industry (for example, Ipsco and the refineries were north of the city) had gutted "shock corridor" of working-class paychecks. Land cost and rents were depressed, the area's tax base shrunk, a variety of social housing in-fill was introduced (including low-income housing and half-way houses), and schools were closed or down-sized (for example, Albert Public School and Scott Collegiate). From the 1960s, the area's new residents were increasingly migrating to the city from depreciated rural contexts. This included First Nations people from nearby reserves who had moved to the city to avoid high levels of joblessness, poverty, and disease. From the 1970s, the "shock corridor" narrative is not only about class war, but also profoundly about race relations. In an effort to control the mobility of both the poor and Aboriginal populations, house prices and rental rates have been used to restrict movement. This can be seen

in the Cathedral area, the Transition area, and Broders Annex, all buffer zones which have been usefully deployed at various times to absorb advances from the poor. As sites of gentrification, these areas slow down the movement of poverty south of the tracks by artificially inflating the value of land rent.

Regina's rigorous grid, in particular "shock corridor," defined by class and race, is not only a window into what has developed, but it is also a template upon which Reginans cast their dreams and aspirations. Getting "to the right side of the tracks" has significant inducements. For instance, in a manner that leaves no room for confusion, the city's "jewels" are kept in the south end (for example, the airport, the Royal Saskatchewan Museum, the Fine Arts conservatory, the Douglas Cardinal–designed First Nations University of Canada, Wascana Park, the CBC studios, the film sound stage, the tennis club, the university, the research park, the Legislative buildings, the Mackenzie Art Gallery, the Science Centre with its IMAX theatre, the Saskatchewan Centre of the Arts, Chapters bookstore, Blockbuster and Rogers video outlets, up-market liquor stores, movie theatres and malls) (see Figure 2). What remains on the north side of the tracks, especially the core, is its own inducement to "get south." Houses are poorly maintained, and rentals are controlled by a handful of slumlords who each own dozens of properties. The concentrated ownership inevitably leads to rate inflation and a de-emphasis on upkeep and maintenance, let alone new investment. In the six cold winter months, it is astronomically expensive to heat these structures, so many residents of the area live in partially heated or non-heated houses. There are no grocery stores in the core area, no butchers or bakers, but the city's two hospitals and police station headquarters and its neighbourhood outreach precinct (attached to what remains of Scott Collegiate) are located there, as are the Casino and the Horse Racetrack, as well as a variety of liquor outlets, pawn shops, fast food outlets, and sex trade stroll zones.

"Shock corridor" is not only a tract of land — it's a

state of mind. It is an ideological strategy of colonial control, a "common sense" or "cognitive map" that institutionalizes underdevelopment (Jameson). Amongst the population, there is a rich history of urban semiotics which describes all of this in shorthand. Regina youth typically call "North Central" the "hood," making explicit reference to ideas about ghetto life that are derived from American movies and music. It seems the city's planning department, which gave the area its name, is intent on encouraging the population to make this connection, given the homophonic correspondence between North Central and Los Angeles' notorious South Central. By contrast, older generations typically call the same area "the rez." White folks, of course, use this as a derogatory term, while First Nations people

Figure 2. Shock corridor and Regina's "jewels."

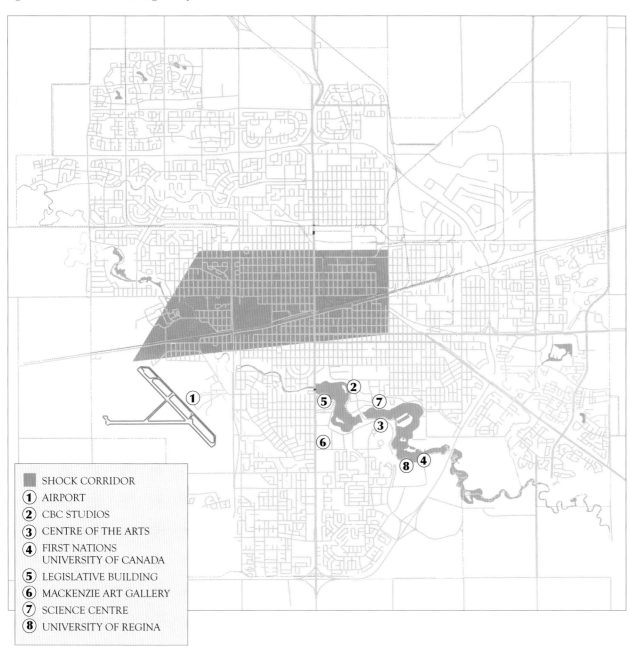

SHOCK CORRIDOR
① AIRPORT
② CBC STUDIOS
③ CENTRE OF THE ARTS
④ FIRST NATIONS
 UNIVERSITY OF CANADA
⑤ LEGISLATIVE BUILDING
⑥ MACKENZIE ART GALLERY
⑦ SCIENCE CENTRE
⑧ UNIVERSITY OF REGINA

Tracks west of the city. Photo by Don Hall.

generally use it to describe the phenomenon of First Nations migration to the city but, more crucially, it is also intended to capture a sense of the lingering and expansive colonialist-imposed poverty that is part of reservation life, which is, of course, being reproduced in the city. This range of age-influenced perceptions of urban life is very rich, and suggests something about the type of politicization which has attracted First Nations' activists to draw radical connections, trans-generationally, between urban class and race politics, colonialism on the reservations and racism in global capitalism.

PART IV – MEMORIES OF UNDERDEVELOPMENT

The logic of the times suggests that we should think of cities like Regina as moving into the new millennium with a solid history of pioneer perseverance behind it, and a current citizenry excited by its role in the twenty-first century. In particular, we imagine that the city's survival strategy must have involved adaptability and change in the face of necessity — the very roots of evolution. And we reserve for places like Regina a status of innocence and naïveté that suggest they have nothing to do with the apparatuses and personalities

that run the world. We could imagine the new suburban developments, for instance, as reflections of the unfolding promise of progress, a democratizing of wealth. My claim, however, is that a more vivid and accurate image of the future for Regina is achieved through critical evaluations of urban geography, or as David Harvey calls it, historical-geographical materialism. Here we see the suburbanization project as both a renewed attempt at middle-class escape (that is, "white flight"), but also a result of the specific operation of "shock corridor," which encourages movement of capital away from the core, expanding colonization outwards and the absorption by large land holders (including governments) of substantial tracts of abandoned land downtown.

The shortcoming of this process is the generalized devaluation of everything and everyone at the centre of the colonizing project such that poverty, malnutrition, racism, policing, hospitals, cheap weapons, prostitution, liquor outlets, addiction, disease, institutionalization and homelessness significantly influence life in the core. In fact, the skeletal "free market" remains which linger in the area (for example, fast-food restaurants, stereo shops, car dealerships) make us aware, in banal but crass ways, of the necessary integration of capital and land in colonial rule. Here, contemporary capitalism, in the shape of a golden arch reaching above the teenage wasteland, exposes its age-old techniques and stratagems, which poke out of the landscape just as though they were a "pile of bones," to recall the original name of the city. Here, memories of development remain like so many sentinels and beacons, within the strafed landscape, serving to confirm the advance of "civilization" and "progress" to these regions. To see underdevelopment and urban containment in cities like Regina is to understand something about how the twenty-first century will see the development of "outpost" towns. These will be the centres of population for what remains of centralized governance of the regions and, to this extent, they remind us of Canadian literary critic Northrop Frye's concept of Canadian "garrison" mentality, as well as encouraging us to anticipate a

world that is like a sci-fi film, in which industry and state collude to colonize the galaxy through a series of proxy settlements. In all this, cities are surveilled and their populations monitored through a variety of technocratic grid-maps (for example, satellite maps for agri-business, weather, policing, military, transportation, communication) which allow for optimum social control. Along these lines of thinking, it is useful to recall that Regina is the first Canadian city to use "blue lights," which is a system that discourages IV drug use in public spaces by making it difficult to see veins in the blue light (Smith). With all this contributing to the *mise en scène*, it is not too difficult to imagine Regina as a future outpost, lit in blue *chiaroscuro* (like a James Cameron movie), viewed from satellites in space and perfectly mapped onto a grid on the viewing screen (as in some of the *Alien* films). Regina is the capital of the twenty-first century. Of course, if that is the only option, then there is no progress, only a time loop of capitalist development of the great plains.

To imagine a radical alterity — a definitive break with the colonial past — is to imagine cities that are not garrisons or outposts, but really functioning neighbourhoods. Underdevelopment is a strategy of segregation, and this is clear in the development of Regina's downtown core. The devaluation of life which has been associated with this area will only end when the "shock corridor" is scrapped. This may happen as a result of continued devaluation of the area, which can be seen as a typical consequence of underdevelopment in colonialism. In contrast to this scenario of devolution and devaluation, resistance to "shock corridor" is going to involve mass organized struggle against colonialism, class and race war, and apartheid. This is not simply a downtown rejuvenation project — as I have argued, that would achieve the exact opposite goal. It would prolong colonialism. The social movements that will instigate radical change in the interests of human rights in these areas will, of necessity, also be making claims about land rights. Any answer to such challenges will have to include reparations for theft and damages to First Nations' land, and the

rightful resumption of First Nations' sovereignty over the area.

My analysis of Regina has really only pointed to the obvious, which is that life on the prairies is still about the contest over land. In this sense, real and "cognitive" maps of Regina tell a provocative story about its past, present and future, stories not fully evoked by a linear chronology. I have argued that this urban space achieved a workable shape and form early on (from the perspective of colonial interests), and this organization of urban space is reproduced as a template of order in all times of crisis, including the contemporary restructuring of capitalism which has been called globalization. In Regina, "shock corridor" is the historically preferred spatial strategy for population control, and we see it currently used as a way of projecting entrenched white colonial presence on the great plains, into the third millennium.

Floor of Antonini Flooring, 1544 Albert Street, now Flaman Fitness. Photo by Don Hall.

SOURCES

Brennan, J. William. 1989. *Regina: An Illustrated History*. The History of Canadian Cities Series. Toronto, Ontario: James Lorimer & Company, Publishers and Canadian Museum of Civilization.

Dale, Edmund H., editor. 1980. *Regina: Regional Isolation and Innovative Development*. Western Geographical Series, Volume 18. Victoria, British Columbia: University of Victoria.

Drake, Earl G. 1955. *Regina: The Queen City*. Toronto, Ontario: McClelland & Stewart Limited.

Harvey, David. 2001. *Spaces of Capital: Toward a Critical Geography*. NY: Routledge.

——. 1990. *The Condition of Postmodernity: An Enquiry into the Origins of Cultural Change*. Cambridge, Mass.: Blackwell.

Howard, Victor. 1985. *"We Were the Salt of the Earth!": A Narrative of the On-to-Ottawa Trek and the Regina Riot*. Regina, Saskatchewan: Canadian Plains Research Center, University of Regina.

Jameson, Fredric. *The Geo-Political Aesthetic: Cinema and Space in the World System*. Bloomington: Indiana University Press; London: British Film Institute, 1992.

Levin, Earl A. 1993. *City History and City Planning: The Local Historical Roots of the City Planning Function in Three Cities of the Canadian Prairies*. Published PhD Thesis. Winnipeg, Manitoba: University of Manitoba.

Massey, Doreen. 1994. *Space, Place, and Gender*. Minneapolis: University of Minnesota Press.

Nader, George A. 1975–1976. *Cities of Canada*. Vol. 2. "Profiles of Fifteen Canadian Metropolitian Centres." Toronto: MacMillan of Canada.

"Natives in Canada suffer from high unemployment." 2005. Indianz.Com. www.indianz.com/news/2005/008747.asp. 14 June.

Smith, Graeme. 2004. "Regina bars get junkie blues." *The Globe and Mail*. 23 September.

Spears, Tom. 2004. "Sask. picked as landing site." *Regina Leader-Post*. CanWest News Service/Canada.com News. www.canada.com/com. 7 January.

west nile rides crow wings

wonder if it is safe to hop

at the crow hop

madmen proclaiming half-truth gospels

"Damn communists! damn half-breeds! damn crow hop!"

itwêw the king of the queen city

swinging scoundrels

saddled up

check their gear

beckon lost gods and idols

drowned in 70s funk

twitching itch

streams of sounds

fractured by laughs and beats

poets, midnight prophets

finding solidarity

preaching the gospels of insanity

indulgence and madness

light saturated

shadowing musicians and poets

getting down, down,

down below the optic nerve

with the smell of kîskwêyâpasikan

in the air

giving us messages

without expectations

The Exchange was where the Crow Hop was born and flourished. It brought together poets, musicians, comedians and people for nights of song, stories and tomfoolery. It is interesting that Regina, which in Cree is oskana kâ-asastêki (which means "Pile of Bones") has now become a place of cultural rebirth for Aboriginal people. Photo by Don Hall.

Crow Hop

by Neal McLeod

from *Songs to Kill a Wîhtikow* (Hagios Press, 2005): 85.

Associate Professor of Indigenous Studies at Trent University in Peterborough, Ontario, Neal McLeod is a Cree painter, writer, filmmaker and scholar from James Smith First Nation. He studied art at the Umeå Konsthögskola (Academy of Art, Umeå, Sweden). He obtained his M.A. in Philosophy in 1996 from the University of Saskatchewan, and his PhD from the University of Regina. In the fall of 2005, his book of poetry entitled *Songs to Kill a Wîhtikow* was a finalist for three Saskatchewan Book Awards, including Book of the Year. He is also the leader of the comedy group called the Bionic Bannock Boys, whose work has been featured on CBC radio. Their film, *A Man Called Horst* (2002), received national attention and was screened in Berlin. He was the co-founder of the now legendary Crow Hop Café which has been a showcase of Aboriginal talent. He is currently working on his second book of poetry entitled "Gabriel's Beach."

The Territorial Administration Building — Mystery and History

by Aydon Charlton

My brothers and I were lucky to grow up on the 1400 block of Athol Street. Right across from home were the Dewdney Pool and Playground. To the south of the playground, on Dewdney Avenue between Athol and Montague streets, stood the historic but rather mysterious tan-brick building where, from 1891 to 1905, a handful of civil servants had administered the entire North-West Territories. From 1905 to 1910, while the magnificent provincial legislative building was being constructed south of Wascana Lake, the Second Empire–style Territorial Building became the site of the legislature of the newly created province. Then it was used as a training school for immigrants from Eastern Europe, and later as a school for the deaf and for mentally handicapped children. By 1924, the Salvation Army had leased the building and would provide a hospital and residence for unmarried, pregnant women until 1971.

But my ten- and twelve-year-old friends and I didn't know that. During the long, hot summers of the late 1950s, we would get tired of playing pick-up baseball games on the dusty diamonds of the Dewdney Playground and swimming at the Dewdney Pool. To relieve our boredom we would climb over the tall fences and sneak through dense caraganas into the dark, secluded grounds of the Salvation Army's Grace Haven for "unwed mothers" — a place of unfathomable mystery for prepubescent boys. There we would search for garter snakes, dig up and devour carrots from the Sally Ann's bountiful gardens, and gape in wonder at the bulging young women who never went out in public, and of whom no one ever spoke.

In those days, the plight of young women who found themselves "in trouble" and "in the family way" was simply not discussed, except in these euphemistic terms. During their pregnancies, these girls temporarily "disappeared" from the small towns where they had grown up, and they went to live for a few months at Grace Haven, out of sight and out of mind.

In the afternoons we'd play "Mounties and Metis" while making use of a very old but solid shed located twenty or thirty yards behind the former Territorial Building. This small outbuilding was also constructed of light brown bricks and was by then full of rakes and hoes. But it had apparently once been some sort of guardhouse. At least that was what was vividly suggested to us by the rusting manacles that remained securely fixed in the walls. So we happily made use of the manacles and the shed to incarcerate our "prisoners" in our no doubt politically incorrect north side Regina version of "Cowboys and Indians."

Occasionally, in the cool dimness of the garden shed that we had restored to its status as a guardhouse, we speculated (incorrectly) that maybe, just maybe, Louis Riel himself had been held in that very building when he was captured following the North-West Rebellion of 1885. (In fact, while awaiting trial Riel was kept shackled to the wall in a dingy cell in the guardhouse at the NWMP headquarters three kilometres to the west of the Territorial Building. During the trial itself, he was incarcerated in a tiny, hastily constructed jail cell in the basement of the two-storey brick courthouse on property located northeast of what is now the Hotel Saskatchewan.) Our most heated disputes, however, were over who would get to be Louis Riel and Big Bear, and who would play the roles of Commissioner George French and Superintendent Sam Steele of the North-West Mounted Police: would it be more fun to be captured, or to do the capturing?

Like most Reginans then and now, we knew little of the Territorial Building's former glories or its unusually varied subsequent uses. But to our youthful imaginations in 1960, a combination of history and mystery transformed the old Territorial Administration Building and the fertile grounds on which it stood into a playworld like no other, anywhere, any time.

Aydon Charlton was born and raised in the shadow of Taylor Field. He attended Albert School, Scott Collegiate, and the University of Saskatchewan, Regina Campus. After writing speeches for Premier Allan Blakeney and Inter-governmental Affairs Minister Roy Romanow, he taught English at the University of Regina for over twenty years. Now retired, he sits on the boards of the Regina Community Clinic and Heritage Regina when he is not golfing or curling or making use of Regina's excellent public libraries.

Seats 1 & 2
Row 16
Section 5
Taylor Field

by Darren Foster

Darren Foster's lifelong fascination has been to meet the challenge associated with examining, capturing and expressing the unique prairie aesthetic. From work in text to photography, film to performance, his artistic practice continues to be characterized by the marriage of realism and abstraction, much like the environment within which he lives.

One of my earliest childhood memories comes to me in a flash of bright light, with the clear blue prairie sky as its backdrop. I am running as fast as I can down a concrete sidewalk in a new subdivision, chasing a white 1972 Chevrolet Impala convertible with its top down. On this sunny Sunday afternoon, I have escaped the clutches of my babysitter and am screaming at the top of my lungs as the car pulls further and further ahead.

My parents are speeding off to another Saskatchewan Roughriders football game. From inside the tan vinyl interior, my father stares straight ahead through dark gold-rimmed aviator sunglasses. My mother fretfully looks back, beautiful as ever, yelling that I must go home. My little legs finally slow.

Years later, my persistence pays off. On occasion, I take my mother's place alongside my father in section 5, 16 rows up from the 55-yard line in Taylor Field's west stands. The seats become a site of ritual and my only permanent home. Growing up, we move five times. But season after season — my whole life — the seats remain the same.

It is a place I have waited for storyline after storyline to unfold, amongst beer and cigarettes and cheers and curses. It is a place of false hopes and close victories played out in rain, sleet, snow, sun and wind. Now that my mother is gone, it is also a place of remembrance.

Photo by Trevor Hopkin.

Taylor Field, Regina's Field of Dreams: Mobs, Magic and Mayhem

by Heather Hodgson

Many people think that *this* is the real heart of Regina. Even more think it's the heart of the entire province! If you're not convinced, look at the numbers. On any given "game day" between June and November, twenty to thirty thousand people flock to Mosaic Stadium and Taylor Field. The stream of traffic, the green jerseys, and flags billowing in the wind can make you believe that every road in this province was built to get the fans to this stadium to watch their team play football.

They come from all walks of life: singly and in pairs, in groups, on foot, on bikes, in cars, trucks and vans. Men, women, boys and girls — even babies wrapped in green blankets! Some wear watermelons on their heads; others paint their faces green. They come from every culture and every corner of the city and province; they even come from south of the border *and beyond*. Across Canada and the United States, millions more are in front of their televisions watching what happens here on *this* field.

Owned and managed by the City of Regina, the stadium holds 28,800 fans. Its artificial turf has hosted two Grey Cup championships, countless CFL, university and high school football games, and in 2005 the Canada Games.

The field was named after Neil J. "Piffles" Taylor, a lawyer and city alderman who was prominent in rugby

Heather Hodgson is a Rider fan. She attends home games with her husband, publishes articles about the Riders, and knits green and white items for the "Rider Corner" at Hip2Knit (where her Stitch 'n Bitch group — with Assistant Head Coach, Richie Hall — meets to knit and talk football).

and football as a player and an administrator in the early 1900s. The games had been moved around to various fields in Regina until 1928 when that year they were played in Park de Young on 10th Avenue. In 1947 the Park de Young was renamed Taylor Field.

Taylor Field was built for football fans. Famous across the land and beyond, they are the hopeful, the faithful and the stalwart — the throngs whose collective team spirit cannot be dampened by drought, cold, wind, the economy, or even a string of losses. Drawn here by their love of live football, those who sit in these stands have weathered decades of triumph and disappointment. The most loyal in the country, they show up through rain and snow, their hearts full of hope that their team will win! And it is this devotion that has caused the Saskatchewan Roughriders to be known as "Canada's Team."

Magic sometimes fuels the mayhem. On September 23, 2005, before 22,779 fans, a wayward jackrabbit jumped on the field during the first quarter of a game against Toronto. Darting about for three long minutes in search of escape, the terrified creature finally rocketed down the entire field for a record-breaking Corey Holmes run into the end zone. The fans went crazy and as the rabbit crossed the line every voice in the stadium yelled *touchdown!* A good omen for the Riders? Yes, decided the fans, despite the game's bad start. Toronto was leading and was at Saskatchewan's four-yard line. The score was 10-0. Noel Prefontaine had kicked a field goal. Then a Rider fumble was recovered, and the foes moved dangerously close to the one-yard line.

That's when the fateful Saskatchewan rabbit intervened. "Rabbit" was proclaimed "word of the game" and the Riders' luck turned around. The formidable defense stopped the Argos twice and on the third down, when the Argo's QB fumbled the ball at the one-yard line, Rider Eddie Davis recovered it! The Riders rallied for a touchdown and the rest of the game was pure magic. So the Saskatchewan Rabbit *did* prove itself to be a good omen for

the Riders, who beat the Argos 24-13. And that evening, every sportscaster in the nation aired the "Saskatchewan Rabbit Touchdown."

The view from the stands at Taylor Field is spectacular. Every seat is a good one, offering different advantages for watching the game. From the upper deck the countryside can be seen stretching for miles around the city. On the west side the view stretches far beyond the twin steeples of Holy Rosary Cathedral to the southeast where the seemingly endless line of a west-bound train is often seen coming down the tracks. Engineers blow the whistle or wave a flag from the front engine while the SGI tower glimmers like a copper bar in the sunlight.

From the east side upper deck, fans get an equally breathtaking view: trees and prairie stretch out to the sun as it sinks its teeth into the horizon. The heat of the sun smiles down on the gleeful faces in the north end zone, too. There, the notorious university fans, famous for their painted green bodies and watermelon helmets, wave their arms, banners and flags with unrivalled enthusiasm.

For Saskatchewan football fans, Taylor Field is the place where their community, a.k.a. Riderville, meets at least ten times a year. It is the place that promises them fresh air (no matter how cold, wet or windy), cold beer, burgers and a wonderful time. Game after game, year after year, win or lose, that's what draws that species called Rider fans here.

Photo by Lorne Beug.

Left: Art McKay in The Utopia. *Photo courtesy of Jack Severson.*

Finding the New Utopia

by Jack Severson

Jack Severson graduated with a Bachelor of Arts from University of Regina. He worked as a preparator for the MacKenzie and the Dunlop Art Gallery, and then as an art instructor at the Saskatchewan Indian Federated College.

In 1975, freshly employed after college and with a house full of roommates, I found myself seeking a getaway spot within biking distance of my home. One place that caught my eye was the New Utopia Cafe on Dewdney Avenue.

It had been around for a long time under several owners. My parents would stop there in the early 1940s on their way to the I.O.O.F. Dance Hall just to the north. Friends who went to Scott Collegiate in the 1960s spoke of hanging out at the Utopia with its Greek proprietor who would keep the cafe open until 1 AM. There had been a new owner since 1971, who had kept the same signage — including a steaming cup of coffee with "STEAKS CHOPS FISH & CHIPS" in orange.

Over the next few years I would pass by the Utopia, usually after work. In spite of signs of regular activity, I would almost always find it closed, with no hours posted.

My first successful visit was on a Saturday afternoon. The restaurant still had the old vinyl booths with jukebox selectors and the old-style restaurant equipment — but what really struck me were the two large, black abstract paintings... painted directly on the walls, a cross between Chinese calligraphy and abstract expressionism. I made a mental note to return with my camera.

I was not able to time my visit to the Utopia right again for years, and I wondered if maybe the cafe was more of a hobby for its owner.

My second visit was mid-afternoon as well, but it already felt like closing time. I could see that the large abstracts had been painted out, but some other work was visible in the back, where the pinball machines were. I was the only customer, and after the owner served me, he returned to the kitchen.

I'd had a cup of coffee and a slice of apple pie. After a while the proprietor came over with the pie pan containing the last piece. He offered it to me — for free, without comment. He appeared to be a man of few words, and I didn't get to asking about the cafe's business hours.

I would continue to drop by periodically, but every time — closed. Then, in February of 1986 an article appeared in the *Leader-Post* about the Utopia's owner, Roger Ing, and his art, a full page with colour reproductions of the work. I was now even more intrigued.

A few months later my friend and neighbour, Dave Cicansky, suggested we go for coffee there. I told him of my problem with the unpredictable hours, and he informed me that the Utopia closed at 3 PM every day. Roger was a breakfast and lunch man.

The puzzle finally came together, and thus began a six-year relationship with the Utopia Cafe, its customers, and especially with Roger and his art work, which I collected voraciously.

Roger was never very communicative in English, yet he was curious about the language, and would ask about certain words or phrases, which he would then play with in his paintings. As we got to know each other, he became more talkative, to the point of calling me at home, and, if I wasn't there, leaving the strangest messages, complete with drama and sound effects.

Though Roger appeared socially aloof or cautious, he took an interest in most of his regulars, remembering the type of magazine they liked or what drink was preferred, and would have both at the table by the time they sat down. He would interact by parading his latest painting or playing the jukebox — sometimes getting stuck on a particular tune and playing it over and over, to the chagrin of some patrons.

I found the creative atmosphere of the Utopia a good counterbalance to the official art world I was employed in.

By 1990 I was teaching art at the Saskatchewan Indian Federated College and while taking students around to local artistic points of interest, I would always include the Utopia. My students loved being there and eventually I invited Roger down to the SIFC studios. He made several visits there over the years, demonstrating his painting skills and generally hanging out, to the enjoyment of all.

The Utopia was shut down by the City Board of Health in 1993. I think it was the artistic chaos that upset the bureaucrats as much as the hygiene of the place. Regardless, as Rick Morel points out in the documentary film that was made about Roger,[1] we saw the end of one of the most important art institutions in this city. I agree... not your typical restauranteur and not your typical restaurant.

1. "Roger Ing's Utopia." 1998. Judith Silverthorne.

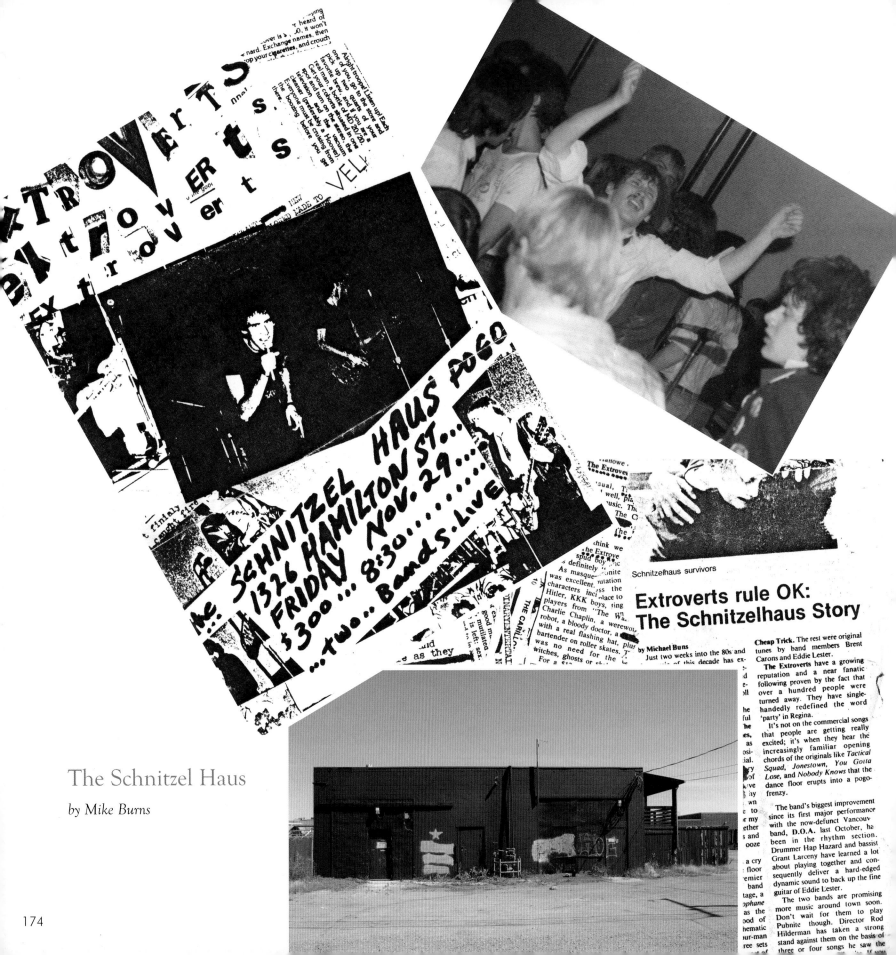

EXTROVERTS

SCHNITZEL HAUS POGO
1326 HAMILTON ST...
FRIDAY Nov. 29...
$3.00... 8:30......
...two.. Bands..Live

Schnitzelhaus survivors

Extroverts rule OK: The Schnitzelhaus Story

by Michael Buns

Just two weeks into the 80s and ... of this decade has ex-

Cheap Trick. The rest were original tunes by band members Brent Carons and Eddie Lester.

The Extroverts have a growing reputation and a near fanatic following proven by the fact that over a hundred people were turned away. They have single-handedly redefined the word 'party' in Regina.

It's not on the commercial songs that people are getting really excited; it's when they hear the increasingly familiar opening chords of the originals like *Tactical Squad, Jonestown, You Gotta Lose,* and *Nobody Knows* that the dance floor erupts into a pogo-frenzy.

The band's biggest improvement since its first major performance with the now-defunct Vancouver band, D.O.A. last October, has been in the rhythm section. Drummer Hap Hazard and bassist Grant Larceny have learned a lot about playing together and consequently deliver a hard-edged dynamic sound to back up the fine guitar of Eddie Lester.

The two bands are promising more music around town soon. Don't wait for them to play Pubnite though. Director Rod Hilderman has taken a strong stand against them on the basis of three or four songs he saw the

The Schnitzel Haus

by Mike Burns

174

Facing page, bottom: The Schnitzel Haus. Photo by Don Hall. All other photos/images courtesy of Margie MacDonald.

The first time I walked into the Schnitzel Haus, I had to recheck the address. How could this tiny family restaurant be listed under 'halls' in the yellow pages? The dining room held maybe 20–25 people! But in the back was a door that opened into darkness.

In a dim-lit room beyond, a short, round woman was laying out paper-thin pastry over half a dozen bar tables. "Strudel," she explained, in an accent as thick and sweet as apple filling.

I looked up. The ceiling receded two stories over my head into darkness. The box was ringed by a tacky wrought-iron mezzanine. It was like I was standing at the bottom of a freight elevator. I realized I'd found what I'd been looking for: a punk palace for the Queen City.

Maria told me the hall was $100 a night. I needed to talk to her husband Joe.

I found Joe in his welding shop, which ran parallel to the hall. He was a rough-hewn Hungarian with an honest face. He agreed to a booking with a memorable handshake.

Within a couple of weeks we had filled the 'schnitz' with every pogo-dancing music fan in the city. It was the birth of a legendary Regina underground. During 1980 and 1981, west coast Punk icons DOA, Los Popularos, The Subhumans and our own locals, The Extroverts, rocked the dim little room on Hamilton street. We saw ourselves as Regina refugees seeking escape from a prairie wasteland of rollerdisco and metal. Our music was angry, our clothes shabby and second-hand, and we danced by slamming into each other. Hard.

Yet Joe and Maria still liked us.

After all, it wasn't the first time the Schnitzel Haus had been home to the dispossessed. Maria and Joe themselves had fled here from war-torn Europe. Then in 1956 their tiny two-bedroom house, attached to the restaurant, became home to an entire soccer team of Hungarians on the run from a Soviet crackdown. Joe was coach, manager and player, while Maria kept them all fed with steaming bowls of goulash. The "Western Riders" played to crowds of up to 5,000 at Regina's Taylor field. Their opponents were largely other recently arrived displaced persons from all over Europe.

Now, twenty-five years later, they once again opened up their hearts and home, this time to bed-headed, impoverished punk musicians. Our guys usually played against type and were respectful and polite to our hosts. Pre-show meals were legendary. Maria would worry about the boys being too thin and she over-filled plates with chicken paprika or rouladen. Breakfast would include up to seven eggs per plate!

Once I came upon Joe in the kitchen as DOA pounded out their set. His eyes had welled up. He searched for words to explain. Finally he said simply 'these men play powerful music.' A cynic might think Joe was in pain from the noise but, no, he was with the program. He knew he was hearing something heartfelt. At the end of the night it was Joe and Maria who gave the Schnitzel Haus — and us — the extraordinary sound of passion and belonging.

Mike Burns was the Queen City's first punk rock impressario. He went on to become an actor playing the lead role in "The Ballad of Don Quinn," an overplayed short film inspired by the characters of the Schnitzel Haus era (he has yet to be paid). On occasion, Mike is still known to pogo.

Performing Regina: Local Beer and King Lear

by Kathleen Irwin

I am a theatre designer — or more aptly put, a scenographer. The difference is not subtle. A designer fills a theatrical space emblematically and strategically. A scenographer considers the historical, political, social and material levels in a specific place and uses these nuances to make dense the experience of performance through that place. In my scenographic practice, I seek out abandoned sites for performance purposes. In this particular instance, my focus, in the spring of 2003, was the kettle room in the old Regina Brewery on Dewdney Avenue, built in 1908. I had chosen

it as the proposed location for a site-specific production of Shakespeare's *King Lear*, weaving together local historical events, the history of the Molson family's rise as an industrial giant and the Lear narrative. The working title for the developing text was "The Dionysian Lear."

The dramaturgical objective was to explore the links between space, text and self-exploration, focusing on the Dionysian aspects of ritual and performance.

Dionysus, also commonly known by his Roman name Bacchus, appears to be a god who has two distinct ori-

gins. On the one hand, Dionysus was the god of wine, agriculture and fertility of nature, who is also the patron god of the Greek stage. On the other hand, Dionysus also represents the outstanding features of mystery religions: ecstasy, personal delivery from the daily world through physical or spiritual intoxication, and initiation into secret rites.

The anticipated result of this investigation was to have been a performance event that braided together the Lear story with the Molson story in order to exploit the notion of spiritual blindness/self revelation and to investigate notions of patriarchy and power through one of Canada's foremost industrial families. The performance was planned as large-scale and interdisciplinary, incorporating responses to the site from artists from across diverse disciplines. It was hoped that it would be, in some way dionysian — somewhat unrestrained in its theatricality. Although the performance was never realized, the unfolding circumstances were ultimately — and ironically — tragic in scope. At the time of the show's planning, the brewery was already threatened and the exercise became more an attempt to focus the attention of the community on the passing of a building that was dense with memory and history. The project was brought to an untimely end when Molson closed the site and proceeded to demolish the heritage building. The demolition was finally realized in the summer of 2004 despite vocal concern from the community aimed at City Hall. As the building fell, momentum was concurrently forming around the idea of a municipal cultural centre, situated in the deteriorating centre of Regina that would become potentially a unique environment for the city, with a cultural, educational, and economic focus. Such a centre, it was hoped, would be recognized as the heart of the downtown neighbourhood's creative community, a catalyst for innovative synergies between sectors, and a beacon for creative sustainability. Meeting many community and commercial needs, it would enable Regina citizens to share in the creation of a cultural destination, an educa-tional centre, and business opportunities in a vibrant downtown.

So, in the end, although the curtain failed to rise on "Dionysian Lear," the process offered an opportunity for practical performance-based research into the relationship between site-specific performance practice and issues-based interventions in local communities.

Although unrealized, the project helped to educate the public and municipal authorities to the notion that transitional buildings and neighbourhoods may experience sustained economic redevelopment if rezoned for cultural and artistic use.

As Associate Professor in the Theatre Department, University of Regina, Kathleen Irwin's research focuses on community-based, site-specific performance. She is interested in animating urban and industrial sites to unlock memory and, in collaborating with their adjacent communities, to refocus attention on defunct buildings towards their cultural redevelopment. Current activity includes publishing and presenting on this subject both nationally and internationally, a large-scale performance at Claybank Brick Plant National Historic Site (*Crossfiring*, September 2006) and several collaborative projects in Estonia, Helsinki and Belgrade.

Opposite page: Molson Breweries building, 2001. Photo by Patrick Pettit, The Leader-Post.
Below: A kettle in the Kettle Room of Molson Brewery. Photo by Kathleen Irwin.

The Strathdee Building looks down on Dewdney Avenue. Photo by Don Hall.

Regina's Old Warehouse District

by Bev Robertson

Regina had to be built for two reasons. A place was needed for the seat of government of the Northwest Territories, and a central location was needed for the distribution of the things brought to the prairies by train. The banks, courts, churches, schools and social infrastructure that followed served only to support these functions and the people who worked within them. Regina's Old Warehouse District provided that distribution service for a large part of the prairies and is as important in understanding Regina's history as are Regina's better-known attractions such as Government House and the Legislative Building.

Goods that could not be practically produced by the sparse prairie population were unloaded from railway cars into the warehouses in The District, and then reassembled and sent out to the many small towns in the southern half of Saskatchewan on small trucks. Ironically, that same "intermodal freight" function is now provided by the CP rail yard on the south side of Dewdney Avenue in The District, using giant machines that reassemble piles of 40-foot containers instead of human-scale boxes.

The old warehouses themselves have a new lease on life, through creative adaptive re-use. The Strathdee Building at the corner of Dewdney Avenue and Cornwall Street is one of the largest and most elegant of the many warehouses that have been adapted to a variety of re-uses. It was built after the "Great Cyclone of 1912" – a tornado – leveled most of the buildings in the vicinity. The Akerman Building immediately across Cornwall Street from the Strathdee Building survived the tornado but it still shows cracks caused by the force of the wind.

Most Reginans know the Strathdee Building as the home of the Bushwakker Brewpub. Half of the upper floors of the building contain a total of eight residential units, reflecting an emerging trend in The District. Roughly a dozen of The District's old warehouses are now partially or completely devoted to residential use. The other upper floors of the Strathdee Building hold a variety of offices and work places, many providing services to Regina's growing movie and computer graphics industries.

The Bushwakker Brewpub's brewery is one of many that have called The District home. The recently decommissioned Molson Brewery and the old Sick Breweries are well known in Saskatchewan. However, as the history of The District emerges, from work commissioned by the Regina's Old Warehouse Business Improvement District, it would seem that much of the booze that found its way down the Soo Railway Line to Chicago from Moose Jaw during the prohibition era was actually fermented and distilled in Regina's Warehouse District.

The Bushwakker has put The District back on the map as an important place for Canadian beverage alcohol. In addition to its many brewing awards, the Bushwakker is home to the Canadian Amateur Brewing Competition and the home of the world's second most successful amateur brewing club in terms of awards won, the Ale and Lager Enthusiasts of Saskatchewan (ALES).

The ALES, the Bushwakker, the Strathdee and The District are all success stories that will not remain secret much longer.

Bushwakker Brewpub.
Photo by Don Hall.

Bev Robertson is a retired member of the Department of Physics, University of Regina. He is one of the founders of the Ale and Lager Enthusiasts of Regina, and retains membership number 001. He is the founder and chair of the board of the Bushwakker Brewing Company, and chair of the board of the Strathdee Condominium Corporation. In 1997 the City of Regina asked him to create a business improvement district in The District. He accepted the challenge, and the BID was realized in 2003.

Photo by Don Hall.

Dutch Cycle

by Jeannie Mah

Jeannie Mah enjoys cycling for exercise, transportation, and exhileration. She likes to watch the Tour de France (and F1) and participates in a weekly Tour de Water Sewage Treatment Plant.

In the 1970s, it was a rite of passage to find one's way to Dutch Cycle, then in a basement shop on 8th Avenue. Buying my own mode of transport, a white Peugeot 10-speed, with my hard-earned money from a summer job with the City of Regina, was my first step into adulthood.

The Vandelinden family, now father, sons and grandsons, still sell bikes with enthusiasm, knowledge, and care. The purchase of a child's first bike is treated with the same respect as the purchase of a high-tech bike, such as a state-of-the-art Canadian-made Cervélo, a thoroughbred of a bike used by the Danish Team CSC in the Tour de France. Indeed, Dutch Cycle is as keen to repair an old beloved bike as it is to sell a new bike. This is love!

Each spring, cyclists of all ages troop to Dutch Cycle. We come for tune-ups, parts, new bikes, and for the sheer love of bikes — it is our petting zoo. Dutch Cycle succeeds without advertising. Those new to Regina soon find their way to this no-frills shop, recently relocated to 1336 Lorne Street in the Warehouse district, because good friends let them in on one of Regina's best secrets.

Dutch Cycle has served Regina with honesty and enthusiasm for thirty-three years, and continues to fuel the green revolution. Buying a bike instead of a car as I began university in 1970 was my first political act.

Vive Dutch Cycle!

Photo by Bradley Olson.

Bradley Olson was born in Regina in 1975, and grew up in Kenya, North Battleford, and Regina. He has a a B.F.A. in Ceramics from the University of Regina, a B.F.A. in Photography from the Nova Scotia College of Art and Design in Halifax, and is now in graduate school in the Photography Department at Ohio State University, in Columbus, Ohio.

Corner of 8th Avenue and Halifax Street

by Bradley Olson

I am interested in photographing the ordinary. I would like to consider how landscape has affected architecture and sense of place. To seek out contradictions and uncertainties within the specifics of an exact location, I examine commercial, retail and residential properties, to see how these "ordinary" occupants in the landscape are affected by the landscape.

Interruptions and uncertainties reveal themselves through the act of photographing. This image is one in a series of photographs which deals with the relationship between the built environment and the local landscape, wherein I propose that geographical location not only affects aesthetics, but also, at the same time, influences the practical systems of work.

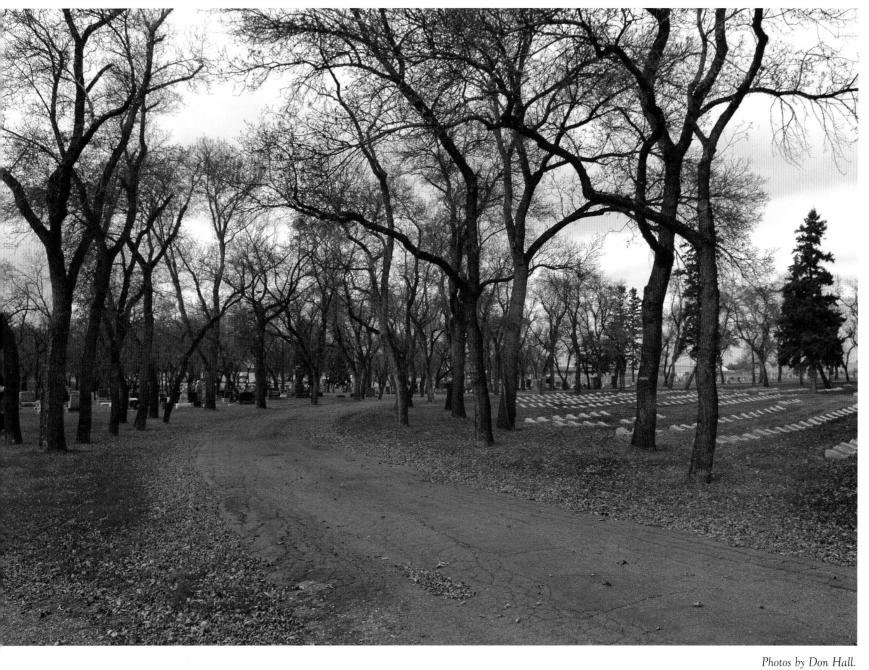

Stranger, Pause As You Pass By...

by Rae Staseson

My 'secret' is the Regina Cemetery, which occupies the northwest corner of Broad Street and 4th Avenue. For years I passed this site, admiring the mature trees and the park-like setting. Decades went by before I finally visited this location and now it is one of my favourite places in the city. It is indeed mysterious, full of local history and I am sure numerous family stories, both real and imagined.

My father, Gordon Staseson, and his second cousin, Harvey Staseson, have been working on our family tree. The tracing of our Romanian roots has proven challenging, fascinating, full of gaps and contradictions. It came as a shock to learn that Dad's paternal grandfather and Harvey's great-grandfather, Andrew Staseson, was buried in this cemetery in 1908. To quote my dad, "It was the first time that I even knew that my paternal grandfather was buried in the Regina Cemetery. Neither my father or mother ever mentioned the fact. Nor did my aunts and uncles. Why, I don't know, and it still remains a mystery."

During the summer of 2004, along with my dad, I searched for the unmarked grave of Andrew Staseson. We had to use our sleuthing powers to decide which plot corresponded with the old burial records. We then walked around the Eastern European section of the cemetery, locating other Romanian relatives. My dad recounted stories about the family, of their homesteading years and their move in to Regina. It was fascinating and often surprising.

The Regina Cemetery has been like finding a buried treasure. I strongly urge those who have not experienced this place, to stop in and take the time to wander throughout the different sections. I promise you will discover a part of Regina that you never knew.

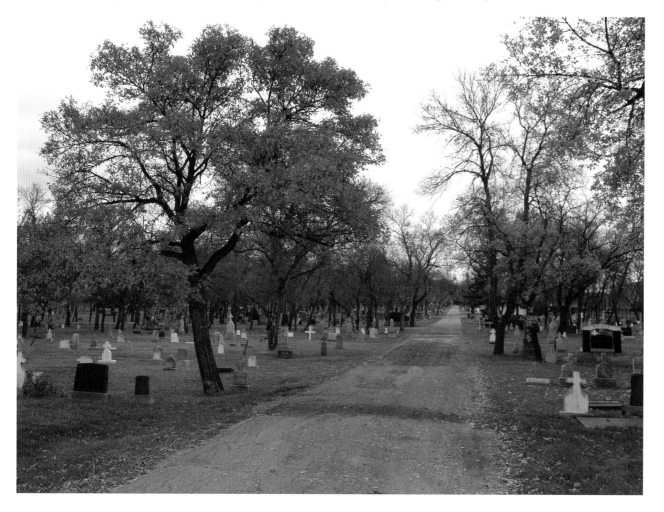

Rae Staseson is an intermedia artist whose work has been exhibited in France, Scotland, Taiwan, Hungary, Mexico and the United States, among other places. Staseson is an Associate Professor of Communication Studies at Concordia University (Montreal) where she teaches video practice and theory as well as visual culture courses. Born and raised in the Queen City, Staseson will always consider Regina "home." She regularly returns to spend time with family, friends and the Saskatchewan landscape.

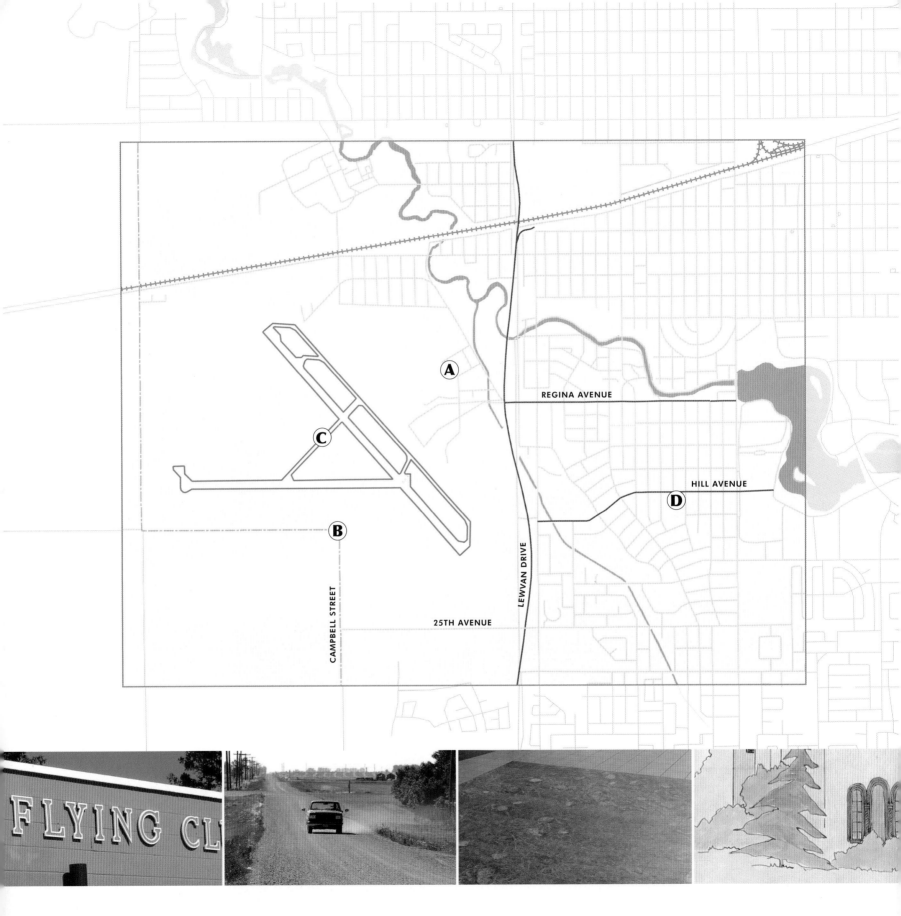

REGINA AVENUE

HILL AVENUE

LEWVAN DRIVE

CAMPBELL STREET

25TH AVENUE

A

B

C

D

FLYING CL

Airport

Regina International Airport: Roland J. Groome Field

by Garrett Wilson

"Are they still using the grass strip at the Regina Airport?" asked the proprietor of the small store on Maui, Hawaii. He was one of the hundreds who trained at No. 15 EFTS (Elementary Flying Training School) in Regina during the 1940s War and had fond memories of doing "circuits and bumps" on the grass portion of the Regina airfield. I was then (1969) also a flyer and able to confirm that the grass strip (that doubled as a winter ski area) was still in operation.

Regina is well-known throughout the aviation world and holds a remarkable number of "firsts" in the Canadian field, most of them due to the pioneering of Roland J. Groome. A flying instructor in the Canadian Aviation Corps during the First World War, Groome was an aviation visionary. In 1919 he established an aerodrome in Regina, and, with his partner and mechanic, Robert McCombie, picked up their first aircraft in Saskatoon, a two-seater Curtiss JN-4 ("Jenny"). The Jenny was in crates, but Groome and McCombie assembled it and flew it to Regina, carrying a letter from Saskatoon's mayor to Mayor Henry Black of Regina, the first airmail delivery in Saskatchewan.

In 1920 Groome's Regina aerodrome was granted Canada's first "air harbour" license. Groome became Canada's first licensed commercial pilot, McCombie the first licensed air engineer, and their Jenny received the first aircraft registration in Canada, G - CAAA. A model of the Jenny hangs over the check-in counters at today's Regina Airport.

Tragically, Groome and a student pilot were killed on 20 September 1935, in a crash caused by a mechanical failure. Fittingly, the airfield occupied by the Regina International Airport is now named *Roland J. Groome Field.*

Groome was ahead of his time, and his first airfield at the corner of Hill Avenue and Cameron Street failed, as did another on the site of today's Golden Mile Shopping Centre. The current location was acquired by the City of Regina in 1928 and the new Regina Airport was officially opened on 15 September 1930. Somehow in the

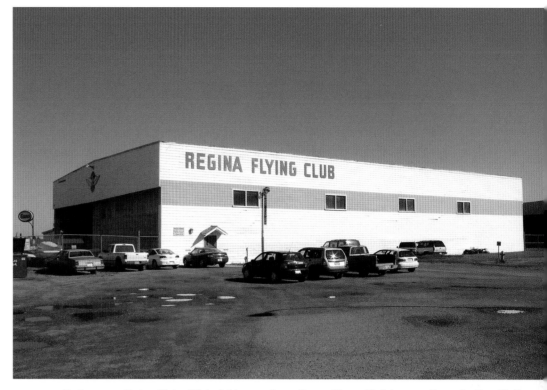

Facing page: Regina Flying Club clubhouse; above: Regina Flying Club hangar. Photos by Don Hall.

Depression year of 1932 money was found to pave two runways, and Regina boasted the only paved runways between Toronto and Vancouver.

The Canadian government, recognizing the future of aviation and the value of a pool of qualified pilots, encouraged training, and the Regina Flying Club became a prominent flying school. During the Second World War it operated No. 15 EFTS for pilots and No. 3 (AOS) Air Observer School for navigators. For years after the war, training continued through the Air Cadet program as well as on the civilian side. Regina still offers some of the best flying training available.

The Federal Transport Department operated the Regina Airport until recent years, when it again came under the local control of the Regina Airport Authority. With scheduled flights across Canada and into the United States, as well as charter flying services and government and corporate facilities, Regina International Airport has fully realized Roland Groome's dream.

Garrett Wilson is a passionate son of Saskatchewan, who practised law in Regina for more than half a century. In the 1950s Garrett trained as a pilot at the Regina Airfield and has maintained a strong interest in its operations.

Out of My City Skin

by Joan Scaglione

Lucy Lippard, one of the most influential writers of our time whose writing weaves together cultural studies, geography, and contemporary art, speaks about sense of place in this way:

> *Place is latitudinal and longitudinal within the map of a person's life. It is temporal and spatial, personal and political. A layered location replete with human histories, and memories, place has width as well as depth. It is about connections, what surrounds it, what formed it, what happens there, what will happen there.*

Today, the first day in September, I'm heading west in my battered '84 Dodge pickup on 25th Avenue from south Albert Street to the corner behind the Regina Airport. I am overcome by a sensory transformation as I make the dog-leg turn bringing me to the Lewvan. Waiting for a break in traffic to shoot across onto a curving dirt road, which will change from 25th Avenue to West 25th, I sense the Lewvan is a palpable divider between city and prairie. Everything is different west of the Lewvan. Gravel kicks up dust under the wheels of my truck. Infinite space swallows me whole. I feel cleansed. I slip into the past when this land was the ocean floor millions of years ago.

West 25th Avenue turns north to become Campbell Street, a grid road with no sign to reveal this fact. A kilometre down the road is the southwest corner of the

Photo by Darlene Gray.

airport. Under the morning's bright sun, I pull my truck off to the side. I can touch the fence that encloses the runway of the Regina Airport at its southern boundary. Small and large aircraft signal arrivals and departures. Standing on this unremarkable corner of land, I am lured by a multiplicity of sensations into an altered state akin to the experience described by Zen Buddhism when "the mountains are no longer mountains." I feel inextricably connected with prairie in this moment and tangibly interconnected with the world, as if I were part of a stream of energetic pathways criss-crossing the earth. A prairie dweller I am, defined, enlivened, unbounded by an invisible totemic energy. The land has marked me forever.

On a blistering summer's night in July seven years ago, shortly after moving to Regina, Denis and I searched for a place to connect us to our new surroundings — a place redolent of a small city's unhurried familiarity that might assuage our sense of uprootedness. The airport, we thought, while not exactly spellbinding, would transform a humdrum lonely evening into an "expedition." Ambling along gravel roads by car at dusk, we came upon the backside of the airport at its southwest corner. We pulled off into a generous space where two grid roads intersect to settle in for earnest observation of the meagre flights that landed and took off. Our eyes remained glued to the runway whenever an engine began to whine. At other times, the inky black stretch of Regina's skyline grabbed our attention. Indolently we indulged in this pastime surrounded by the delights of a prairie meadow. An unseen chorus of a thousand meadowlarks flitted through the fields warbling tender melodies. That evening presaged an intimacy with the prairies. It inscribed us with memories of sounds and sights and feelings; it connected us to unknown histories of the land and wove us into its future.

One hot summer day a few years ago during the grasshopper invasion I can remember Denis and I sprawled in the high grass by the airport mesmerized by the blue of a prairie sky against the ripening gold of wheat fields. A nearby telephone pole at the grid road intersection stood thickly encrusted with battalions of grasshoppers. I succumbed to the urge and knocked the pole, watching an explosion of leaping bodies. City and prairie collide within me here.

My secret Regina? I ask myself what *is* secret about a place? Is it our ignorance of its existence? Or is it a place we are so familiar with that we are incapable of seeing it? Perhaps our preconception about what makes a thing "known" is a trick to distract us from grasping the more essential experience of the world. Prairie has the power to call forth original places of the Self. It tramples the rational, pre-occupied, citified beings we become when out of sync with the land. I revel when I am out of my city skin. My secret Regina speaks about awkward moments in search of a sense of place in a new city and finding my own centre in it.

Changes are coming to this unobtrusive corner of the prairies. "Nearly $1 billion in residential and commercial development is up in the air as a controversy rages about the proper use of land just south of the Regina International Airport," began the March 14, 2005, article in Regina's *Leader-Post*. The Regina Airport, the City of Regina, and private developers have vested interests in this parcel of prairie. Soon it will become part of Regina's history of expansion. Before this happens, perhaps those involved might take a warm summer evening's drive to the southwest corner of the airport, where the city meets the prairie and the meadowlarks' song ripples like waves through the grass.

Lippard, Lucy. *The Lure of the Local*. New York: The New Press, 1997: 7.

Joan Scaglione has been transformed by living in the Prairies. Her art practice revolves around integrating Nature, Self, and the Divine. She is a sessional instructor at the University of Regina and an instructor at the Neil Balkwill Centre.

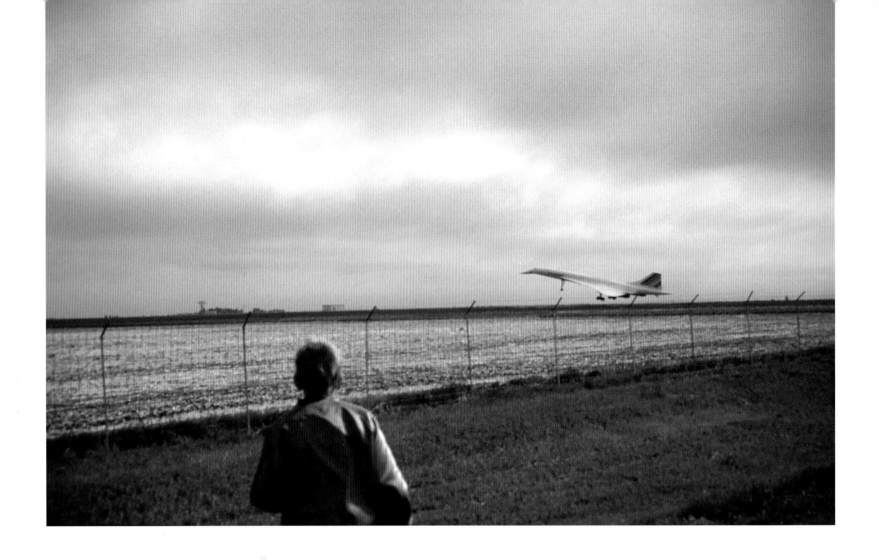

50° 25' 55" N
104° 39' 57" W

by Randal Rogers

The geese have begun their southern journey, retracing invisible lines through the sky as they pass, just as aircraft high above remind us of their presence through traces in sight and sound, slowly evaporating through the honking, even as they tell us of the world beyond. Coming from that world to Regina for the first time, now over two years ago, I am struck by how the plane seems to not descend at all from its exalted height, ever so gently drifting toward the snowy prairie without a sound before seizing it with a final guttural roar. Moments later, I am standing in the dim but somehow harsh light of the Regina International Airport arrivals lounge. The area itself is a testament to modernism gone awry — teeming with people, low, mean, false ceilings and muddied, terra cotta tile in sundry shades of brown enveloping every slippery surface. If we are swallowed by the jetway while exiting the aircraft, then the arrivals lounge marks the last moment before the airport-body expels its content while, simultaneously, warning us that our place within the supermodernity of flight is temporary, and must be surrendered in this shameful journey from aircraft to carousel, which terminates with our excretion into the snow.

But much has changed since this first visit in 2004. A new arrivals hall has materialized to "bring the facility up to world-class standards," with soaring ceilings and exposed structural elements, lightly stained wood panels, quietly blushing grays, shades of beige, taupe, and a tone strangely reminiscent of an unseen sandstorm in Nantucket. And art! Light is now the key — flooding the hall with the bold radiance of the prairie at midday, it reflects throughout the space, off the aircraft-design-inspired curvalinearity of many of its surfaces. But it is the

Facing page: Air France Concorde with French President François Mitterand on board landing at Regina International Airport, May 1987. Photo by Bernard Flaman.

Right: Arrivals lounge of the Regina Airport terminal, with Shelley Sopher's "Old Man on His Back Tipi Ring." Photo by David McLennan.

arriving passengers that mark the real difference here. From the cylindrical, glass-roofed cupola with the passing hours of the day inscribed upon its perimeter, passengers literally emerge from another space and time as the escalator carefully transfers them from heaven to earth in this reversal of the Assumption of the Virgin, before finally placing them so tenderly upon Shelley Sopher's prairie[1] and at the feet of mere mortals. You can almost hear the angels heralding as these cosmopolitans return. And if the old arrivals lounge was the — pardon me — anus of modernity, then the new hall stands as the eyes of supermodernity — a transparent screen opening onto the prairie landscape beyond, greeting passengers as they reclaim their earthly place.

But what, exactly, is this place? If the airport is a sort of non-place, the spatial fulcrum between here and there, then passengers, too, shift from cosmopolitanism to identity as they once more glide toward the mundane. The new hall attempts to place the Queen City squarely within the "world class," linking us aesthetically to other great halls across the globe — the Concorde-inspired lounge of Charles de Gaulle in Paris, the immense curvature of Kansai in Osaka and, more close to home, the cavernous new arrivals hall in Terminal 1 at Pearson International. Yet, now firmly enfolded within supermodernity, the question of our own em-placement — here — begs to be asked. After all, with aircraft movements reduced by some twenty-five thousand per year between 1999 and 2005,[2] and now having the added shame of flying Jazz to Toronto (*quel horreur*), are the tracers in the sky far above not mocking as they pass over and leave us to the honking of geese alone? Maybe so, but prairie folk don't stand on pretense. When we descend from the heavenly cupola, it is not the landscape we see above the heads in the crowd. No. We search instead for the familiar faces of family and friends who we know will be there to see us home. And for this, architecture, finally, makes no difference.

Dr. Randal Rogers is an assistant professor in the Faculty of Fine Arts at the University of Regina, where he coordinates the Interdisciplinary Studies graduate program. His research is on historical and contemporary world fairs, the nation and globalization, and he teaches in the areas of interdisciplinary theory and practice, the body and illness, queer theory, globalization, modern and contemporary art, and representation. Randal still dreams of one day becoming a pilot.

1 "Old Man on His Back Tipi Ring" is a photo-tile work by Shelley Sopher, commissioned by the Regina Airport Authority through a competition in 2004. "Old Man on His Back Tipi Ring" was photographed on the Old Man on His Back plateau in southwestern Saskatchewan. Circles of stones that anchored the skin or canvas covering of tipis, tipi rings are the visible remains of human habitation here. Standing directly above each stone, Sopher photographed the tipi ring in a grid pattern: two hundred and thirty-four individual photographs reconstruct the tipi ring in two dimensions on the airport floor. Old Man on His Back Prairie and Heritage Conservation Area is one of Canada's last remaining tracts of mixed grassland. Plains Bison have been reintroduced into the area and some of the cultivated land is being restored to native prairie.

2 http://azworldairports.com/airports/p1290yqr.htm

Lora Burke, "Last House in Lakeview," 1978, ink and watercolour. Private collection. Photo by Don Hall.

The Romance of Flight

by Pat Krause

The house that once stood alone at the southwest corner of Regina's Lakeview is my forties time capsule. One of its four bedrooms upstairs is my inner sanctum. I went there to cry, gloat, preen, dream, and sit at my desk at the west window to do homework, write in my diary, or gaze at the world outside.

The sea of prairie and endless sky gave me the illusion of being able to see forever. I saw puffs of snow on crested wheat grass that resembled cotton bolls; my mother and little sister picking crocuses; my father and kid brother hitting golf balls; me being taught to drive by my father on rutted dirt trails; the giant blizzard of '47 snow bank that buried a Lewvan Line train; and the airport beacon's bright circular path sweeping across the night sky.

In 1943, starting high school was delayed until September 20 so able-bodied male students could help the war-effort harvesting. My imaginary R.C.A.F. pilot increased his flights by my isolated tower, dipping the wings of his yellow Tiger Moth at me, his Prairie Princess. On October 29, I printed my diary entry in capital letters: MET A GUY NICKNAMED EYEBALL EYE-TO-EYE IN DETENTION AND HE WINKED!

One night in April 1950, I helped Frank (my guy Eyeball) do his homework for his new airline career. I see us clearly. We're sitting at the kitchen table at my house. My family is out. I cook for him to show off my housewifery skills which are nil.

I watch him eating his heart out for me. Oh, he looks so handsome in his Trans-Canada Airline Passenger Agent uniform. I quiz him on International Civil Aviation codes for airports: Regina? – YQR; Yorkton? – YQV; Winnipeg? – YWG.

Time out for congratulation kisses.

I move my diamond-ring-finger hand down a list of airline lingo. Con? – Contingency pass holder flying on a seat available basis. Bumped? – Deplaning a Con if there isn't an empty seat. Fam-flight? – Familiarization flight for a new employee and spouse.

More kisses. The future glows like the gold wedding band I'm wearing on our October fam-flight to YWG via YQV.

Neither one of us has ever been up in an airplane before, but my husband is an expert on procedures.

"Once we're airborne, it'll be just like sitting in our living room," Frank says as we taxi out to the end of the runway.

He holds my hand as the DC-3 SKYLINER accelerates from a rough purr to a shuddering roar.

When the engines grind down to a grumbling growl, he says, "See? Smooth as sil—"

And the sudden thunderous jackhammer thrust of the real takeoff, not the full-throttle instrument check at the end of the runway, plasters us against the back of our seats, faces white as sheets.

Now, an earthbound widow since 1995, I retreat to my inner sanctum to dream his hand is holding mine.

Pat Krause has won literary awards for her fiction and creative non-fiction. She has published two books of fiction: *Freshie* (Potlatch, 1981) and *Best Kept Secrets* (Coteau, 1988). Coteau Books will publish her memoir, *Acts of Love*, in 2007.

Above inset and left: The north- and west-facing windows in Pat Blair Krause's bedroom gave her a view of the prairie and the airport. Photos by Don Hall.

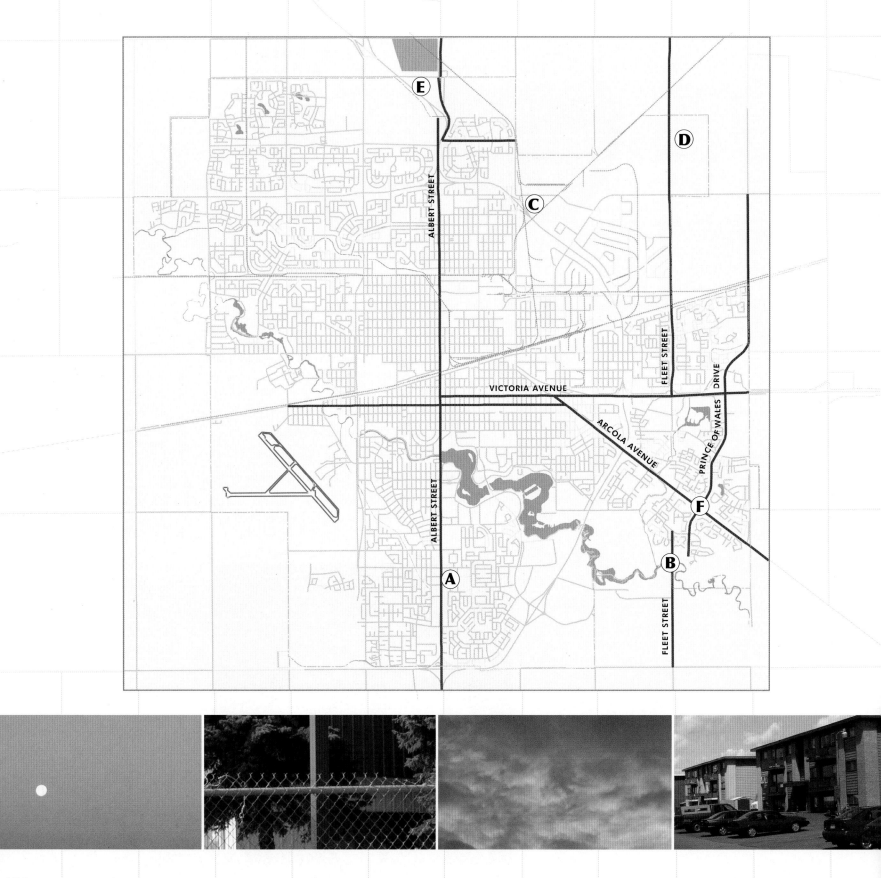

Edges

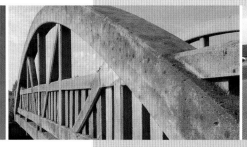

The Alley Behind Spence Street

by Gerald Hill

Born along the Trans Canada highway in southern Saskatchewan (the town of Herbert), Gerald Hill still lives there, in south Regina. He teaches English at Luther College, University of Regina, and parents three beautiful children. His third collection of poetry, *Getting to Know You*, won the Saskatchewan Book Award for Poetry in 2004. His fourth collection, *My Human Comedy*, will appear in 2007.

"A blizzard hides behind my frosted window," say the alley-dwellers. Their apartments face west, overlooking the alley running south from Parliament, just east of Albert Street. Across the alley lies a parking lot, two or three of them. The entire area is written in yellow lines and concrete over which the wind blows a hard whistle, and the snow, already deep, wears an armour of hard dark space. Such a wind won't give up. When it does, the blizzard is over.

But alley-dwellers know that in not much more than two or three months, the sun will go down right about now with what, let's face it, is pure glory, a sunset the rest of the world offers but can rarely deliver. Tourists from Alberta will see real sunsets for the first time ever. The evening above the alley will never have flown colours like this.

Perhaps I'm getting ahead of myself. The alleys lead to streets, and the streets lead out of town, and many of the alley-dwellers *have* been out of town, now back again, this time opting for three-storey walk-up life in the south end. They didn't intend to, but find themselves spending more time, when weather lets them, on their balconies overlooking the alleys.

Alley-dwellers facing straight west find the TraveLodge Hotel forming the horizon forty degrees to the south, the back end of a strip mall from ten degrees south to ten north. Sub, pita, movie, gas, and burger franchises

cluster near the alley, which seems to wind among them like water under a pier. Garbage and delivery trucks follow their own angles in the alley. On game day, football fans tear through — whooping hard, hours before kick-off. Straight north or south, alley-dwellers see the rows of balconies and parking lots below, and a fast-food, feeder alley, the connection to Spence Street, bearing heavy high school traffic at noon and after school.

With that much knowledge, alley-dwellers' prospects would not amount to much. But then they raise their eyes a little, look above the streetlights, beyond the strip mall ahead, beyond the silhouette of an apartment block on Rae Street and a jet taking off. And there, saving the view, turning every alley-dweller into the luckiest gal or fella on the face of the earth, lies the western sky (although the western sky never lies).

Other than that there's not much to say. The sky is complete, and even the most routine functions of a commercial alley don't mind beauty, and the wind, which all this time has blown either warm air or blizzards, sees itself in charge of this whole scene.

Facing page, far left: the alley behind the Spence Street apartments.
Photo by Don Hall.
Facing page, right, and this page: the western sky (times six) as seen from the alley behind Spence Street.
Photos by Gerald Hill.

197

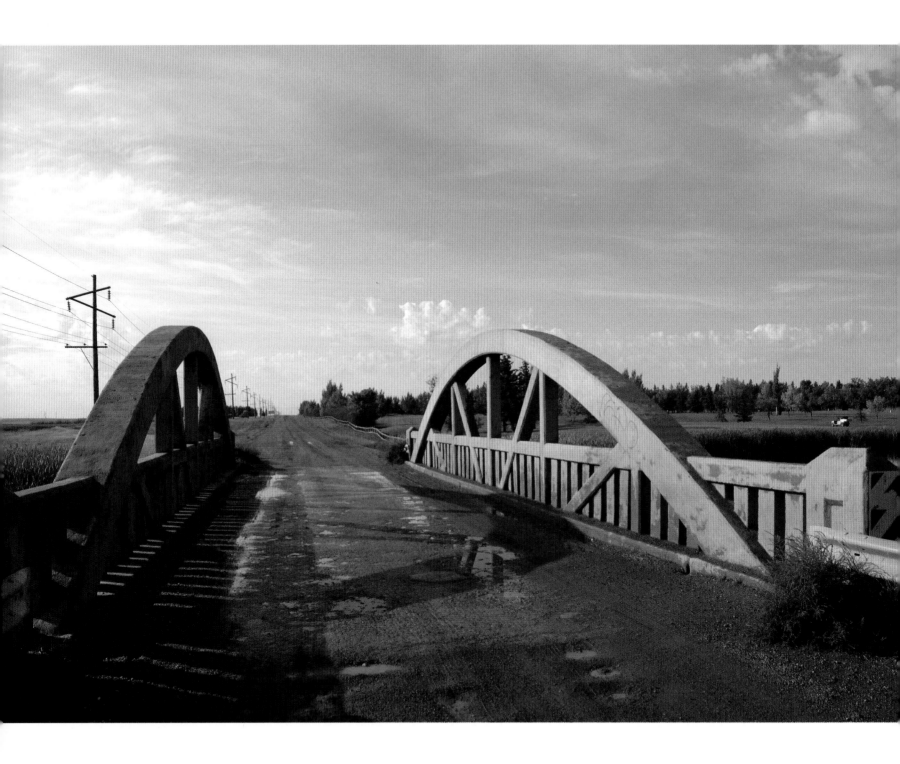

The Fleet Street Rainbow Bridge

by Claude-Jean Harel

Photos by Don Hall.

It may not be the most flamboyant architectural structure in Regina, but a lot more than it seems at first glance is invested in the Fleet Street Rainbow Bridge.

This particular crossing of Wascana Creek at the eastern edge of the city has a long and documented history dating at least back to 1885. In 1920, the current structure replaced an earlier wooden bridge on this site. Around the turn of the twentieth century, settlers likely accessed lands south of Wascana Creek by crossing here over relatively level banks.

This reinforced concrete bridge is Regina's oldest. It is also a classic example of the type of arch bridges that became popular in Saskatchewan after 1914 – a remarkably well-adapted transportation solution for the Great Plains environment.

It would be fair to ask what might be learned from examining in detail the workmanship involved at this site. From an industrial archaeology standpoint, there is an entire tradition awaiting discovery.

For instance, at the time, it was not uncommon for bridge workers to camp at the site for days at a time, especially when pouring concrete was involved. To slow down the curing process at night during hot weather, in order to ensure a good weld between pourings, ice blocks might have been brought in, crushed, and laid on top of freshly poured layers to slow the curing until the next morning.

In 1920, this location was much more isolated from Regina's centre than it is today. This place truly was in the countryside.

To build such a bridge, the contractor would have had the building materials delivered to the nearest railway siding. These would then be hauled with horse and wagon to the site. A hand concrete mixer with a capacity of one-quarter of a cubic yard might have been used to mix cement sand, gravel and lime.

First, wooden piles would be driven into the ground to support a wooden form structure. The concrete was poured from the bottom to the top of the bridge, starting with the abutments on each bank. Lead plates were placed on top of abutments to receive the concrete deck, which was then poured. The lead plates minimized the impact of frost and thaw through the seasons by allowing a certain amount of give and enabling the deck to slide a little as temperature changes shrunk and dilated the structure – a simple, clever mechanism that works.

Rebar had been layed inside the forms before they were filled with concrete to add tensile strength to the concrete's compression qualities. The arch, of course, helps distribute the weight of the deck and added to the structural integrity of this fine work of engineering.

As people drive over the bridge today, nearly 90 years after it was built, few know just how long this discreet and beautiful element of our municipal heritage has been making it possible for citizens to set out for the south bank.

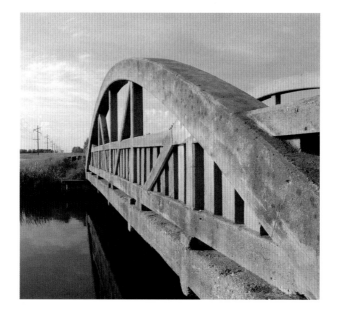

An anthropologist, award-winning journalist and an accomplished heritage interpreter, Great Excursions president Claude-Jean (C-J) Harel is a graduate of the universities of Saskatchewan and Leicester (England). C-J is a member of the Association for Heritage Interpretation (UK/Ireland), an affiliated member of the French Federation Technicians and Scientists of Tourism, and the recipient of a 2005 City of Regina Municipal Heritage Award. He is also a regular contributor to CBC radio and television programs.

Photo by Don Hall.

The Power of the Land

by Helen Marzolf

For two decades, Helen Marzolf has been obsessed by the landscape genre and its capacity to cloak the physical environment. Helen lives on the west side of Mt. Tolmie in Victoria, British Columbia, a little mountain that irritates and informs her landscape preoccupations.

My jaw would lock into early onset bruxism every time I drove by the mural emblazoned on one of the big tanks in the industrial area of northeast Regina. The mural elicited unwholesome thoughts about the vulnerable aquifer beneath the tanks; the landscape tradition's feckless amenability; the myth of Nature's endless regenerative capacity. Heck, the mural fanned the tinder of a thousand random frustrations lurking in the tangle of my consciousness. Luckily, the Subaru never went out of control.

I felt as though that mural had been around for most of my adult life. I was wrong, of course. Alberta artist Tag Kim led a team of painters — Sung Kim, Chris Klassen, Blaine Arnot — who completed it in twenty days in September 1998. But my mis-memory is justifiable. The mural carries the insistent imagery of the immigration posters that first attracted Europeans to the plains. Like the posters, "The Power of the Land" is an archetypical landscape celebrating abundance: a majestic stag and a piping plover share a wetland meadow foreground. In the background, golden grain fields surround a distant farm. Here, the land is a heritage trophy, performing the emblematic function of reas-

surance. Such images are potent touchstones for most people who live in Saskatchewan and for the province's ever growing diaspora. There's another connection, too. Where many early immigration posters featured industrial imagery — the very latest farm machinery, robust trains, and the billowing smokestacks of a nascent industrial base — "The Power of the Land" doesn't need any industrial footnotes.

By commissioning the mural, Enbridge Pipelines Inc. gives motorists a disarmingly candid view of the triad of industry, agriculture and environment. Let's face it: the plains are an industrial landscape, and the power of the land resides less in the regenerative potential of the prairie than in supply and demand. I appreciate such unambiguous directness. Industry predominates and the environment is a veneer that we all carefully nurture, from a safe distance, like a painting, or a photograph. Or a mural.

I thought I had the mural pegged as cynical camouflage. But, like most things that elicit strong reaction, it is far more complex. Besides acting as a painterly skin of reassurance covering tanks, the mural is also an environmental icon. Senior Corrosion Technician Barry Sudom offered this reading when I called about the artists' names and the mural's date. His comments took me by surprise. On a practical level, the mural is a small part of Enbridge's anti-corrosion efforts to keep the crude oil in the tank. But the painting is intended to remind viewers, including Enbridge employees, of a shared commitment to the environment.[1]

I worry, sometimes, about being pickled alive in briny stridency about things environmental. My thoughts about the mural, "The Power of the Land," still vacillate. At the same time, I want to believe Enbridge tries to leave a less heavy footprint.

1 Enbridge Pipelines Inc. was awarded the Environmental Practice of the Year award at the 2001 *Financial Times* Global Energy Awards. One initiative has been a policy to reserve topsoil and to reseed with indigenous species. Telephone interview with Barry Sudom, September 15, 2005.

Photo by Claude-Jean Harel.

City of Regina Sanitary Landfill

by Claude-Jean Harel

No wonder refuse disposal sites are among destinations most favoured by anthropologists as a source of information about the way we live today.

Our garbage is like a book waiting to be read. The things we throw away are revealing about our patterns of consumption. If only we could have different sections for people who live in Albert Park, North Central, Wascana View and the Core — then we would really get a sense of people's practices across the City.

I have always considered a trip to the dump as a bit of an adventure. In the distance, the mountain of garbage stands above the horizon, as a man-made landmark attesting to the impact of human settlement in the Regina Plain.

As one approaches the dump's entrance, the intricate stratigraphy of refuse layers emerges more clearly, beyond the flocks of gulls. We are about to enter the ever-expanding world of the discarded, governed by a methodology of substances, materials and components not normally found in such concentrations.

Driving up the hill with my offering in tow, I come across a garden of unwanted old fridges and freezers, standing by for the final journey to oblivion.

Alas, at the summit, the general dumping area awaits the next load, animated by a choreography of pickup trucks and trailers, gently approaching the resting place of old carpets, broken beds and counter tops, while bulldozers shape the hill a little further on.

Social encounters here are punctuated by a brief "good morning" or "hello." Anonymity, it seems, is the preferred tone when citizens come to the altar of redundancy.

Anthropologist and founder of The Great Excursions Company, Claude-Jean Harel has been taking learning and enrichment-minded travellers behind the scenes for years. His staging areas include back lanes, former industrial sites, as well as natural and cultural heritage places emerging and forgotten.

201

Regina Humane Society

by Joseph Pettick

During the early 1950s the Western Humane Society was represented by a solitary individual named Jack Studholme. His work came to public attention when the local media covered stories and published photographs of him rescuing a bear from the top of a wood telephone pole in Regina, and saving the life of a wild deer which had been injured by an automobile on the highway. At that time Jack was living alone in a small, primitive shack in west Regina, near the sewage lagoons.

To be more accurate, he lived in the shack filled with animals which he had rescued. There were dogs and cats everywhere; some were in cages, but others were run-

ning free because there was a shortage of cages in which to house them. The shack was heated with an oil-burning space heater. When I first took out some food and visited with him I enquired about the animals running free. "How do you manage discipline among all these cats and dogs?" It was the middle of winter and it was very cold at the time and he was sleeping in the same space as the animals. His response was predictable. "All of us are keenly aware that we are living in extreme danger and that the need to survive brings us close together."

About 1962, SaskPower brought in a natural gas network to heat homes and other buildings in Regina. Many of us donated our unused heating oil to the humane society to help out.

At that time and for many years to follow, the city of Regina operated a dog pound of its own, looking after stray and abandoned animals throughout the city. It was a sort of "bare bones" operation which was a crowded lockup for animals to be housed until it was time for them to be terminated. The facility was in poor condition.

A group of concerned citizens formed the Regina Society for the Humane Care of Animals in the late 1950s, electing City Police Inspector Al Juno as president. They set an ambitious goal to organize a membership and to build proper facilities.

Among the new members, a widow, who remains anonymous, donated a large number of original paintings which were auctioned off for $6,000. The sum was then matched by the city and a Quonset hut shelter was built in 1965 north of the city near Highway #6 on donated land across from the IPSCO plant.

Support for the shelter was received from the City of Regina, Wascana Centre Authority, Associated Canadian Travelers, the Wild Life Branch of the Provincial Government, IPSCO, the RCMP, Regina City Police and Doctor Charles Fawcett and the Regina Veterinary Clinic. An expansion of the Quonset hut was built and an official opening took place November 1, 1970.

In 1974 a fire gutted the shelter, and reconstruction of the old wing was completed in 1975.

In 1980 during a visit to the shelter, I met Merle Anderson and Nelda Svetkov, two of the hard-working and devoted members of the board of directors. They impressed upon me that the number of cats and dogs being handled was rapidly increasing and the shelter was running out of space. To encourage the board to deal with the problem, I met with them and made a donation of several thousand dollars specifically for use in initiating a fundraising drive to build a major new building adjacent to the existing Quonset-shaped shelter.

Through our architectural firm I donated the full services of myself and the engineering consultants as a gift to the Society. The drive for funds to build the shelter was the usual hard road to navigate, but the goal was finally achieved. I used the influence of our firm with material suppliers and sub-trades to have them donate or supply materials and labour to keep building costs down.

The construction of the new shelter began in 1981; it was opened in 1982. Using materials salvaged by our firm from a building being demolished, the new building was connected to the original Quonset. On December 14, 1982, the new shelter was officially named the "Joseph Pettick Animal Shelter."

Today the entire complex has a replacement value in excess of one-and-a-half million dollars and handles over 5,000 dogs and cats in the average year. You might say the work performed by the Regina Humane Society is ranked at the top of our pet projects.

Lifetime member of the Regina Humane Society, Joseph Pettick has looked after a vast collection of pets over the years, including three Capuchin monkeys, dogs, pigeons, songbirds, turtles, and tropical fish. His assistance to the Regina Humane Society prompted the shelter being given his name.

Suggestions on How to Find Yourself the Last Remaining Human On Earth*

by Jen Hamilton

* To find yourself the last remaining human on Earth, go to the Arcola and Prince of Wales Avenue intersection in Regina, and look "away" from the city. It needs to be daytime, and it's better if there are no clouds in the sky. Sunday, early morning of a long weekend, works the best as there is less traffic; I've been there mid-day during the week with surprising rates of success. Go there by car, as with speed a highway behaves differently.

Facing page: Looking "away from the city" on Arcola Avenue at the Prince of Wales intersection. This page: Looking "towards the city" on Arcola Avenue at the Prince of Wales intersection. Photos by Jen Hamilton.

I am driving home from the east Vic shopping conglomerate. I am the last remaining human on Earth.

At the intersection I look left and quiver, like you would if faced with a void, or with being the last human on Earth. I am reminded of a movie I saw as a kid.

This guy finds himself to be the last remaining human on Earth. Everyone he knows and everyone he expects to see has mysteriously disappeared. He goes into a bar. He sees unfinished drinks and tipped-over chairs; Christmas-style lights decorate a wall and blink on and off. A stereo plays. He goes outside. There is no one: no pedestrians, automobile traffic, or airplanes.

So I imagine for a few seconds, I am that guy, the last remaining human on Earth. Arcola Avenue at the Prince of Wales intersection lends itself to this last-human-on-Earth feeling. In the bright, uniform daylight the road stretches into a grim vanishing point. And even though the odd car drives by across the way, I give in to a feeling of solitude.

* * *

Arcola is punctuated by light standards. As I drive, they hit my peripheral vision one after another, like long, worrying exclamation marks. Backyard fences restrain the regiment of houses that are about to charge the highway.

The sky and the road are full of summer. I am excited by the prospect of the vast expanse, yet somehow the emptiness sponsors a small amnesia. I see the technological sublime of the highway. I forget where I've been and where I am going. A stereo plays.

Jen Hamilton studied sculpture/installation at the Ontario College of Art and upon graduation in 1992 was awarded the lieutenant-governor's medal, and the Sir Edmond Walker Scholarship to attend graduate school. In 1996 Hamilton received her M.F.A. from Concordia University in Montreal. In 1997 she moved to Regina, Saskatchewan, to develop and teach the Intermedia programme at the university. Since 2003 she has been participating in national and international artist residencies. She works collaboratively, and as an independent producer of installations, drawings, sculptures, and technological-based art works.

Index of Authors